# Rules, Rituals,
# and
# Responsibility

HERBERT FINGARETTE

*Critics and Their Critics*

VOLUME II

# Rules, Rituals, and Responsibility

ESSAYS DEDICATED TO HERBERT FINGARETTE

EDITED BY

## Mary I. Bockover

OPEN ❀ COURT

La Salle, Illinois

Critics and Their Critics

OPEN COURT and the above logo are registered in the U.S. Patent
and Trademark Office.

© 1989 by Ferdinand Schoeman for "Alcohol Addiction and
Responsibility Attributions"

© 1991 by Open Court Publishing Company for all other material

First printing 1991

Printed and bound in the United States of America.

Library of Congress Cataloging-in-Publication Data

Rules, rituals, and responsibility : essays dedicated to Herbert
   Fingarette / edited by Mary I. Bockover.
       p.   cm. — (Critics and their critics ; v. 2)
   Includes bibliographical references and index.
   ISBN 0-8126-9164-4. — ISBN 0-8126-9165-2  (pbk.)
     1. Responsibility. 2. Philosophy. I. Fingarette, Herbert.
   II. Bockover, Mary I. III. Series.
   BJ1451.R85     1991
   170—dc20
                                             91-30830
                                                CIP

# CONTENTS

# CONTENTS

## PART TWO

# CONTRIBUTORS

**ROGER T. AMES** received his Ph.D. from the School of Oriental and African Studies, University of London, in 1978 under the supervision of Professor D. C. Lau. He is presently Professor of Chinese Philosophy at the University of Hawaii, and is editor of the journal, *Philosophy East and West*. He is also currently working with Professor D. C. Lau on a collaborative translation of portions of the *Huai Nan Tzu*. His major publications include *The Art of Rulership: Studies in Ancient Chinese Political Thought* (1983); *Thinking Through Confucius* (with David L. Hall, 1987); and *Nature in Asian Traditions of Thought: Essays in Environmental Philosophy* (edited with J. Baird Callicott, 1989).

**İLHAM DİLMAN** received his Ph.D. from the University of Cambridge and is currently Professor of Philosophy at University College of Swansea in Swansea, Wales. He has taught at the University of California at Santa Barbara, and has been Visiting Professor at the University of California at Los Angeles and at the University of Oregon at Eugene. He has read papers at various universities at conferences in Britain, the U.S., Canada, and Turkey. Some of his major publications include *Matter and Mind, Two Essays in Epistemology* (1975); *Studies in Language and Reason* (1981); *Freud and the Mind* (1984); and *Quine on Ontology, Necessity and Experience* (1984).

**GEORGE FLETCHER** received his J.D. from the University of Chicago and his M.A. in comparative law from the same school. He is currently a professor at the School of Law at Columbia University, and is editor of *S'Bara: A Journal of Philosophy of Judaism*. His books include, *Rethinking Criminal Law* (1978), and *A Crime of Self-Defense: Bernhard Goetz and the Law on Trial* (1988). He has also written several articles on legal philosophy, and is now writing a book called *Loyalty*.

**ANGUS C. GRAHAM** (1919–1991) received his Ph.D. from the School of Oriental and African Studies, London University. He was Professor of Classical Chinese at the S.O.A.S. until his retirement in 1984. He also taught at Brown University, and was recently a visiting professor of philosophy at the University of Hawaii. He published on Classical Chinese philosophy, textual criticism and grammar, moral philosophy, and also translations of Chinese poetry. His books include *Later Mohist Logic, Ethics and Science* (1978); *Chuang-tzu: The Inner Chapters* (1981); *Reason and Spontaneity* (1985); and *Disputers of the Tao: Philosophical Argument in Ancient China* (1989). He was the subject of the first volume in this Critics and Their Critics series (*Chinese Texts and Philosophical Contexts*, edited by Henry Rosemont, Jr.), a volume to which Herbert Fingarette was a contributor. Professor Graham died while the present volume was in preparation.

**ANN FINGARETTE HASSE** received her law degree from the University of California at Berkeley in 1973, and is now a General Attorney for the Southern Pacific Transportation Company in San Francisco, California. As their sole antitrust attorney, she manages all Southern Pacific's antitrust litigation. She is the daughter of Herbert Fingarette, with whom she co-authored the book, *Mental Disabilities and Criminal Responsibility* (1979). She has also published articles on both archaeology and law, including "The Marmaria Puzzles" (1970); "Keeping Wolff from the Door: California's Diminished Capacity Concept" (1972); and "Drug Intoxication and Criminal Insanity: Old Dilemmas and a New Proposal" (1976).

**MIKE W. MARTIN** received his Ph.D. from the University of California at Irvine in 1977. He is currently Professor of Philosophy at Chapman University where he has served as chair for the philosophy department and Chapman Faculty. He has also taught at the University of California at Irvine and at UCLA. He has been the recipient of several fellowships from the National Endowment for the Humanities, and was awarded a Graves Award for Outstanding Teaching in the Humanities from Pomona College (1983). His publications include *Ethics in Engineering* (with Roland Schinzinger, 1983, 1989); *Self-Deception and Self-Understanding: New Essays in Philosophy* (editor, 1985); *Self-Deception and Morality* (1986); and *Everyday Morality* (1989).

STANTON PEELE received his Ph.D. in social psychology from the University of Michigan. He has taught at Harvard University Graduate Business School and Columbia University Teachers School. He is currently a psychologist in private practice, health researcher, and consultant with Mathematica Policy Research. In 1989, he won the Mark Keller Award presented by the *Journal of Studies on Alcohol*, and his major publications include *Love and Addiction* (with Archie Brodsky, 1975), *The Diseasing of America* (1989), and *The Truth about Addiction* (1991).

HENRY ROSEMONT, JR., received his Ph.D. from the University of Washington in 1967, and is currently Professor of Philosophy at St. Mary's College of Maryland and Distinguished Consulting Professor at Fudan University in Shanghai, China. He has taught at Oakland University, the University of Hawaii, and as Visiting Fulbright Professor of Philosophy and Linguistics at Fudan University. He is editor for the Society for Asian and Comparative Philosophy Monograph Series, and has been invited to give lectures and papers throughout the U.S., as well as in Europe and Asia. Some of his major publications include "The Pre-Established Harmony Between Leibniz and Chinese Thought" (with D. J. Cook, 1981); *Explorations in Early Chinese Cosmology* (1984); "Against Relativism" (1988); and *Chinese Texts and Philosophical Contexts: Essays Dedicated to Angus C. Graham* (1990).

FERDINAND SCHOEMAN received his Ph.D. from Brandeis University in 1971, and is currently Professor of Philosophy at the University of South Carolina. He has been a visiting lecturer at the University of California at Berkeley, an N.E.H. Fellow, and is an active participant in workshops and seminars sponsored by the National Endowment for the Humanities. He was review editor for *Law and Philosophy* (1981–1984) and is currently on their editorial board. Some of his major publications include *Philosophical Dimensions of Privacy: An Anthology* (1984); *Responsibility, Character and the Emotions: New Essays in Moral Psychology* (1987); "Statistical vs. Direct Evidence" (1987); "Are Kantian Duties Categorical?" (1990).

# ACKNOWLEDGMENTS

Since this book was designed to acknowledge the profoundly important work of Dr. Herbert Fingarette, I will thank him here for being such an inspiring teacher. He was one of my professors in graduate studies in philosophy at the University of California at Santa Barbara, and the gratitude I feel for his valuable instruction is what fueled my desire to edit this collection of essays dedicated in his honor. I am greatly indebted to Dr. Fingarette for his intellectual contributions, as well as for his genuine warmth and sense of responsibility as a person.

I must also thank Henry Rosemont, Jr., one of the contributors to this volume and editor of the first volume in the Critics and Their Critics series, *Chinese Texts and Philosophical Contexts: Essays Dedicated to Angus C. Graham.* Henry suggested that this gesture would be appropriate to honor a teacher I had come to admire so very much. Henry was one of my professors as an undergraduate at St. Mary's College of Maryland, and was my first inspirational teacher in philosophy; he was the person who first moved me to appreciate—and enjoy—the discipline.

I also want to thank Leslie Fingarette from the bottom of my heart, for assisting me in this project by providing names of some potential contributors, by sending me some useful information with which to begin an introduction to this volume early on, and for keeping the whole business a secret from her husband for the months it took to sufficiently organize. I also thank Ann Fingarette Hasse for her contribution to, and support of, this project. Like her mother, she was most kind and helpful.

I also offer many thanks to Leo S. Chang for the graceful Chinese calligraphy in Chapters 5 and 6. Professors Rosemont and Ames were delighted with both its accuracy and beauty. Finally, I want to extend my most sincere gratitude to all the contributors to this book, and to Open

Court Publishing Company for its production, especially Kerri Mommer for her remarkable diligence, dedication, and friendliness.

I hope it goes without saying that I am truly delighted to be able to dedicate this book to such a distinguished and inspiring philosopher, Herbert Fingarette.

Mary Bockover
*Arcata, California*
*May, 1991*

# BIOGRAPHICAL NOTE

Herbert Fingarette was born on January 20, 1921, in Brooklyn, New York. He went to elementary school there, then moved to Los Angeles, California the year he started junior high school. He also attended high school in Los Angeles, and then went on to attend the University of California at Los Angeles (UCLA).

World War II interrupted his undergraduate studies however, in January of 1943. He then spent three and one-half years in the army, starting as a private, and ending as a lieutenant assigned to the Information-Education group of the Army General Staff at the Pentagon. While in the service Herbert Fingarette married Leslie Swabacker on January 23, 1945, and was finally discharged from active duty in 1946. The couple then returned to Los Angeles in June of that same year. Herbert Fingarette immediately returned to UCLA to finish his B.A. in philosophy, and in 1947 began graduate studies in philosophy at the same school. The couple had their only child, Ann, in December of 1947.

In 1948 Herbert Fingarette was appointed as a Lecturer in Philosophy at the University of California at Santa Barbara (UCSB). He received his Ph.D. from UCLA in the summer of 1949, and was appointed at UCSB as an Instructor for their tenure-track position in philosophy at that time. He went up through the ranks, becoming a Full Professor in 1962. He was honored by the UCSB faculty as Distinguished Teacher and also as Faculty Research Lecturer, as well as having been very active in campus and in university-wide governance.

The Fingarettes found Santa Barbara to be a delightful place to live and raise a child. The University also provided the finest resources, scholarly society, and working conditions a scholar could want. The couple became deeply rooted, and they live in Santa Barbara to this day. Leslie Fingarette has been Herbert Fingarette's life-long secretary and editor, in addition to being his closest companion. Their daughter, Ann Hasse, has also become a professional collaborator. She and her father

wrote a book together called *Mental Disabilities and Criminal Responsibility* (1979). Leslie Fingarette was their editor and secretary. Herbert Fingarette and his daughter have also worked—and continue to work—on a number of other legal projects together.

To close, Herbert Fingarette has always been a man of great professional privacy. His only professional collaborators have been his wife and daughter, who have offered him great insight and support. He has been a first-rate scholar and teacher, and in 1984 was the first American philosopher to be awarded national honor for distinguished work in philosophy as Romanell–Phi Beta Kappa Professor of Philosophy. He has been a Fellow of the American Council of Learned Societies, the National Endowment for the Humanities, and the Center for Advanced Studies in the Behavioral Sciences at Stanford. In addition, he was elected President of the Pacific Division of the American Philosophical Association (in 1976). His other major publications include *The Self in Transformation, On Responsibility, Self-Deception, Confucius—The Secular as Sacred, The Meaning of Criminal Insanity,* and *Heavy Drinking.* Dr. Herbert Fingarette retired from UCSB in June of 1990, but he continues to advance the discipline of philosophy with his diligent and perceptive research.

# GENERAL INTRODUCTION

This volume in comparative philosophy traverses areas such as philosophy of law, Asian philosophy, ethics, and philosophical psychology. The outcome is an exciting work examining various philosophical disciplines and approaches, all having at their core the same basic concern: how to limit, define, or apply the concept of responsibility within some significant personal or cultural context. The concept of responsibility is complicated and multidimensional to be sure, and this book discusses some of the ways human beings have accepted or denied taking responsibility in their own lives, or have tried to provide a framework for responsibility in their society or culture. The differences which result from the fact that we are personally and culturally disparate must not obscure what is universal however, and what serves as the underlying and cohesive theme of this book. For responsibility—although dependent on context for its specific normative character—has been taken seriously by every human culture known to exist.

On a more personal note, this collection of essays is dedicated to Dr. Herbert Fingarette, an exemplary philosopher and scholar. Its contents reflect the primary subject areas to which Dr. Fingarette has so far contributed. It is a labor of fondness and respect from everyone who has been involved with its creation, although the contributors herein do not hesitate to challenge Dr. Fingarette when they disagree with him.

This volume consists of two main parts. Part One comprises nine probing and insightful essays, each concerned with some area of philosophical interest the author shares with Dr. Fingarette. Part Two, "Comment and Response," includes Dr. Fingarette's analysis of each of these essays in addition to his Conclusion, which succinctly elucidates and examines the unifying theme and sub-themes of this volume, and the unifying concerns that characterize his distinguished career as a philosopher.

The first essay, written by Ann Fingarette Hasse, focuses on how

policy decisions determine legal responsibility and criminal culpability. This is brought out in light of the current law on criminal conspiracy, most notably the ruling precedent laid down in the case of *Pinkerton v. United States* which determined that guilt for criminal conspiracy only requires that one has agreed to join the conspiracy. This precedent can be sharply contrasted with the basic common law principle that a necessary condition for criminal guilt is involvement in the instigation, preparation, or actual commission of the crime. Thus we can see that legal responsibility is dependent upon the policy decisions that shape its meaning and provide its context.

The next essay, by Ferdinand Schoeman, is concerned with the responsibility heavy drinkers have for their alcohol abuse and its related conduct. This essay has further implications however, for it examines some key parameters for holding or not holding people responsible for their behavior in general. Schoeman also analyzes some common misconceptions about alcoholism, for instance, the misconception that it can be defined as a disease or that its failure to be defined as such necessarily implies that one is responsible for alcohol and related abuse. Stated generally, this essay maintains that heavy drinking is far more complicated than it has typically been made out to be, and to understand it more fully requires an examination of voluntariness, social and cultural influences on drinking, the psychological constitution of the drinker, and a range of other factors.

Stanton Peele follows with an essay that also addresses the topic of alcoholism, along with the essentially connected issues of voluntariness and responsibility. His focus, however, is more on how the field of alcohol studies is driven by emotional, financial, and doctrinal motives that maintain its impoverished state, instead of being driven by the desire for objective, scientific truth. Peele uses the professional attack on Dr. Fingarette that Dr. Madsen's "alcohol study" makes in print as the basis for this discussion. In fact, according to Peele, the large majority of alcohol studies in America either lack valid scientific data or put forth questionable interpretations of valid data. Peele argues, as does Schoeman, that alcoholism and its related behavior can not be adequately explained in terms of being a disease; this is far too simplistic

and vague a conception of what is in fact a very complex human problem.

George Fletcher offers an essay that is a comparative work in its own right, examining how Jewish Law can serve as a basis for substantively analyzing some central and contemporary common law principles. This essay is also crucially concerned with questions of responsibility, but within a traditional Jewish and then comparative context. Specifically, Fletcher focuses on the Biblical concept of "blood-guilt" and how this is related to being responsible for killing another human being. This analysis can be applied to the pertinent concerns of punishment and self-defense, concerns that clearly have significance for the common law principles which systematically affect the limits of legal responsibility today.

The essay that follows is written by Henry Rosemont, Jr., and is also a comparative work, drawing upon ancient Chinese thought to examine some basic problems with the Western concept of personal rights and the egoistical concept of responsibility this entails. Rosemont contends that personal rights are not universal moral laws that apply cross-culturally; to the contrary he investigates a profound "moral" teaching practiced by a sizable part of the human population even today—that of Confucius, which makes no use of the concept of rights that we are so preoccupied with in the West. In essence, for Confucius, to be a person is to stand in significant relation to others. Thus, the focus of his philosophy is on the interpersonal dimension of human life, which can be sharply contrasted with our highly intrapersonal focus on the individual.

Roger T. Ames writes on a related topic, focusing on the concept of self that emerges from a Confucian perspective. Ames's discussion suggests that there is a Western concept of self which is not altogether different from the Confucian concept of *jen*. More specifically, Ames establishes a clear conceptual link with the notion of self *qua* unique individuality, a notion that is not alien in the West, and that is of central importance to the philosophy of Confucius. Confucius's notion of individuality differs from the traditional Western notion of the isolated and autonomous self, however. According to Confucius, one's unique

individuality is socially determined, i.e., the self for Confucius is a complex of social roles that one ideally and distinctively embodies in the course of his or her life. To be a person then, or to cultivate one's self, is to develop an open, responsible stance toward all others in accordance with one's various social roles. Clearly, a concept of unique individuality can emerge even when set in a fundamentally social or interpersonal context.

Next, Mike W. Martin brings us back to a Western approach to responsibility, analyzing what it means to be honest with oneself. He carefully distinguishes between certain authentic personal virtues and their pretentious look-alikes. Thus, we are given a basis for identifying what is genuinely valuable—most centrally, the virtue of being honest with oneself—from perverse facsimiles of virtue. The importance of self-honesty can be appreciated most fully by understanding how it affects one's personal integrity, autonomy, and self-fulfillment. More specifically, self-honesty is central to a "web" of virtues which also includes faith, hope, and charity among others, all of which "limit, balance, and guide" one another. The worthwhile consequence of pursuing self-honesty (which can be a struggle), is that it is the basis for developing a more autonomous, integrated, and fulfilled individual. This is a powerful picture of being responsible for oneself, indeed.

In his essay, İlham Dilman is also fundamentally concerned with self-knowledge and its connection with personal unity and autonomy. Stated succinctly, Dilman's thesis is that self-knowledge constitutes self-change and is not just a necessary precondition for it. To gain self-knowledge is to change oneself, and in a way that allows for greater autonomy—for having greater control over one's life. Thus, one "finds oneself" or gains true self-knowledge when she chooses a certain destination in life and lives in accordance with it. One then creates her own destiny, so to speak; she finds herself living a life freely chosen, having responsibly committed to it. In essence then, living an authentic personal life entails self-knowledge, a greater unity of self, and greater personal autonomy. This, of course, will also depend on contingencies beyond one's control, and will invariably reflect what one values.

The last essay, written by Angus C. Graham, bravely addresses the nature and significance of the mystical experience. Graham asks

Western thinkers to consider that other (notably Asian) traditions centrally attempt to draw human consciousness toward an appreciation of what could be called an ineffable, private, or even mystical, experience. And although rare, such experiences occur even in our own culture; heightened states of felicity, perceptual clarity brought on by hallucinogens or the more disciplined practice of meditation, are examples. Often times having such an experience makes any previous question about the significance of life melt away. We come to see life's beauty and value fully and directly—as we experience it. But we cannot pass on what we have gained to others who have had no such experience for the same reason; therefore, the knowledge is private. This is really not different in kind, however, from one's not being able to understand the principles of quantum mechanics without having the relevant conceptual experiences. Thus, according to Graham, "mystical" experiences may be far more natural than we in the West may presume. Consider that truly appreciating art or poetry depends on experiencing them as beautiful. This is how we come to understand their intrinsic value, and again, this is not different in kind from the (less ordinary) mystical experience which creates a spontaneous appreciation of the wonders of life itself.

I will say very little about Dr. Fingarette's "Comment and Response." Clearly, the nodal points of the essays will be key considerations in the reply. To state them summarily, the pivotal concerns are: responsibility, choice, rights, integrity and autonomy, self-hood, self-knowledge, our connection with others and more generally, with life itself. The cluster of concerns that emerge in the essays are addressed with a clear eye on the cohesive theme which underlies them all. Seemingly disparate, from distinct traditions and employing different approaches, we find that these concerns are related—despite their various contexts.

I will also say little about Dr. Fingarette's Conclusion, for it is his expressed desire to lead the reader to an appreciation of the concerns and discoveries that characterize his work as a philosopher. What I can say is that Part Two provides an enormous insight into the paradox of living a human life. On the one hand we are responsible beings, and on the other, much of life is beyond our control. On the one hand we are different from others—personally, culturally, religiously, and philo-

sophically, but on the other, there seems to be a thread that joins us all together as human beings. This sort of tension has plagued philosophy since the discovery that people could think and feel in fundamentally different ways. Can we reconcile these apparently contradictory states of affairs? Can we live with ourselves in the face of not fully knowing that what we are committed to or responsible for has a firm philosophical footing?

# FOLLOWING AN UNMAPPED WAY: A BRIEF PHILOSOPHICAL AUTOBIOGRAPHY

I appreciate the invitation to present a brief intellectual autobiography for this volume. In addition to the personal pleasure such an indulgence affords, it poses a very practical question: How do I explain (and justify?) working in such disparate fields?

For me this has been a natural evolution. I have made only one major programmatic decision in the course of my career. That decision was born at the time I began my doctoral dissertation. It came to ripeness and full self-consciousness in my second year of teaching. By the time I came to write the dissertation I began to realize that the fashionable issues of the day in professional philosophy were purely intellectual. They were challenging. They were "foundational." But, committed as I was to moral philosophy, I realized that I had not been exposed to a single concrete moral problem during my entire graduate career. I came to see what I was doing as eternal prolegomena, a systematic evasion of moral concern, ever setting the table but never a bite to eat.

So, for my dissertation topic, I turned to what was then outside the bounds of proper Anglo-American philosophy—the literature of psychoanalysis. There, I felt, I would at least be in touch with texts that explored concrete human problems in depth. Of more immediate and practical interest to me for the dissertation, however, was the unique claim of psychoanalytic therapy—to change one's way of life as the direct outcome of acquiring self-understanding. I hoped for confirmation of my Pragmatist thesis that value judgments could be based on knowledge, rather than being inherently subjective or "emotive" as the Logical Positivists of the day would have it.

I found no elegant solution to my theoretical problem. Yet the project was the turning point of my philosophical path. I gained a vivid realization of how many human, and specifically moral and philosophical problems, were posed by the psychoanalytic literature.

I pursued this line of inquiry, and soon made a conscious and enduring commitment. I would henceforth forego the fashionable issues in professional philosophy and follow—let the chips fall where they might—the problems that were meaningful to me wherever they led.

The central substantive theme that emerged for me was that of responsibility—what it is, how we come to have it, how we can lose it. That theme and other closely related questions, have remained central to all my work ever since.

My initial focus on responsibility resulted from recognition that the theme of psychoanalytic therapy was not that a sick person, a victim of the Unconscious, was in need of esoteric information from the doctor. Instead, the therapeutic setting was revealed as one in which a responsible moral agent, with some modest collaboration, was called upon to summon up the courage to bear anxiety and thus be able to face long-feared realities. I saw that therapy is a matter of learning to live these things, not merely to collect information about them. This in turn makes it possible to accept responsibility for how one shall live henceforth in the light of that reality. The aim of my own writing about these issues was not to psychoanalyze the philosophers but to gain philosophical insight into the significance of psychoanalysis and into the human dilemmas it probed.

These studies soon opened my eyes to the significance of what the Existentialists on the Continent had been teaching. They too spoke about anxiety, choice, and responsibility; but the Existentialist style of expression was antipathetic to what we philosophers in the U.S. most worshipped—clarity of expression and logical rigor. Our favored examples of "meaningless" language were drawn from the rhetoric of Continental philosophy. Now, however, I began to write about responsibility from the standpoint of both secular and theological Existentialism, in their literary as well as their explicitly philosophical forms.

Then came a new intellectual shock. I had been writing about the enlightenment that the discipline of psychoanalytic therapy can evoke, and the liberation this brings. I found that in so doing I was spontaneously using metaphors, idioms, images, and paradoxes that were inescapably reminiscent of mysticism, of Eastern doctrines such as Karma, and of the enlightenment disciplines of Buddhism. They too

spoke of self-induced ignorance and illusion, of bondage, enlighten-ment, liberation, spiritual at-one-ness. The logic of my inquiry turned me to the study of doctrines which until then had been anathema to me. Once again I realized how rigidly parochial were the boundaries within which the genuine powers of analytic philosophy had been re-stricted by most professional philosophers of the period.

Even such "superstitious" notions as Karma and Re-birth came to have deep significance for me. There were—as I came to see it—inescapable parallels with the psychoanalyts' notion of the different "selves" each of us had, the different lives we live, most of them uncon-scious. Karmic doctrine speaks, however, of our forgotten lives from the past. From either standpoint, all these "lives" have a psycho-moral role in the way our present (i.e., conscious) life goes along—that is the law of Karma. Are these Eastern doctrines literally true? I came to see, and eventually to write about, the confusion and ambiguities that lie within that simple notion of the "literally true."

These writings about psychoanalysis, Existentialism, and Eastern thought were eventually collected into my first book, *The Self in Transfor-mation*—which, when finally published in 1963, represented a personal, moral, and philosophical revolution in my life. The essays turned out to have a genuine unity. They traced, from a variety of perspectives, the individual's psycho-spiritual movement from childhood to maturity.

These studies led to a kind of hunger to demonstrate to myself and others that the insights could also be addressed in the format of analy-tic philosophy. My view was that it was the historical tradition of analyti-cal philosophy that was narrow, not the methods themselves. I had written an essay on responsibility, in a more orthodox "analytical" style for the philosophical review, *Mind*. Along with this I later published in book form a collection of individual essays, entitled *On Responsibility*. But I also felt by this time a need to present some of my views more expansively to the Anglo-American philosophers in a form congenial to the current style.

In the course of the teaching I was then doing there emerged a special interest in the problem of self-deception. The idea that one could deceive oneself was a challenging intellectual paradox demand-ing solution. More pertinent to my own special interests, I came to

appreciate that self-deception is a strategy by which we evade facing realities and thus evade responsibility. The topic called for close and rigorous conceptual analysis, grist for the philosopher's analytic mill. In resolving the paradox, I arrived at a novel theory of consciousness. This in turn allowed for systematic re-analyses of the self-deception concept as it appears centrally in Freud, Sartre, and Kierkegaard. And it led me, somewhat serendipitously, into the study of the divided selves that emerged in the "split-brain" neuro-anatomical experiments which had recently been reported. All this became the subject matter of my book, *Self-Deception.*

In the mid-1960s my work in psychiatry happened at one point to lead to an invitation to participate in a symposium on criminal insanity and criminal responsibility. I accepted, but only after pleading rank ignorance of the law. The result of that experience was a mind-opening realization of the riches a study of the law could hold for me. The law, after all, has a long history of trying to come to terms with insanity because insanity—and other forms of mental disabilities—undermine responsibility. The issues raised have generated an enormously rich literature of legal case reports, medical opinions, and scholarly legal analysis.

From the many years I subsequently spent working on these questions came a number of law review articles as well as two books on the topic, one of them co-authored with my daughter, Ann. It has been one of the joys of my personal and intellectual life that Ann, who is a lawyer, has by now been my collaborator on a number of law-related projects.

My studies of legal responsibility and mental disability led me eventually to another major topic of concern in the law—alcoholism and drug addiction. These, too, are conditions in which responsibility seems impaired. Such people purportedly "lose control" of themselves, become irresponsible substance abusers, and in consequence become irresponsible actors generally. But do they really "lose control"? The debate raged. Here again was a rich literature, not only legal but also scientific and medical. This led me into the extensive scientific research in the area. Over the course of the past twenty years or so I have explored the issues at length in a number of articles for law reviews and for scientific publications.

I recently wrote the book *Heavy Drinking* in my only attempt to address, and in a way to proselytize, a general public. I felt that the people entirely committed to research or therapy in the substance abuse field are constrained by oppressive ideological, institutional, and economic pressures. They know about, but do not feel free to speak publicly about, the anti-establishment picture that emerges from current science. As an independent scholar, expert in the field, I felt that I could bring the facts into focus, and make their significance clear to a misled general public. The better part of some four years of my efforts were recently devoted to the writing of the book, and to dealing with the professional and news-media responses to it.

The work in law had increasingly evoked in me the recognition that responsibility is not a univocal concept in the context of the law. It is defined differently for different purposes in different kinds of legal contexts. In short, legal responsibility seems to be not a single God-given fact but an attribution that serves legal policy. This point can be generalized beyond the law, and the theme is central to my Comments in this volume.

This emerging insight into the nature of responsibility had its impact on my intellectual development in two utterly unpredictable ways. I became fascinated by, and deeply committed to the study of the Book of Job on the one hand, and to the teachings of Confucius on the other. I shall explain.

My early interests in Asian thought had inevitably taken me into contact with the teachings of Confucius. Yet for me the Chinese admiration for Confucius remained an enigma for a long time. He seems to "preach." He never comments on the human situation in terms of such fundamental concepts as responsibility, choice, freedom, anxiety, or in terms of self-deception or inner conflict. The inner drama of the soul is absent.

At last, as it dawned on me how context-relative *all* these concepts are, and as I was pressed by the urgency of my own conviction that Confucius *must* have an important message, I suddenly saw that indeed he did have a great vision. His vision, however, was one in which the concepts central to my moral world played little or no role. Once again, I had been parochial. I needed to—and did—immerse myself in

Confucius's thought. A serendipitous pleasure, as well as an intellectual necessity for truly understanding his teaching, was learning to read the original Chinese texts.

I argued in my book, *Confucius—The Secular as Sacred*, that Confucius showed how human nature, insofar as it is distinctively human, is communal. He then showed how this communal nature, insofar as it is consummately human, is "ceremonial." Western law has a place for ceremony, but it serves the overarching value of the West—individualism. The ceremonies of our law are directed to assessment of individual liability, guilt, and responsibility. For Confucius, life itself is, ideally, a sacred ceremony. Indeed for him the ideal communal life approaches the condition of music and dance. Utterly absent is the central Western metaphor of the "inner drama" on the "inward stage" of the soul.

If Confucius presented to me a radically different perspective from which to look at the human community and its value, so too did the Book of Job. But the two perspectives differ dramatically. Teaching the Book of Job in my Philosophy of Literature course, challenged by the apparently anarchic message of the work, I came to find in it a tremendous message.

Human society, human concerns, human concepts of justice, responsibility, desert and punishment (and, I might add, human ceremonies)—all of this, says the Lord, is in the end *merely* human. Yes, we are indeed near unto the angels; and indeed our human concerns are authentic concerns—for us. But in taking our needs and moral concerns, our basic concepts, as rooted in the transcendent, as somehow objectively in tune with the Law of the Cosmos, we are fools. And the Lord ridicules honest Job for sticking by so foolish an idea. Reality is revealed in the thunder of the Lord as incomprehensibly richer, immeasurable grander, and infinitely more terrifying than our limited human concepts could ever comprehend. Responsibility under law is a great and valued human concern, but a cosmic irrelevance.

My essay on "The Meaning of the Law in the Book of Job" reflects my years of study of this Book, of its history, language, and dramatic structure. In my mind, no single work reaches that Book's heights of

grandeur and truth. At that level only Mozart, Beethoven, and Schubert share the terrain. This, to me, is the terrain of the sublime.

HERBERT FINGARETTE
*June 12, 1991*
*Santa Barbara, California*

*Postscript*

This autobiographical essay is dedicated to my wife, Leslie, who has been an intimate participant in my intellectual life. I am not here referring to the sheer labor she has contributed—all these years alongside me, arduously translating into typed text my constantly revised and illegible handwritten manuscript. Beyond such help, she has also been my first audience. Her keen sensibility has repeatedly brought me down to earth when I have been seduced by the pleasures of free-floating abstraction. Her unerring sense of the important issue, and an insistence on expressing it in English rather than Academese, have constituted a discipline that has had a substantive impact on my work as well as a stylistic one. Although not engaged in the more technical aspects of my work, she has been in more ways than I can describe here a close participant in my philosophical life.

# PART
# ONE

# The Criminal Responsibility of Conspirators for the Acts of Their Co-Conspirators

*Ann Fingarette Hasse*

It is generally the rule in criminal law that a defendant cannot be found guilty of a crime unless it is shown that that defendant actually committed the crime. There are, however a few exceptions to this rule. One striking example is in the law of conspiracy.

A criminal conspiracy is an agreement among at least two persons to accomplish some unlawful result.[1] Defendants can be charged with both conspiring to commit a crime and with a substantive criminal offense as well.[2] For example, a defendant can be charged with having agreed to join a conspiracy to sell drugs. In addition, the same defendant can be charged with the separate offense of illegally carrying a gun during the course of that conspiracy.

The United States Supreme Court's decision in *Pinkerton v. United States*[3] further expanded a criminal defendant's responsibility when it established the rule that Conspirator A can even be held guilty of a substantive crime which Conspirator B actually committed, although A did no more than join the conspiracy. For example, assume Conspirator A agreed to participate in a drug ring; Conspirator B was a courier for the drug ring and in the course of that operation carried a gun illegally. Under *Pinkerton*, Conspirator A is guilty of the substantive offense of illegal possession of a weapon.[4]

However, what is unresolved is whether Conspirator A can be found criminally responsible for, and thus convicted of, a substantive crime committed by Conspirator B *before* A even joined the conspiracy. The answer to this question, as will become apparent, in turn raises serious

doubts about the validity of the *Pinkerton* rule itself. The first step in this analysis is to return to the Court's discussion in *Pinkerton*.

In *Pinkerton*, the Court faced an appeal by Daniel Pinkerton, who had conspired with his brother to defraud the IRS. Daniel's brother Walter was convicted on nine substantive counts and on the conspiracy count. Daniel was found guilty on six substantive counts and on the conspiracy count. All of the substantive offenses were committed by Walter. Daniel appealed the conviction on the substantive counts because there was no proof that he had participated directly in any of them.

The Court held that "it has been long and consistently recognized" that the commission of substantive crimes and the creation of a criminal conspiracy are "separate and distinct offenses."[5] The Court called a conspiracy a "partnership in crime," a concept which has been used by courts throughout the years to describe criminal conspiracies.[6]

In this case, the Court agreed that there was no evidence that Daniel had participated directly in any of the substantive offenses. The Court found, however, that because Walter committed the substantive offenses in furtherance of the unlawful agreement between himself and Daniel and because Daniel had never withdrawn from the agreement, Daniel was guilty of the substantive counts as well.[7] The Court reasoned that, by joining the criminal conspiracy, Daniel showed the necessary criminal intent to do the substantive acts.[8]

The Court relied heavily on the principle of conspiracy law that "the overt act of one partner in crime is attributable to all."[9] If that is the case, the Court said, in addition to being found guilty of conspiracy, why shouldn't each conspirator be held criminally responsible for each separate substantive offense committed by any other conspirator in carrying out the goal of the conspiracy?[10]

Justice Rutledge dissented from the majority opinion, raising issues which have continued to disturb a few courts and which express fundamental concerns. Justice Rutledge argued, first, that allowing a defendant guilty of one offense to be convicted of another not proved against him results in an "almost unlimited scope of vicarious responsibility for others' acts."[11] He viewed the result as double punishment for the same crime.

Justice Rutledge pointed out that the majority appeared to view the conspiracy as a kind of general partnership resulting in a vicarious

criminal responsibility "as broad as the vicarious civil liability of a partner for acts done by a co-partner in the course of a firm's business."[12] He believed that transferring the vicarious liability concept developed for civil law to criminal law was wrong. The guilt of a criminal defendant is "personal, not vicarious."[13]

Despite Justice Rutledge's eloquent dissent, the Supreme Court affirmed the *Pinkerton* rule three years later.[14] Ironically, since then, the term which Justice Rutledge used—"vicarious responsibility"— has become the common term used by appellate courts to describe the *Pinkerton* rule. A typical example is the Fifth Circuit's holding in *United States v. Moreno*:

> In *Pinkerton v. U.S.* . . . . the Supreme Court set out the principle of vicarious liability in conspiracy cases. A conspirator can be found guilty of a substantive offense based upon the acts of a co-conspirator done in furtherance of the conspiracy. . . .[15]

The Seventh Circuit has characterized the *Pinkerton* rule as a "doctrine of conspiratorial liability."[16]

The result of this doctrine, as one court bluntly put it, is that a court does not need to inquire into the individual culpability of a particular defendant for each of the substantive offenses committed in furtherance of a conspiracy.[17] This was precisely the concern expressed by Justice Rutledge when he argued that criminal guilt should be "personal," not vicarious.

What Justice Rutledge was referring to when he analogized Daniel's conviction to vicarious civil liability is a concept which has developed in civil law as a way of spreading the risk for damage or injury to persons or property. Vicarious liability in civil law shifts full responsibility for injuries or damages to a party who has not in fact committed the injurious act. However, because of a special relationship to the acting party or because of social and policy considerations, that party is made responsible for the damage. For example, a parent can be responsible for a child's acts resulting in injury or death or in property injury.[18] An employer can be held responsible for the negligent actions of an independent contractor it hires where the work involves what is considered to be unusually dangerous activity.[19] The concept of vicarious liability developed as the commercial world grew more complex and as large businesses with their incumbent risks began to affect society as a whole.[20]

Thus, under civil law, members of a joint enterprise or joint venture can be liable for the acts of the other members of the enterprise. Often the analogy of a partnership is used.[21] As discussed above, the partnership analogy has been used repeatedly with reference to criminal conspiracies as well.[22]

Given the *Pinkerton* premise that all members of a partnership in crime, i.e. a conspiracy, can be vicariously liable for all substantive offenses committed by their co-conspirators, does it make any difference whether those substantive offenses were committed *before* a defendant actually joined the conspiracy? This issue is the subject of some controversy among the courts.

The question was addressed in a peculiar way by the United States Supreme Court in *Levine v. United States*.[23] There, the Court vacated its initial grant of certiorari because the Solicitor General "conceded," in response to questions by the Court, that a defendant cannot be held criminally liable for substantive offenses committed by members of the conspiracy before or after that defendant was a member of the conspiracy. No rationale for this "concession" is stated, and the basis for the concession is not readily apparent.

The actual result of the *Levine* decision has been confusion and conflict among the courts. The first problem has been that courts have generally held that acts committed by co-conspirators prior to the defendant's joining the conspiracy can be used to convict that defendant on the *conspiracy* count.[24] This derives logically from the principle described in *Pinkerton* that each conspirator's overt act is attributable to the others. However, the language used to describe this principle is often sloppy and fails to differentiate clearly between criminal liability for the *conspiracy* count and criminal responsibility for the *substantive* counts. So, for example, the Fifth Circuit remarks that once a defendant is shown to be a conspirator, "he is responsible for acts of the conspiracy occurring before or after his association."[25]

The second problem is that those courts which have specifically addressed the issue of criminal responsibility for substantive offenses committed prior to a defendant's joining the conspiracy have split over that issue. Thus, a few courts have found that a conspirator is responsible for the substantive acts committed prior to that conspirator's joining the conspiracy while the majority of courts have held the exact opposite.[26] The courts provide virtually no analysis for their

positions,[27] although one court commented revealingly that the more prevalent refusal to extend liability for substantive criminal acts done before a conspirator joined "may stem from due process concerns about vicarious guilt in attenuated circumstances."[28]

Perkins has suggested that defendants should not be held criminally responsible for substantive offenses committed prior to joining the conspiracy because to convict on that basis would be to "establish guilt by ratification."[29] Perkins argues that it is impossible for a person to retroactively conspire to commit an already concluded crime.

Although there may be some technical validity to this argument, there is something fundamentally wrong about the result. If we assume (1) that an individual by joining a conspiracy adopts the conspiracy's goals as his own and (2) as a result of his agreeing to join in the conspiracy becomes liable for all the acts committed by other conspirators in pursuit of those goals, what does it really matter *when* those acts were committed? To put it another way, if one is willing to accept the concept that Defendant A can be found criminally responsible for a crime that Defendant B committed during the course of the conspiracy *simply because Defendant A gave knowing agreement to the conspiracy*, then there seems to be no logical reason for distinguishing between crimes committed before Defendant A joined the conspiracy and crimes committed after Defendant A joined the conspiracy.[30]

The real problem is the more fundamental one raised by Justice Rutledge: that of finding a defendant *criminally* responsible for a crime which that defendant did not commit. In other words, the real problem is the *Pinkerton* rule itself.

In tort cases the purpose of vicarious liability is to spread the risk in a complex business world, to assure that an injured party is recompensed fully. That is not the goal of the criminal law. Criminal guilt, as Justice Rutledge said, is personal. Given that guiding precept, each conspirator should be held criminally responsible for knowingly entering into an agreement to accomplish an unlawful result. However, there should be no vicarious criminal responsibility for substantive crimes committed by other conspirators; only those who actually commit the substantive offense should be found guilty. This result eliminates the strained and artificial division between crimes committed before and crimes committed after the defendant joined. More importantly, it recaptures the essence of criminal responsibility.

# NOTES

1. An early definition was supplied by Justice Holmes in *United States v. Kissel*, 218 U.S. 601, 608 (1910) where he described a conspiracy as an agreement *and* a result. A variant definition is that proposed by Perkins and Boyce, *Criminal Law*, 3rd ed. (Mineola, N.Y.: Foundation Press, 1982) at p. 682 where the authors suggest that a conspiracy be defined as "a combination for an unlawful purpose." See also *Securities Investor Protection Corp. v. Poirier*, 653 F. Supp. 63, 69 (D. Oregon 1986).

2. The distinction does not arise in civil cases. There, a plaintiff simply charges that defendants conspired to injure the plaintiff and recites the acts which caused that injury. There is no need to differentiate.

3. 328 U.S. 640, 66 S. Ct. 1180 (1946).

4. See, for example, *United States v. Gironda*, 758 F.2d 1201, 1211 (7th Cir. 1985) where two conspirators were found guilty of violating 18 U.S.C. § 942 (c) (2), which prohibits carrying a "firearm unlawfully during the commission of any felony" even though it was another conspirator who actually carried the gun. To the same effect is *U.S. v. Diaz*, 864 F.2d 544, 548–49 (7th Cir. 1988).

5. 66 S. Ct. at 1182.

6. Justice Holmes in *United States v. Kissel*, supra, made one of the classic pronouncements that a conspiracy "is a partnership in criminal purposes."

7. 66 S. Ct. at 1183.

8. Id. at 1184.

9. Ibid. This statement is usually made with reference to the statutory requirement that there be at least one overt act before a criminal conspiracy has taken place. The principle is also to establish statute of limitations dates for each member of the conspiracy.

10. The Court did allow that a "different case would arise" if the substantive offense committed was outside the original conspiracy and was not in furtherance of it. This is the now famous "exception" to the so-called *Pinkerton* rule of conspiracy. Ibid.

11. Id. at 1185.

12. Id. at 1186.

13. Ibid.

14. *Nye & Nissen v. United States*, 336 U.S. 613, 618 (1949). The Court reaffirmed that in *Pinkerton* it had held "that a conspirator could be held guilty of the substantive offense even though he did no more than join the conspiracy, provided that the substantive offense was committed in furtherance of the conspiracy and as a part of it."

15.  588 F.2d 490, 493 (5th Cir.), *cert. denied,* 441 U.S. 936 (1979). Other courts have used similar language: the District of Columbia Circuit in *United States v. Sampol,* 636 F.2d 621, 676 (1980) has stated that, once a defendant's knowing participation in a conspiracy has been established, the defendant "will be vicariously liable for the substantive acts committed in furtherance of the conspiracy by his coconspirators." The Ninth Circuit in *United States v. Gagnon,* 721 F.2d 672, 676 (1983) *rev'd on other grounds* 470 U.S. 522 (1985) has held that a "coconspirator is vicariously liable for the acts of another coconspirator even though he may not have directly participated in those acts. . . . ").

16.  *United States v. Redwine,* 715 F.2d 315, 322 (7th Cir. 1983), *cert. denied,* 467 U.S. 1216 (1984).

17.  *United States v. Alvarez,* 755 F.2d 830, 849 (11th Cir. 1985), *cert. denied,* 474 U.S. 905 (1985).

18.  California Civil Code § 1741.1.

19.  See, e.g., *Van Arsdale v. Hollinger,* 68 C.2d 253, 66 Cal. Rptr. 20 (1968).

20.  Harold J. Laski, "The Basis of Vicarious Liability," 26 *Yale Law Journal* 106, 111 (1916).

21.  See William L. Prosser, *Law of Torts,* 3rd ed. (St. Paul, Minn.: West Publishing Co., 1964) at 488: "The doctrine of vicarious responsibility in connection with joint enterprises rests upon an analogy to the law of partnership." Prosser distinguishes a joint enterprise as being for a more limited period of time and for a more limited purpose. Within that enterprise, the law holds each member as an agent of the other.

22.  See discussion and notes at page 4.

23.  383 U.S. 265, 86 S. Ct. 925 (1966).

24.  See, e.g., *United States v. Lynch,* 699 F.2d 839, 842 n. 2 (7th Cir. 1983); *United States v. Carrascal-Olivera,* 755 F.2d 1446, 1452 n. 8 (11th Cir. 1985).

25.  *United States v. Dearden,* 546 F.2d 622, 625 (5th Cir.) *cert. denied* 434 U.S. 902 (1977). See also *United States v. Brasseaux,* 509 F.2d 157, 161 (5th Cir. 1975) ("Moreover, once having entered into a common scheme with the other conspirators, appellant is bound by all acts committed by them in furtherance thereof, including those acts committed without his knowledge before he joined the conspiracy."); *Lile v. United States,* 264 F.2d 278, 281 (9th Cir. 1958) ("If [a defendant] joins [the conspiracy] later . . . he may be held responsible, not only for everything which may be done thereafter, but also for everything which has been done prior to his adherence to the criminal design.").

26.  See *U.S. v. Blackmon,* 839 F.2d 900, 908–909 (2nd Cir. 1988) (drawing the distinction between liability for conspiracy, where a defendant "may be legally responsible for acts of coconspirators," and liability for substantive

crimes, where a defendant "cannot be retroactively liable for offenses committed prior to his joining the conspiracy."). See also *United States v. Covelli,* 738 F.2d 847, 859 (7th Cir.) *cert. denied* 469 U.S. 867 (1984) and citations therein for cases opposing any extension of the vicarious liability rule to substantive offenses committed before the defendant joined. California has developed a similar rule in *People v. Weiss,* 50 C.2d 535 (1958), reaffirmed in *People v. Marks,* 45 C.3d 1335, 1345 (1988). There are a few cases which appear to hold that conspirators can be convicted on substantive offenses prior to that conspirator's joining the conspiracy, e.g. *United States v. Read,* 658 F.2d 1225, 1230 (7th Cir. 1981) (clearly in conflict with *Covelli* above); *Anderson v. Superior Court,* 78 C.A. 2d 22, 177 P.2d 315 (1947) and *Van Riper v. United States,* 13 F.2d 961, 967 (2nd Cir. 1926), *cert. denied* 273 U.S. 702 (1926).

27. For example, the California Supreme Court in its discussion in *People v. Weiss,* supra, did not offer any rationale for its decision other than to recite the fact that a "principal" in a crime as defined by the Penal Code was one who is "concerned" in the commission of the crime and, "manifestly," a defendant who has not yet joined a conspiracy is not "concerned" with crimes committed pursuant to it.

28. *United States v. Carrascal-Olivera,* supra. The Fifth Circuit in *United States v. Moreno,* 588 F. 2d 490, 493 (5th Cir. 1979) also noted in passing that "Several of our judges have noted their concern that vicarious guilt may have due process limitations" but concluded that that "concern need not trouble us here."

29. Rollin M. Perkins, "The Act of One Conspirator," 26 *Hastings L.J.* 337, 344–45 (1974).

30. The question of responsibility for acts committed pursuant to the conspiracy *after* a defendant withdraws from the conspiracy has a different answer. In that case, the defendant is disavowing the purpose as well as the activities of the criminal conspiracy. If withdrawal is really accomplished, then criminal responsibility should cease as of the date of withdrawal.

# Alcohol Addiction and Responsibility Attributions

*Ferdinand Schoeman*

It is both a pleasure and honor to participate in a testament to Herbert Fingarette's distinguished career as a scholar, mentor, colleague, and teacher.[1] Few scholars deserve to be considered masters in their field, but Professor Fingarette's exemplary contributions clearly display mastery of numerous fields. His range of learning, his breadth of interest, his creative and systematically clarifying reinterpretation of vast amounts of confusing and conflicting studies, both empirical and theoretical, his sense of judgment and intellectual integrity, and his focus on philosophical issues that lie at the center of human concern, all these factors speak to his unique genius. This is all part of the public record, and in a way so well appreciated that it hardly needs to be enunciated. There is also a private record that reveals a complementary yet fuller picture of Professor Fingarette's figure. In years of private correspondence, Professor Fingarette has displayed himself as modest, actively and energetically caring, forthright, and constructive. In addition to being a first rate scholar, he embodies and inspires values constitutive of a philosophical community. I have been generously enriched as a person and scholar for being part of it.

\* \* \*

The problems encountered by those who are alcohol dependent share much with the critical personal problems we all face. The way we think about the alcoholic has implications for the way we think about human problems in general. Conversely, the more alcohol dependence does share with other problems, the more the factors

that relate to those other problems relate to alcohol abuse. Appreciating this will help us put into context some of the puzzling features that long-term alcohol abuse poses.

Scientific research is aggrandizing in its aspirations. It is not enough for those doing research along one possible line of inquiry to regard their own approach as important and even indispensable. Researchers, in their isolation, also tend to view alternative lines of inquiry as marginal and misleading. Identifying the real unity amidst the apparent diversity has been the hallmark of the scientific spirit recognizable already in the sixth century B.C. with Thales's proclamation that "all is water." Unfortunately, often the underlying unity that is discovered in theories is no more sensitive to the diversity of the phenomena than it was in Thales's landmark (watermark?) effort. Though calls for ecumenism among researchers are voiced now and then,[2] apparently the human mind gravitates strongly toward singular, even simplistic, ways of thinking about phenomena.

The allure of simplification is felt outside strictly scientific realms as well and must be seen as a manifestation of human thought patterns expressed in nearly all our reflective activities. In the moral domain, we are drawn to black and white alternatives for classification or judgment. If someone falls below the mark, whether the mark is the legal or the broader social standard, we tend to want to hold the person fully accountable unless we are persuaded that he is not at all accountable. Indeed, one observes the phenomenon of people wanting to treat everyone as fully responsible for any behavior that is at all classifiable as purposeful. This has led to the spate of states adopting the oxymoronic category of "guilty but insane."

These two manifestations of the problem of oversimplification converge in the area of alcohol-abuse studies. Proponents of biochemical or genetic accounts of alcohol abuse have at times argued that their findings demonstrate that large classes of individuals have diminished control over their excessive drinking patterns or over their behavior while under the influence. Several researchers who have been skeptical of biochemical accounts have wanted to discount the relevance of biology completely, and argue that the cause of wrecked cars, families, or lives is wholly attributable to environmental forces. Proponents of these two perspectives, biomedical and psycho-social,

concur, however, on seeing individual alcohol abusers as victims of forces over which little personal control can be exercised.

Among critics of these single-factor theories are to be found many who would argue that since each even remotely plausible theory of abuse will have only a limited range of relevance and that issues of individual character and choice are nearly always relevant, there is no basis for mitigating the gravity of the harm to self or others that the alcohol abuser can be accused of inflicting. The options we seem to be left with are that the alcohol abuser either has radically diminished control or is fully accountable.

Needless to say, the very terms of the debate as it arises in the case of alcohol abuse are to be found in other areas of inquiry. The field of criminology is rife with theories that would completely exonerate all offenders just as it is filled with proponents of the view that genetic or psycho-social factors are completely beside the point. Theories of intelligence and worldly success experience the same debate. Even theories of religious salvation reflect this bifurcation: there are views of absolute predetermination, having nothing whatsoever to do with individual choice, on the one hand; the alternative view is that every person is completely unencumbered and correspondingly fully responsible when it comes to matters of the spirit.

These polarized postures cannot reflect the perspective good judgment would bring to bear on the issue; judgment eschews wholesale answers to recurring questions. Occasionally questions recur because the facts necessary to settle them are unavailable. In the case of alcohol abuse, however, the problem is deeper. Questions or approaches recur because there are real difficulties with all of the solutions that have been offered, stemming in part from an impoverished set of categories for conceptualizing the issue. Not only is there a dispute between those providing services to alcohol dependent people, but there is also plenty of debate among those seeking scientific accounts of alcohol dependence and abuse. What this means is a somewhat disorderly state of understanding, where patterns are not evident without careful elaboration of details about each case. My approach will be to plumb the divergent perspectives for insights that may provide the foundation for a comprehensive and coherent outlook.

It would be wrong to infer that the recourse to particularized, detailed judgment is the result of the failure of science to provide an answer. In many ways, science has already provided us with illuminating information about alcohol-induced comportment and addiction. What science provides is not enough to settle the moral questions. We would be mistaken in expecting that kind of answer from science in the first place, though often scientists assume, or are cast in, the role of being experts in just this sort of determination.

In this paper I challenge a range of hard-line views about alcohol abuse, views that suggest that because there is no credible evidence of adequate single-factor causal accounts of alcohol abuse, patterns of alcohol abuse need not be seen as undermining or mitigating the abuser's responsibility for his/her behavior. But I also challenge the more compassionate view that because alcohol abuse undermines responsibility in many contexts, it undermines it in all. I will begin by reviewing the majority opinion of a recent Supreme Court case and discussing the significance of diseases in the attribution of responsibility for behavior. I then examine the view that we are responsible for our own character in light of some recent medical uncoverings, to show that the implementation of the hard-line perspective on attributions of responsibility would turn our selves and society into entities bereft of humane understanding. Along the way, I discuss some problems with thinking that people are responsible for choosing what cultural or traditional norms they should adopt and write about commonsensical considerations that attenuate or qualify attributions of responsibility. I conclude the paper by observing that the way we should think about responsibility for drinking patterns is not one issue but many, and answering it requires that attention still be paid to the context of the question.

## 1. *Traynor and McKelvey v. Turnage*

Let me begin this conceptual excursion by describing a line of reasoning evidenced in a very recent Supreme Court ruling, *Traynor and McKelvey v. Turnage*.[3] In this case, Traynor and McKelvey sought extended benefits from the Veteran's Administration on the grounds that their earlier problems with alcoholism constituted a handicap

for which they were not responsible. Veterans are entitled to an extension of the period during which benefits can be provided if a handicap for which they are not responsible prevented them from utilizing their benefits within ten years of being discharged. Justice White, writing for the majority, found that the Veterans' Administration's rule treating alcoholism as the result of the willful misconduct was not unreasonable or arbitrary in light of the substantial body of medical evidence supporting that outlook. White reasoned that alcoholism that is not the result of an underlying psychiatric disorder is not so entirely beyond the agent's control as to undermine the willfulness of the drinking and thus the condition. Citing an article by Professor Herbert Fingarette,[4] White claimed that it is controversial whether alcoholism is properly regarded as a disease, and that even if it is a disease this does not mean that there is no element of [culpable] willfulness on the part of those alcoholics who continue to drink. He concluded by suggesting that no basis could be found for judging this sort of alcoholic devoid of all control for excessive drinking. For purposes of this case, alcoholism could therefore be considered a willfully incurred disability.

With this line of reasoning in mind, I want to point to some phenomena that challenge our ordinary notions of when agents are responsible for their conditions, choices, and qualities of character. The significance of these challenges for the concepts and for our judgment will be developed below.

## 2.  The Relevance of Disease to Attribution of Behavior

An examination of the notion of a disease in our culture will help us become clearer about the problem. To be in a diseased state is normally to be in a condition of impaired functioning, to have one's overall capacities or some specific functioning incapacitated. Characteristically we would regard failures to perform up to normal levels as excusable in someone with diminished abilities. The reason for this dispensation is that it is unfair to expect of a person a level of performance that he or she cannot achieve without unusual costs being borne.

What standard or standards are invoked in this claim? If I put a much higher value on undisturbed evening rest than do most people, the unusual costs involved in attending to my choking baby at night are not of the sort that counts in this moral calculus. However much I prefer my sleep to my children's lives, this sort of consideration carries no moral weight. To take another example, I can plead in defense to a criminal charge that I succumbed to coercion when the threat was serious damage to my arm, but not when the threat was serious damage to my violin, even if I care more for my violin than for my arm.[5] The central point here is that the notion of an act being voluntary involves value judgments about what behavior is fitting in what contexts.

We cannot always be at our best, and inevitably we cannot always be minimally adequate. Why do we hold people to a standard of performance even though we know that everyone has periods when they cannot actually perform up to that level? One response is that ideally we would only hold people to a standard that they can at the time meet, but that evidentiary problems beset personalizing a public standard to an individual's particular and momentary inabilities. This difficulty may account for the difference between social standards and legal standards, the former being more tailored to individual conditions.

Alternatively, it could be that we hold people to standards they cannot at times meet because we would be wrong to suppose that having standards can involve anything less demanding.[6] The problem for this perspective is that we do recognize inability as excusing some of the time, and in light of this we need to account for why it is appropriate some times but not others.

A third possibility is that we hold people to a standard we know they cannot meet at times because we think that having this standard helps people locate the resources to perform better than they otherwise would. The standard itself is a factor determining whether people will succeed in conforming to certain expectations. Having a less forgiving standard weights individual motivations in a direction favorable for a desired outcome.

If a potentially excusing impairment is self-inflicted, then though the agent cannot function at full throttle, the diminished capacity itself is attributable to the agent, and whatever failures the impairment effects, these too are attributable to the agent. For instance, Aristotle tells us that if a guard fails in his functions because of being in a

drunken state, the laws of Athens inflict twice the penalty on him as would normally be imposed for the dereliction.

Various attitudes are attendant upon our characterization of behavior resulting from an impaired condition. Problematic behavior that results from non-blameable impairment, like an epileptic fit, a narcoleptic nap, abusive swearing associated with Tourette's disorder, are characteristically met with sympathy and consolation rather than with criticism and rebuke.

Recognizing this leads us to a problem. As we learn about how individual choices make impairments more or less likely, we tend to generate less sympathy for those who are stricken with a disease attributable to personal habits or decisions. The familiar quip, "Smoking cures cancer," reflects an emergent callousness toward those we think accountable for their frightful condition. In the same vein, those who acquire AIDS as a result of their own promiscuous sexual practices or drug abuse are thought by many to be getting just what they deserve. As we learn more about how diet, exercise, patterns of relaxation, and other habits of life make one more or less prone to diseases of certain sorts, and how qualities of character make recovery variably likely, fewer and fewer afflictions come to be seen as completely out of personal control. Correspondingly, we tend to show less compassion for the condition we regard as controllable.[7] As more about impairments comes to be connected to choice, less about a person will seem like a visitation, and more will seem like the consequences of a blameworthy character defect. The upshot of this is to radically attenuate the conditions under which we will afford sympathetic responses to human suffering even when incurred in an otherwise appalling disease state.

## 3.   Some Unnerving Discoveries

Some recent discoveries portend attributions of responsibility for many conditions that have been thought purely matters of fate. It was reported this summer in the New York Times that new studies of people with multiple personalities suggest some fascinating prospects. For ease of description let us say that body $B$ is home for personalities $X$, $Y$, and $Z$. $X$, we are told, may be highly allergic to certain substances and develop a rash or hives when these substances are ingested or present in the environment. But if personality $Y$ emerges in $B$, the allergic

reaction may readily dissipate. Given that allergies are generally not thought to be mind-mediated, this result is intriguing.

Reactions to drugs also may vary from personality to personality within the same body. Drugs that make $Y$ sleepy may have no effect on Z. Finally, even the curvature of the eye may change from personality to personality. A prescription for corrective lenses for $X$ may be completely inappropriate for $Y$ or $Z$, these personalities requiring a prescription tailored to their individual cases. Again, who would have thought that brains or minds exercise control over reactions to drugs or the shape of the eyes? To know that these things occur is not yet to know how to control these phenomena, but it leaves open the prospect that someday allergies, reactions to drugs, and who knows what else, may be controllable by the agent affected.

Another recent study reported that people prone to cynical, hostile, and angry responses are more likely to suffer premature death from coronary and other causes.[8] People so disposed are said to have "toxic personalities," probably traceable to biological characteristics present at birth.

There are studies that show the effect of confidence on the course of malignancies in people. Those convinced that they will lick the disease as a result of an optimistic and confident outlook are more likely to survive the disease than those whose outlook is more glum.

Of course knowing that confidence about achieving a cure will help is not to say that it is up to the person to effect that outlook. Many if not most of us would be terrified by the diagnosis of a malignancy and find gratuitous and heartless the complaint that if only we could have a bright outlook—i.e, if only we were different people, we would have a fighting chance to survive.[9]

Something similar has been discovered about alcohol-abuse rehabilitation. Among problem drinkers, those with the outlook that their condition is one that they cannot control are less likely to control it than those who confront the problem with a different frame of mind about alcohol consumption.

> Social-cognitive models of alcoholism maintain that alcoholics' expectations and self-conceptions will influence how they respond to a single drink. Alcoholics who are convinced that there is no alternative after having a drink other than embarking on a binge will be more likely to undergo this chain of events. . . .

The drinker's self-conception of being an alcoholic also affects the course of drinking problems. Subjective beliefs about the disease of alcoholism and about the nature of the person's drinking problem can be more important than objective levels of dependence for selecting treatment goals. Those who believe in the disease theory and that they are alcoholics have a poorer prognosis for controlled drinking. . . . Vaillant discovered another factor that determined controlled-drinking versus abstinence outcomes for alcohol abuse: whether the drinker's ethnic group had a disease-like conception of alcoholism or whether it was simply concerned with the difference between moderate drinking and drunkenness.[10]

Researchers are finding that qualities of character, cognitive beliefs, and directions of cultural identification are significant factors in the body's reaction to different kinds of assault or conditions and the person's ability to dig himself out of a troubling situation.

Not all the qualities of character have an impact for the same kind of reasons or even in roughly similar respects, but it still turns out to be mediated by character, directly or indirectly. What is significant about this is that, as Aristotle informed us thousands of years ago, our character is itself something for which we are accountable. Once we have reached a mature age, we are assumed to have had ample opportunity to have dealt with those aspects of character that present problems. This outlook does not presuppose that people are not biologically or culturally disposed to be a certain way, but only that character is plastic enough to modify if one begins early to form the right habits. And though we may not have succeeded in extinguishing qualities we regard as undesirable or in nurturing those we deem admirable, we tend to see ourselves and others as responsible for whatever degree of success or level or failure we have achieved at any given time. Very little short of outright thought control or wholesale moral corruption insulates a person from accountability for what as an adult he or she has become.

## 4. Consequences of the Responsibility-for-Character View

These comments about character are unexceptionable, but they do have implications. If the qualities of our character give us some measure

of control over our reaction to environmental chemicals, disease agents, and diseased conditions, and if we use the standard criterion of having a measure of control to calibrate a level of accountability, then many of the things we regard as unattributable to agents may strictly be so attributable. The social function of the notion of a disease in mitigating moral blameworthiness becomes strongly attenuated.

We cannot rest content with the attenuation of sympathy and support for problems that result in part from qualities of character or choice. What must constitute a part of our outlook is a standard of reasonableness: what is it fair to expect of a person? It is not enough to demonstrate item by item that with attention and motivation, an individual could have improved each quality had he so chosen. For even if he could have changed each, he surely could not have improved *all* of his characteristics had he so chosen.

We also know that not all people face the same hurdles in developing their characters along certain lines. Some may find certain changes rewarding while others find them continually at odds with something pressing inside of themselves. Some may find efforts at important change falling on fertile soil, while others find that their efforts meet only obdurate rock. Some may find that just at the time they recognize the need for change, the stresses in their lives prevent them from being able to address life constructively.

Also, some may find external support for important changes, while others encounter discouragement for the same efforts at redirection. In his impressive attack on the disease notion of alcoholism, and in his reconceptualization of heavy drinking as a central activity of life, Professor Herbert Fingarette observes:

> One cannot simply and without consequences forsake a central activity, abandon a preferred coping strategy, or disable a defense mechanism —however costly it has proven to be.[11]

A few pages later, he continues,

> But, as the data show, heavy drinkers who are motivated to change and who are persistent in the face of setbacks can change *if they are given* the appropriate tools and strategies for reshaping their lives.[12]

These passages suggest that the degree to which change is possible, even for those highly motivated, will in many cases be dependent on factors

over which a long term heavy drinker will have limited or no control. Having a supportive family, having economic opportunities, having alternative role-models—these are not resources easily accessible to many. Not everyone has within reach the appropriate tools and strategies for restructuring life.

Two related cautionary themes, that I will develop below, emerge from this discussion. (1) The fact that a characteristic is not the result of a disease does not mean that the individual is condemnable for the trait. (2) Qualities of character are in varying and unstable degrees attributable to the individual.

## 5. The Problem of Culture and Choice of Values

There is a tendency to think that if biological explanations of alcohol abuse are only one aspect of the problem, with cultural and individual factors looming large, it is simply up to the individual to control drinking patterns. Once we introduce cultural factors, matters become complicated in ways I do not think are widely enough recognized or appreciated. Cultures and traditions have a strong influence over how a person will frame his or her experiences of the world. Cultures and traditions will also impose values, loyalties, and directions on its members. Although we like to say that people are responsible for the values they adopt from the cultures they occupy, there is something peculiar about this. The peculiarity lies in omitting consideration of the authority that the culture and traditions have over people. And having authority means that individuals are not and do not see themselves entirely free to pick and choose from among its norms those which are worth embodying. Three reasons can be offered to support this claim. (1) Many alternatives to an outlook are never presented. We cannot say that people deliberately reject options not part of their horizon. (2) Some options that upon consideration may seem preferable may not be real options for us. For instance, one might say that a pre-scientific outlook is preferable because more humanly centered than is our outlook. Recognizing this does not make this outlook possible for us. (3) If people approach a tradition in the spirit of selective and reasoned embrace and rejection of what is taken as settled in the

tradition, the culture or tradition is at best one of several overlapping cultures they feel part of and is one that has attenuated authority for them.[13]

Some points deserve elaboration here. Because we find it important that people situate themselves within a culture, we must accept that they will come to accept some behavior or styles that people outside the culture find troublesome or misguided. We recognize that they will not approach all issues as ones to be settled by an objective—culturally neutral—perspective. Second, even if people recognize that cultural values conflict with widely held norms, it is not clear that it is the saliently rational norms that should dominate whenever there is conflict. Let me illustrate. John Wideman makes clear in an auto-biographical account[14] that his rejection of ghetto values during adolescence came with enormous costs by cutting him off from the vision, riches, and pains identified as African-American experience, and thus from himself. As we learn more about the role of cultural identification, I believe we will also appreciate the limited authority an ethical scheme has over people's lives.

Learning takes place via trust in certain formal and informal authorities: parents, teachers, community leaders, elected officials, religious leaders, role models, and the "successful" behavior patterns one sees around oneself. These paradigms of social learning, belonging, and participation, and thereby of moral being, are indispensable. Our cognitive and moral economies require that we rely on such authorities for the bulk of our everyday judgments. The Kantian prospect of a person locating himself ethically without reference to heteronymous factors is a fantasy.

There are two points about the determination of right action that I wish to develop. First, I do not think that we can get very far in trying to figure out what is right without reference to authorities of one form or another. Second, even if we could figure out in every case what is right, there would be many situations in which that determination would not definitively settle what the person should do.

In academic or serious discussions of any sort we tend to assume standards and styles of judgment that are logically exacting. Even if we recognize that people in general are not disposed to employ such standards and styles, we assess this to be a failing on their part. I suggest

that this approach is misguided. We are no more capable of rigorous and searching moral thought in our everyday judgment than we are capable of logical rigor in our everyday inferences. Each sort of rigor would handicap us. For instance, we cannot help making judgments about people on the basis of stereotyped thinking. We rarely would have the time to learn enough about the people we interact with to see if they are what they seem to us based on comparisons with other people we know or with what the culture tells about people of this apparent sort. The struggle for philosophical perfection would render us inept at the most basic tasks for living. Survival, both individual and cultural, depends on the transmission and use of strategies or heuristics that prompt passable responses in a majority of critical situations.

Solomon Asch suggests an interpretation of the observed shift of individuals' assessments toward authoritative or peer assessment when there is a discrepancy—an interpretation involving a critical piece of social dynamics. Asch points out that the phenomenon of conformity has been seen by psychologists as either the result of an effort to avoid social punishment or achieve social rewards on the one hand or as the effect of manipulation by those with power or authority on those without these qualities on the other hand. Either of these perspectives presupposes that the shift occurs in only one direction. Asch questions this presupposition, suggests that the shifts are bidirectional, and proposes that the phenomenon can be seen as a group process that has the character of a group achievement. The conforming phenomenon is not to be judged as a distortion in individual rationality but as an essential factor in promoting social being.[15]

In a speculative essay on social evolution,[16] Donald Campbell suggests that a universal tendency for conformity to the opinions of prestige figures and others may be essential to the human capacity to retain socially adaptive strategies, and not the character defect typically discovered in those conforming. Campbell points out that for this mechanism to have succeeded in retaining adaptive social customs, the mechanism would have to "operate blindly, without regard to apparent functionality."

This suggests that there are strategies connected with sociability and traditions that serve a role ignored by philosophical theories driven by rational reconstructions that stress individual autonomy in value

orientation. The social processes contain more in overall adaptive value than do particular theoretical reconstructions, and this entitles these processes to our adherence even under circumstances that initially may make them appear ungrounded. As long as we recognize that there are aspects of our strategies we may not understand, it is reasonable to opt for the socially-selected strategy rather than some apparently higher ranked alternative. Our conforming strategies and proclivity to traditions can be defended wholesale against rationalist alternatives, without always offering an account for their particular outcomes in the way that human authorities can.

# 6.   Attributing Alcohol Consumption Patterns

In the case of alcohol-consumption patterns, considerable effort has been expended on assessing whether the most potent causal deter-minants to drinking are genetic, social, contextual, or individual. I take it that based on what is currently known about alcohol-use that, despite being strongly favored by treatment centers and some funding agencies, the genetic and the corresponding disease account of alcohol abuse are no longer uniquely strong contenders when it comes to explaining most troublesome drinking patterns. On the other hand, cultural and contextual factors are now regarded as important in understanding alcohol abuse. To quote Peele again,

> Field studies have found demographic categories to play an impor-
> tant role in alcoholism. Cahalan and Room identified youth, lower
> socioeconomic status, minority status (black or Hispanic), and other
> conventional ethnic categories (Irish versus Jewish and Italian) as
> predicting drinking problems. Greeley, McCready, and Theisen con-
> tinued to find "ethnic drinking subcultures" and their relationship
> to drinking problems to be extremely resilient and to have with-
> stood the otherwise apparent assimilation by ethnic groups into
> mainstream American values. . . . Vaillant found Irish Americans in
> his Boston sample to be alcohol dependent (i.e., alcoholic) seven times
> as often as those from Mediterranean backgrounds (Greeks, Italians,
> and Jews), and those in Vaillant's working class sample were alcohol
> dependent more than three times as often as those in his college
> sample. . . . [17]

. . . Vaillant also found that return to moderate drinking versus abstinence was not a function of having alcoholic relatives but was related to the cultural group of the alcohol abuser. This finding is reminiscent of the higher incidence of binge drinking alternating with abstinence among conservative Protestants and others from dry regions in the national survey . . . and the coincidence of high rates of alcoholism and abstinence for both Protestants and Southerners. . . . As Vaillant explained his finding, "It is consistent with Irish culture to see the use of alcohol in terms of black or white, good or evil, drunkenness or complete abstinence."[18]

There are a number of tempting inferences related to this discussion that are important to identify and discuss critically. The first of these is that if alcoholism is not a disease, then it is up to individuals to control their drinking. This is the implicit message of some of the important cultural studies of alcohol abuse. Stanton Peele's important article on cultural components to controlling the effects of alcohol is titled: "The Cultural Context of Psychological Approaches to Alcoholism: *Can We Control the Effects of Alcohol?*" Something similar is suggested in MacAndrew and Edgerton's great book *Drunken Comportment: A Social Explanation.*[19] Let me quote an extended passage that encapsulates their outlook and prepares us for the inference.[20]

[We contend] that drunken changes-for-the-worse occur not because of alcohol's toxic assault on the higher brain centers but because the state of drunkenness is accorded the status of Time Out. . . . Returning to alcohol's adverse effects on the drinker's sensorimotor performances, we would now note that these impairments have the important "cueing" property of being easily recognizable by all concerned. The existence of the state of drunkenness is self-monitorable in the sense that the drinker can simply "look within" and determine whether or not—and if so to what degree—he is "under the influence." By the same token, since many of alcohol's effects on the drinker are highly visible to those around him, his "condition" is publicly monitorable as well. . . . Finally, the very act of drinking itself has the quality of a "warning sign" about it, and this, too, is very much in its favor. Since in those societies in which drunken changes-for-the-worse occur everybody knows that drinking often leads to drunkenness and that drunkenness is frequently accompanied by untoward conduct, those who wish to avoid the possibility of "becoming involved"

have ample opportunity to depart the scene. And since to be fore-
warned is to be forearmed, there is an important sense in which those
who remain have only themselves to blame should any mishap befall
them. Add to all of this the fact that no single drinking bout, nor even
a series of drinking bouts, produces in the drinker any easily iden-
tifiable long-term impairment in his health, and one can begin to see
how well alcohol satisfies the criteria that might reasonably be pro-
posed for an *ideal* Time-Out-producing agent. For since alcohol is a
predictable, relatively harmless, and easily monitorable sensorimotor
incompetence producer, it remains for societies but to "declare" that
its ingestion produces an involuntary and thus an uncontrollable *moral*
incompetence as well.

Now indeed, if alcohol itself does not produce moral incompetence
and uncontrollable behavior, then what excuse does an individual have
who transgresses legal norms while under the influence? The defense
of blaming one's culture doesn't have much appeal in either a court
of law or a court of public consciousness. This moral inference is also
manifest in the majority Supreme Court opinion discussed above, argu-
ing if the cause of habitual drinking is not genetic or in other respects
medical, then the drinking behavior itself is "willful misconduct" and
the habit a "willfully incurred disability."

In a dissenting opinion,[21] Justice Blackmun argued that the plain-
tiffs deserved a particularized evaluation of the degree to which their
alcoholism was voluntary, and therefore the Veteran Administration
erred in making the presumption of voluntariness irrebuttable.
Blackmun pointed out that both Traynor and McKelvey began drink-
ing at an early age: eight or nine in the case of Traynor and thirteen
in the case of McKelvey. Alcohol dependence was widespread in
McKelvey's family. In light of these facts, I think that we would want
to follow Justice Blackmun by saying that even if alcoholism is not a
disease in the classic sense, there are cases in which we would not want
to hold the alcoholic blamable for his condition.

The focus on the presence or absence of disease in alcohol studies
points to a restrictive set of alternatives. As indicated above, we tend
to respond to people differently if we think that their behavior or
demeanor is the result of a disease rather than the result of, what?,
something that is not a disease. If their behavior is the outcome of

a disease, then we will be supportive. If not, we will be critical if the behavior has transgressed some norm. (Earlier I suggested that some of the empirical basis for making this distinction is questionable.) But are these the only options? Disease and support on the one hand, or health and condemnation on the other? What if we know that someone is having a hard time for any of a variety of reasons, and that there is a good prospect that with the support and encouragement of others, this soul can muster the courage or effort or self-confidence to improve. Does the fact that he or she is not diseased require us to withhold our support and require that success, if it comes, will have to come without the encouragement of others? Or what if we believe that even with support, this person will fail for any of a variety of reasons. Is it clear then that we should be condemning?

We have a spectrum of responses available. Our thinking about what is fair to expect of people must respect the ambiguities implicit in our understanding of what individuals can do even if they are not diseased. Let me begin with a neutral example before turning to the alcohol-related context.

A runner will run faster in a race than when practicing. It is not that the runner will just try harder in a race, but that there is added endurance, drive and excitement, and hence capacity for running. This suggests that what abilities a person has are at times dependent upon external factors. Furthermore, we know that confidence is an important factor both in creative and in competitive contexts. It is uncontroversial to say that people will perform better, exhibit enhanced abilities, if they have confidence in themselves. Of course we can say that in some situations, having confidence in one's ability is a function of having reasonable beliefs and certain character traits, that both these beliefs and traits are the responsibility of a mature individual, and that fault lies in underestimating what patterns of change are possible.

What we know about the importance of beliefs and objective context to determinations of abilities in the realm of sports also applies to the struggle with alcohol. We might find fairly reasonable the abject outlook a person adopts. He may see that his own efforts at change have thus far been unsuccessful. He may see that most of those around him have not managed any better. He may put stock in a cultural

outlook that predicts failure for those like him. He may be aware of statistical studies that show that people with his profile fall in the 70% or higher failure rate cohort. Finally, he may find respected therapists substantiating his own dismal outlook of his native capacity to modify a bad habit.

The kind of understanding we will afford people who have fallen short of our social ideals is often taken to be an ideological issue, pitting those who advocate hard line views of responsibility against those who encourage compassion. But viewing it this way is a mistake. We all want our attributions of responsibility to reflect just standards. The question we must address is: What does applying this standard require of us? Does it require us to ignore consideration of individuating features of an individual's past, including socialization? Does it require us to ignore barriers, social and psychological, that stand in the way of many well-intentioned addicts' efforts at recovery? The issue is not one between justice and some more compassionate stance but between different visions of justice. Again, let me allude to the fact that the issue as it arises for the alcohol abuser is substantially the same issue as it arises in many other domains of public and private life. What we learn from the history of this debate is that socially acceptable resolutions will display features that reflect both objective and subjective conceptions of just attribution.[22] Researchers err in thinking that new developments will radically change this mixture toward an illness model just as law-and-order visionaries err in thinking that the mixture will shift radically to the objective standard because of the inability to prove scientifically that either socialization or biochemistry is the last word on patterns of alcohol abuse.

Alcohol abuse is a human problem that is unlikely to yield to straightforward scientific or moral analysis. This means that our moral attitudes and social policies are destined to fall on all sides of the issues. We will be forced to both insist on the responsibility of the heavy drinker and afford rehabilitative services and prevention programs that to many, including those being serviced, suggest diminished accountability. I believe that it is not unusual now for alcohol abusers to be deemed responsible by a court and then sentenced to participate in programs that tell the abuser that he/she is not accountable for continuing patterns of drinking. However incoherent this compound

picture strikes one as being, we don't have available a more satisfactory, coherent picture. Philosophers have a professional responsibility to insist on coherence. They also have a social responsibility to be clear about the price and consequences, and judge whether it is worth it in particular cases. As we saw with Thales, sometimes theoretical elegance is prematurely bought.

In thinking about the implications of the foregoing discussion, it might be useful to focus on an example that is less constrained by legal or constitutional complexities than was the case with which we began our consideration. Professor Ralph Tarter described a dilemma for those who make decisions about liver transplants that involves the considerations we have been discussing. Many people need liver transplants, but alcohol abusers are represented among this group out of proportion to their percentage in the general population. Should the fact that a person's liver became diseased through alcohol abuse be regarded relevant when allocating the few livers that become available for transplant?

Here we might be tempted to finesse the issue by observing that a person with a record of abuse is a poor transplant prospect for medical reasons alone. But independently of being medically counter-indicated, in first considering the issue I confess to thinking that it is unfair to allocate scarce resources to someone who caused a problem when the same resources could be used to help someone who is innocent in the relevant sense. My second thought, though, was that this response seems oblivious to most of what I have been worrying over in this paper. To the extent that we cannot make a determination of who is and who is not blameworthy for having ruined his or her liver, then we must not use alcohol abuse as a morally disqualifying factor.[23] But as a social policy, should we put the same resources into seeking cures and treatments for diseases that are in some sense largely self-inflicted and those that are not, holding everything else constant? I suggested above that we do not know where such a policy would lead in light of discoveries about character and diseases. On the other hand, we have a general, and probably salutary, attitude that discounts suffering on the part of people who knowingly enough assume the risks for behavior that is not regarded as socially valuable to start with.

In terms of medical treatment, we might want to argue that if choices must be made they should be made on the basis of need, not desert,

even though this *could* mean giving priority to people whose problems are self-inflicted.[24] In terms of allocation of resources for development of cures, we might legitimately use avoidability as a criterion along with other criteria, like number of people affected directly, the number of parties affected indirectly, the comparative efficiency of expenditures along given lines, etc. But use of the criterion of avoidability would have to apply to nearly all sufferers of a given malady and it is very unlikely that we could fairly come to such a judgment.

## 8.  Concluding Thoughts

So, what should we think?[25] We should feel perplexed in our responsibility attribution practices, even as applied to as widespread and historic a phenomenon as alcohol consumption. We should not think that science has failed us in not answering this question for us. We should appreciate that it is the community's responsibility to set standards of accountability that reflect and respect the limits and strengths of human nature.

Among the realizations we may come to is that the question of the responsibility of the heavy drinker for his or her behavior is not one issue but a range of issues; answers suitable in one domain may not be appropriate in another. Factors relevant to deciding what should be covered by standard medical insurance plans are not necessarily those to be used in settling cases at law governing what benefits the Veterans Administration will be required to supply. Setting a public posture to reform social expectations about the degree of control drinkers should exercise may not prove helpful in addressing what to do with someone who for thirty years has believed that drinking is not a matter of self-control.

Deciding as an individual or a society to be supportive and understanding to someone burdened by alcohol abuse may not at all stem from a belief that the behavior patterns were outside anyone's control. One might think that a given individual's drinking problems are not attributable to anyone else, but that there are so many tragic challenges this person has had to face that it is no wonder that his drinking is uncontrolled.

We may think no one else is to blame for a person's drinking problems but nevertheless regard the society as disqualified from making a moral judgment. For instance, one might argue that it is hypocritical for a society that socializes people to drink as a way of alleviating anxiety, expends enormous resources in advertising the desirability of alcohol consumption, and structures tax incentives to consumers who do this in a business setting, to then condemn people who drink excessively while facing real problems. Or one might think that a culture that neglects to offer services to a high percentage of troubled children cannot legitimately complain when these same children adopt nonconstructive means of living with these problems. Alternatively, policy considerations might well lure us into treating alcoholics as accountable though we know that some significant percentage of these are unfairly blamed. A range of factors that are relevant to some of these determinations may well be irrelevant to others.

Depending on the setting, there may already be in place a deliberative body that is able to make an individualized assessment of the degree to which an individual is blameworthy for his alcohol dependency. In the context of a criminal trial, there is already such a body. In the case of a potential recipient for an organ transplant there is also already a body that can try to make an individualized determination of accountability of the potential recipient for his/her condition. In the case of extensions of veterans benefits for alcoholics, we may ask how much it would add to the administrative costs of the Veterans Administration to allow veterans who want to claim involuntariness of their drinking to be provided with a forum for evaluating this claim.

In concluding let me point to some considerations that can help both explain our conflicting attitudes about the alcoholic exemplifying a whole range of human problems and resolve practically what our response to such issues should be. In the discussion of disease and responsibility that has transpired thus far, we have been assuming that there is one level of ability or competence such that, whatever is at stake in the context, if the individual meets that level, he is accountable, otherwise not. If we take a look at how we generally attribute behavior, seeing when we say that the act was the agent's and when not, we find no one level of competence satisfying in all behavior contexts.

We attribute behavior to an individual, generally, so long as we do not find some aspect, external or internal, of the environment "overwhelming." The assessment of when pressures are overwhelming, however, cannot be made in terms of the level of the pressures by themselves. This point can be illustrated by reference to the notion of coercion. The concept of coercion is relevant here because it is used as a way of gauging whether a person's behavior reflects or is an expression of the person's will. An intricate array of reasons is relevant to assessing whether an agent is to be regarded as the author of his action. Compare: I agree to sell you my house for $10,000 because you threaten to slash my face unless I do so. During a recession when I lose my job and have no prospect of another, I agree to sell my house for one tenth its value so that I can afford to keep myself and family from starvation. Though the prospect of death is more fearsome than the prospect of a scarred face, the latter agreement is regarded as more binding than the former, less an undermining of the agent's real will. If a policeman subtly pressures a suspect in a custodial setting, a resulting confession is regarded as forced and hence not the product of the defendant's will, while if a doctor tells me that unless I submit to a procedure I will die of natural causes, my consent to the procedure is regarded as voluntary and representing my real (very scared) self.[26]

Recognizing that there is a variable standard of accountability and attribution helps us see first of all why we may have conflicting attitudes in thinking about alcoholism and similar problems. Say that an impairment, like fatigue, is serious enough so that for most contexts the impairment counts as an excuse from accountability but that in some very serious contexts, like driving or sentry duty, it does not. By and large then we have reason to be supportive and forgiving toward the person who falls below the standard in most contexts, but not for people who fall below in some contexts. In the case of the alcoholic, we can be forgiving and supportive for some behavior, but not for behavior that seriously endangers others.

Let me illustrate with a recent affair.[27] Hedda Nussbaum acquiesced in the abuse and eventual murder of her adopted daughter. Ms. Nussbaum herself had been the victim of repeated, serious abuse. Does her own victimization excuse her from accountability for her daughter's death?

One can coherently say that suffering abuse would excuse her from a lot of personal failings, but not for standing by while her daughter is killed.

In cases such as the one described, *up to a point* we would be supportive, compassionate and, if necessary, forgiving toward Hedda Nussbaum because of what she had to endure. Her situation calls for compassion and understanding, and these emotions and attitudes toward her are apposite. It would also be odd to suggest that we can just turn these off at the threshold where we judge her condition no longer excusing. We feel that she does deserve our sympathy, even if she deserves a harsher response too. Though these responses conflict, they are not contradictory or ungrounded. And that is my first point. We have an explanation for conflicting attitudes: sympathy and support for conditions that excuse for many contexts, and resentment for violating norms that even disadvantaged people should not violate. (After all, it cannot be that only non-disadvantaged people can do wrong. If there are normal people who are cowardly or lack integrity, why should there not also be cowards and scoundrels among the disadvantaged?)

Back to the alcoholic: we can be sympathetic, understanding, supportive, and forgiving for a wide variety of behaviors without precluding legitimate expressions of resentment for some serious or important failings. We are not limited to one response. The alcoholic, the abused spouse, the disadvantaged, all deserve our support, sympathy and constructive endeavors on their behalf. But they, like the rest of us, also live in a community with values that can be more demanding for some range of behaviors than for others. We can and should be supportive when something we can do addresses a human problem. We can and should be resentful when someone, even with a problem, doesn't show enough judgment or restraint.

How do we tell when asking something of a person is asking too much? Without thinking that I can answer this question, I want to emphasize that this is a moral or social question for which biological and psychological data are relevant but not decisive.[28] All I can offer here is an observation that what we take to be conflicting outlooks toward heavy drinking are really more appropriately seen as reasonable responses to separate objective aspects of a perplexing problem.

# NOTES

1. A special expression of appreciation is due to Herbert Fingarette, not only for published pieces that provoked many of the thoughts contained in this paper, but for especially gracious and elaborate suggestions lavished on an earlier version of it. The author wishes also to thank Elizabeth Patterson, Frank Zimring, Pat Hubbard, Nora Bell, William McAninch, George Schroeder, Natalie Kaufman, Mary Bockover, and Kaye Middleton Fillmore for valuable comments on an earlier version of this paper. This paper was first presented at the Vanderbilt Conference on Alcohol Studies, which took place in October of 1988. The author is indebted to the organizers of that conference, Lawrence Gaines and Penelope Brooks, for organizing this forum. The author is also indebted to the National Endowment for the Humanities for financial support during the time that this paper was written, and to the Earl Warren Legal Institute at the University of California at Berkeley and the Law School at the University of South Carolina for providing ideal academic environments.

2. See Kaye Middleton Fillmore and Soren Sigvardson, "Editorial: 'A Meeting of the Minds'—A challenge to biomedical and psycho-social scientists on the ethical implications and social consequences of scientific findings in the alcohol field," *British Journal of Addiction* 83 (1988): 609–11.

3. 108 5. Ct. 1372 (1988).

4. "The Perils of Powell: In Search of a Factual Foundation for the Disease Concept of Alcoholism," *Harvard Law Review* 83 (1971): 793–812.

5. See Herbert Fingarette, "Victimization: A Legalist Analysis of Coercion, Deception, Undue Influence, and Excusable Prison Escape," *Washington and Lee Law Review* 42 (1985): 65–118, Fingarette, "Legal Aspects of Alcoholism and Other Addictions: Some Basic Conceptual Issues," *British Journal of Addiction* 76 (1981): 125–32 and section 209 of *The Model Penal Code and Commentaries* (Philadelphia: American Law Institute, 1985).

6. See Robert Adams, "Involuntary Sins," *Philosophical Review* 96 (1985): 3–32.

7. This does not just pertain to vulnerability to diseases. It is a human tendency to regard increasing one's vulnerability to harm from any source as a fault and as attenuating the sympathy others will address to one. If I leave my bicycle or house unlocked when I go for a vacation, there will be less sympathy for my loss than if I had secured these and been robbed anyway. Similarly, if I am robbed while walking through Central Park at 3:00 a.m. with $100 bills pinned to my shirt, few will be sympathetic to my plight.

8. Sandra Blakeslee, "Cynicism and Mistrust Linked to Early Death," *New York Times,* January 17, 1989, p. 21.

9. See Susan Sontag, *Illness as Metaphor* (New York: Farrar, Straus and Giroux, 1977).

10. Stanton Peele, "Cultural Context of Psychological Approaches to Alcoholism," *American Psychologist* 39 (1984): 1342–43.

11. *Heavy Drinking: The Myth of Alcoholism as a Disease* (Berkeley: University of California Press, 1988), p. 122.

12. Ibid., p. 128 (emphasis added).

13. I realize this claim deserves considerable elaboration. The very role of tradition is different within different traditions, and not all traditions have the same relationship to potentially competing outlooks.

14. John E. Wideman, *Brothers and Keepers* (New York: Penguin, 1985).

15. Solomon Asch, "Issues in the Study of Social Influences on Judgment," in Irwin Berg and Bernard Bass, *Conformity and Deviation* (New York: Harper & Brothers, 1961). This interpretation may have connections to what John Rawls has termed Kantian constructivism, where the objective is not truth but consensus that is not based on manipulation.

16. Donald Campbell, "On the Conflicts Between Biological and Social Evolution and Between Psychology and Moral Tradition," *American Psychologist* 30, no. 12 (1975): 1003–1126.

17. Stanton Peele, "Cultural Context of Psychological Approaches to Alcoholism," *American Psychologist* 39 (1984): 1339–40.

18. Ibid., pp. 1346–47.

19. Craig MacAndrew and Robert Edgerton, *Drunken Comportment: A Social Explanation* (Chicago: Aldine Publishing Co., 1969).

20. Ibid., p. 169–71.

21. 108 S. Ct. 1372 (1988).

22. See Francis Allen, *The Decline of the Rehabilitative Ideal: Penal Policy and Social Purpose* (New Haven: Yale University Press, 1981), pp. 69–71.

23. Dr. Jane Jacobs reported that it is common to find families of continual drinkers adopting the attitude that the drinker has no choice and families of binge drinkers adopting the view that if the person does in fact resist drinking most of the time, then the drinker does have control over those times when the drinking recurs. My own predilection is for trusting the attitudes of those who (have to) live with people with problems.

24. See *Allen v. Mansour* 681 F. Supp. 1232 (E.D. Mich. 1986). In this case, Allen, a 27-year-old suffering from end-stage liver disease, caused by consumption of alcohol, wanted Medicaid to pay for a liver transplant. At this time Allen had abstained from drinking for four months, but the authorizing body had a policy of not authorizing transplants for liver disease for alcoholics who had not been abstemious for at least two years. Speaking for the Court, Chief Judge Pratt found that the two-year policy was arbitrary. Although the court

granted Allen his injunction, by the time it was issued, his condition deteriorated to the point that he could no longer be operated on.

Cases like this are tragic, and whatever one's principle's are, they seem to melt before the facts of a person's desperate and corrigible condition.

25. I want to thank Herbert Fingarette for suggesting the line of think-ing that I pursue in this concluding section.

26. Not all threats that are rightful fail to count as coercion, as is evidenced in legal coercion's centrality to the criminal law. See Alan Wertheimer, *Coercion* (Princeton: Princeton University Press, 1987).

27. Nadine Brozan, "Unresolved Question: Is Nussbaum Culpable?", *New York Times,* January 24, 1989, p. 15.

28. See Herbert Fingarette, *The Meaning of Criminal Insanity* (Berkeley: University of California Press, 1972).

# Herbert Fingarette, Radical Revisionist: Why are people so upset with this retiring philosopher?

*Stanton Peele*

One would not think of Herb Fingarette as a radical revisionist. A gentlemanly, soft-spoken man, he has spent his years in philosophy contemplating questions of behavior and responsibility, writing for legal and behavioral journals, and participating in learned councils that deliberate on these issues. This was how he became engaged in the most contentious topic in modern social science (excluding, perhaps, racial differences in intelligence): the debate over whether alcoholism is best regarded as a disease.

As a legal/moral philosopher, Herb had long been concerned with issues of criminal responsibility. In his book, *Self-Deception,* Herb argued that explicit consciousness required a person to spell out the motivations and consequences of his or her actions: the refusal to do so comprised a particular variety of self-deception.[1] One noteworthy consequence of the compromised personal agency brought on by a person's ignoring, and thereby disavowing, personal engagement in his or her actions is to undermine moral and criminal responsibility. If a person is unconscious of how his or her actions lead to harm of others or what brings on this misconduct, then may he or she not be excused for these actions?

An opportunity to explore this model was presented for Herb when the Supreme Court considered the issue of whether alcoholism is a disease and whether being alcoholic excuses one from criminal responsibility.[2] Although, when entering this fray, Herb's sense was that alcoholism had been established to be a disease, his examination of the

issues thoroughly convinced him otherwise. There was no genetic or other biological explanation for why a person drinks too much either on a particular occasion or habitually, why a person commits violent or criminal acts when drunk, why a person decides that he or she is an alcoholic and that drinking is an excuse for misbehavior. Instead, Herb saw, drinking was an all-purpose excuse, a special case of self-deception anointed by science but actually steeped in the lore of magical "loss of control"—"I couldn't help myself"—as though this *description* of irresponsibility was somehow an explanation and an excuse for it.

Herb's position achieved its greatest notoriety when his work was cited by the Supreme Court in denying two alcoholic veterans VA educational benefits they were unable to use within the period established by VA regulations because, they claimed, they were alcoholics. In other words, they spent so much of this time drinking that they didn't feel like going to school, a situation they claim was brought on by the disease of alcoholism from which they suffered. One irony in this case was that, although the VA's position was that these men engaged in willful misconduct rather than manifesting a disease, the VA treatment creed is very much one based on the disease model. The VA expressed a different, sensible position in this case because to do otherwise would simply overwhelm the federal government with unimaginable claims it owed people who were too drunk to demand them at some time in the past.

As a psychologist, I am interested primarily in the psychological implications of disease views of human behavior, and of the excuse-making and lack of self-awareness they signify. Herb Fingarette has addressed these issues as a philosopher. In his book *Heavy Drinking: The Myth of Alcoholism as a Disease,* Herb makes clear that it is both more accurate and more useful to think of heavy drinking as a "way of life" than as a disease. Herb's great achievement was, with the dispassion of a professional philosopher and the compassion of a concerned human being, to dispose of the fallacy that the only alternative to treating alcoholism medically as a disease is to treat it punitively as a sin or a crime:

> There is no reason to see heavy drinking as a symptom of illness, a sign of persistent evil, or the mark of a conscienceless will. Rarely do people wickedly choose a destructive or self-destructive way of life. On the contrary, we shape our lives day by day, crisis by crisis. . . . We

each share the propensity to choose opportunistically when under stress. So, on a series of occasions, a drinker chooses what seems the lesser evil, the temporarily easier compromise, without a clear appreciation of the long-run implications.

If our righteous condemnation is not in order, neither is our cooperation in excusing heavy drinkers or helping them evade responsibility for change. Compassion, constructive aid, and the respect manifest in expecting a person to act responsibly—these are usually the reasonable basic attitudes to take when confronting a particular heavy drinker who is in trouble. . . . [3]

Herb makes clear that the disease model, by dismissing the heavy drinker's responsibility for his or her excesses, also denies the drinker's responsibility to change his or her way of life in ways that matter:

Instead of encouraging those concerned to see the drinking in the context of the person's way of life, and thus to discern what role or roles it may play for that person in coping with life, the logic of the disease concept does the contrary. It leads all concerned, including the drinker, to deny, to ignore, to discount what meaning that way of life may have. Seen as an involuntary symptom of a disease, the drinking is isolated from the rest of life, and viewed as the meaningless but destructive effect of a noxious condition, a "disease." [4]

He then asks a key question:

But what if this is totally wrong? What if that life reflects, perhaps unwisely and obscurely, the drinker's attempts to cope with feelings, emotions, attitudes, relationships that are not acceptable to others—perhaps not fully acceptable even to the drinker—but that are, for better or worse, those that surge up in the drinker's soul? [5]

In other words, what if you accept the disease theory's seductive offer—that of viewing your desire to drink and your difficulty in controlling your drinking as alien to you, as having some mysterious biological, perhaps genetic cause? With great relief, you find yourself "off the hook." Meanwhile, though, you still can't talk to your spouse, or you still feel inadequate at your job. What have you accomplished? You haven't dealt with our drinking or your life. This, according to Fingarette, is the *self-deception* engendered by the disease notion of alcoholism, which only adds to the confusion and paralysis experienced by the heavy drinker. This self-deception is expressed, for example,

in the claim that the alcoholic who is completely incapable of control after taking one sip can nonetheless be held rigidly responsible for controlling the urge to take that sip. As a description of human motivation and behavior, this quick shift from complete control to loss of control doesn't ring true—and the drinker knows it.

Is it possible that Herb might not have fully recognized the kind of response that writing an iconoclastic—if truthful—book on alcoholism would elicit? For the reaction his book aroused was immediate and brutal. In the same year *Heavy Drinking* was published, a member of his own faculty at the University of California at Santa Barbara (William Madsen, Department of Anthropology) published an entire pamphlet whose sole purpose was attacking Herb and his book.[6] It was as though, out of the imminent danger that some unsuspecting lamb would be led astray by Herb, it was necessary to produce a concordance which any reader of *Heavy Drinking* must keep by his or her side for instant refutation of Herb's heresies, even though thousands of popular works already exist to promote the disease position Herb refuted.

There are many intriguing aspects to Madsen's broadside. I select one, based on Herb's mild-mannered proposition (or at least what would appear to be such in any other than the alcoholism field) that we "view alcoholism pluralistically" and try a variety of approaches to treating alcoholism. In particular, Herb proposed—since studies of public alcoholism facilities consistently find that fewer than 10% of graduates abstain for any period following treatment—that some goal of moderated drinking be included in the panoply of therapies for and accepted outcomes of alcoholism treatment.

Madsen, typical of representatives of the alcoholism field who find this an intolerable heresy, responded to Fingarette's summary of information indicating the moderation training and treatment goals can be useful by referring to the "most impressive and precise study" ever conducted on the subject of moderate-drinking. This penultimate study, Madsen claimed, can once and forever lay to rest the dangerous idea that some alcoholics reduce their drinking problems without abstaining. The study, which appeared in the *New England Journal of Medicine* and was authored by John Helzer and his colleagues at Washington University's School of Medicine, dealt with outcomes

among a highly alcoholic hospital population.[7] Madsen summarized the study as proving that, since only 1.6% of hospitalized alcoholics resumed moderate drinking, that "to urge alcoholics to try for a goal with a demonstrated failure rate of 98.4% is madness."

Philosophically minded readers may recognize in this statement the logical fallacy of the excluded middle, where, since the researchers defined 1.6% of patients as moderate drinkers, Madsen concluded everyone else failed at this goal. One might deduce from Madsen's description of a 98.4% failure rate for moderate drinking that the hospitals in this study pushed controlled-drinking therapy. In fact, these hospitals in all likelihood recommended total abstinence to alcoholic patients. Actually, not all of the hospital units where alcoholics were treated offered specific therapies for alcoholism; only one of the four was an inpatient alcoholism ward. And the alcoholism unit had the *worst* outcomes of any of those studied, showing one half the remission rate (among survivors) of a medical/surgical ward. Indeed, from five to seven years after treatment, only 7% of those in this inner-city alcoholism ward survived and were in remission!

Based on these data, one would think humility was called for in discussing current hospital treatments for alcoholism, rather than the cocksure rejection by Helzer et al. and Madsen of an alternative approach—one that was not actually tried in the study under consideration. Could not someone say that this study demonstrated primarily the failures of standard therapy and the need to consider alternative approaches? In another piece of research on hospital treatment of alcoholism, Edward Gottheil of Jefferson Medical College reported that from 33% to 59% of patients engaged in some moderate drinking during a two-year follow-up of alcoholics treated at a VA hospital; only 8% of this hospitalized group abstained throughout the two years. Gottheil commented:

> If the definition of successful remission is restricted to abstinence, these treatment centers cannot be considered especially effective and would be difficult to justify from cost-benefit analyses. If the remission criteria are relaxed to include . . . moderate levels of drinking, success rates increase to a more respectable range. . . . [Moreover] when the moderate drinking groups were included in the remission category, remitters did significantly and consistently better than nonremitters at subsequent follow-up assessments.[8]

What actually did occur for the remaining 98.4% of the surviving Helzer et al. subjects (a question that the actual research answers in some detail, although the authors of the *New England Journal* article do not emphasize these results)? Fifteen percent of them were abstaining at the point when they were assessed from five to seven years later. We don't know to what extent they did or did not try moderate drinking previously. Another group, consisting of 4.6% of treated patients, *did* drink exclusively in a moderate manner, but in fewer than thirty months during the three-year assessment period. While Helzer et al. did not define these as moderate drinkers, many would say they were. They certainly were not failures at attempts at moderate drinking. Finally, another 12% of these patients admitted that they had more than six drinks on three occasions during at least one month in the previous three years, but claimed they had had no drinking problems over these three years.

These patients, Helzer et al. believed, were denying their continued alcoholism. And to prove it, the researchers checked with relatives of these patients and hospital and other records to see if they could find proof of continued alcoholic problems. The investigation turned up none, so that Helzer et al.'s decision to say these patients were "in denial" was based on an a priori conclusion about the nature of alcoholic patients, i.e., that they can't drink again without problems. Overall, then, the Helzer study found—among alcoholic survivors of hospital treatment—that 6% had been drinking moderately or lightly for three years and that 12% had had at least one intermittently heavy drinking period (lasting for as little as a month) over three years but said they had no more drinking problems, while no evidence or collateral reports could be found to gainsay them. It might seem that Madsen's statement that Helzer et al. "demonstrated [a] failure rate of 98.4%" for controlled drinking clearly misstates the actual situation.

Madsen himself claims not to be against controlled-drinking therapy, and he doesn't even think it is that hard to practice successfully: "Any third-rate counselor should be able to help a non-addicted drinker moderate his or her drinking," he wrote in his pamphlet (p. 25). The trick, then, according to Madsen, is to decide who is the non-addicted alcohol abuser and who is the addicted one. In alcoholism treatment in the United States, no one takes the trouble to differentiate between the two. For example, Kitty Dukakis, who began getting

drunk following her husband's 1988 presidential election loss, after a lifetime of social drinking, was taught at the Edgehill Newport Hospital that she was a lifelong alcoholic who must abstain forever. We might ask whether any alcohol abusers screened at Edgehill Newport are referred to appropriate outpatient or controlled-drinking counselling based on their being, in Madsen's words, "non-addicted."

As for *real* alcoholics, Madsen declares, "Not a single validated case of a competently diagnosed alcoholic returning to normal drinking has ever been demonstrated." What, then, about the 1.6% of alcoholics who returned to moderate drinking (and the additional 4.6% who drank moderately but too occasionally for Helzer et al. to accept them as genuine moderate drinkers) in the Helzer et al. study that Madsen cites so enthusiastically? Was this research incompetently administered, and do we need therefore to ignore it? If the Helzer et al. study provides the bottom figure for alcoholics' resuming moderate drinking, the upper figure might be from a study published in 1987 in the *Journal of Studies on Alcohol* by two Swedish physicians who followed socially stable alcoholics two decades after their hospitalization for alcoholism. "Social drinking was twice as common as abstinence among the former alcohol-dependent [addicted] subjects" in this group. This research would represent a considerable failure at diagnosis and accurate follow-up, according to Madsen, and one can only marvel that it was accepted for publication at this late date in the most prestigious American journal devoted to alcohol studies.[9]

When Herb summarized the material in *Heavy Drinking* in an article in the journal *Public Interest*,[10] Madsen once again attacked Herb, in a response published in the same journal.[11] Again, Madsen spent quite a bit of space—half of his response—on the issue of controlled drinking, about which Herb had relatively little to say in his book or article, beyond that it be considered in the context of the failures of standard treatments, such as that which produced a remission rate like the 7% Helzer et al. found for inpatient alcoholism treatment. Meanwhile, private treatment centers charge exorbitant rates for group therapy and individual counseling that consist primarily of exhortations to alcoholics to quit drinking, and that have been shown to have no greater effect than receiving a lecture about the dangers of alcohol, being prosecuted for a drunk driving arrest, or the simple passage of time.[12]

Madsen's *Public Interest* response contained a prolonged discussion of the case of Mark and Linda Sobell—a husband-and-wife research team who taught alcoholics moderate-drinking techniques before it became essentially verboten in the U.S. to do so and who subsequently were attacked in a 1982 article in *Science* which claimed that few if any of these treated alcoholics achieved moderation.[13] Actually, the *Science* investigators noted, at least one alcoholic did become a moderate drinker, but (in Madsen's paraphrase) "this person may not have been a genuine gamma alcoholic." (Gamma alcoholics are the same genuinely addicted alcoholics not one of whom Madsen has said has ever been found to return to moderate drinking.) Madsen attacked Fingarette in the pages of *Public Interest* for "lacking all scientific credentials." He then proceeded to review the Sobell controversy by referring to the television program *60 Minutes*, which ran a segment on the Sobells' experiment.

*Sixty Minutes* interviewed a number—but not all—of the surviving controlled-drinking subjects in the Sobells' study. It did not interview any of the subjects in a hospital abstinence group that the original experiment compared with the controlled-drinking subjects. Thus, *60 Minutes* filmed Harry Reasoner walking near the grave of a subject in the controlled-drinking group in the Sobells' experiment (the first such death occurred eight years after treatment). However, Reasoner could also have walked near the graves of many of the hospital abstinence group as well—since more of them died in the period the *Science* article studied (and since) than did those in the controlled-drinking group!

The discovery of the deaths of patients who received standard hospital abstinence treatment appeared as a result of an investigation of the Sobells' experiment conducted by a committee appointed by the Toronto Addiction Research Foundation brought on by allegations of fraud against the Sobells by one of the authors of the *Science* article, Irving Maltzman. This blue-ribbon committee published an exhaustive document, in which it noted:

> The charges made and implied with respect to the Sobells involve the most serious kinds of allegations it is possible to make against . . . scientist(s). . . . By choosing not to compare the [controlled-drinking] subjects' outcome with data from an appropriate control group,

subjects' outcome with data from an appropriate control group, Pendery et al. implied that the long-term prognosis of the subjects was worse than would have occurred with routine treatment. No form of treatment of alcoholism known to the Committee is clearly perfect for any group; hence comparisons must be made of treatment groups in order to evaluate any particular treatment. . . . Science, the activity, would have demanded such a comparison, even though *Science,* the magazine, did not.

Ultimately, the goal of the scientific study of alcoholism is not well served by disputes such as this one.[14]

Other investigations have been conducted of this research, including one by the United States Alcohol, Drug Abuse, and Mental Health Administration (ADAMHA). After taking testimony from all concerned patients and the authors of the *Science* article and examining the Sobells' data without restrictions on two occasions, the ADAMHA committee declared it "did not find evidence to demonstrate fabrication or falsification of data reported by the Sobells."[15] That Madsen repeated in a national magazine Maltzman's claims of fraud without citing the Addiction Research Foundation and other investigations that have exonerated the Sobells is character assassination and it is reprehensible.

A television crew could also walk near the graves of the subjects in the Helzer et al. study who were taught to abstain in the hospital but who died. That many alcoholics whom people try to help don't stop drinking alcoholically and may eventually die of alcohol-related causes is indeed tragic—but who should be blamed for this? And who should be praised for their great success in treating alcoholics? Madsen knows—"Treatment programs based on AA principles, such as the Betty Ford Center, the Navy Alcohol Program, and the Employment Assistance Programs, have recovery rates up to 85 percent."[16] Indeed, since nearly every program in the United States is based on AA principles, America must have one of the most effective treatment systems for this disorder ever conceived! For the 85% figure to be accurate, almost nine of ten people who enter treatment must stop drinking alcoholically, which—according to Madsen—means they stop drinking altogether.

Surely, these are tremendous claims. And one can wonder how Madsen makes them so confidently, since he referred to no published treatment outcome research either in his article in *The Public Interest*

or in his pamphlet. If Madsen has evidence of such sure-fire treatment for alcoholism, he should perhaps take some greater trouble to make these facts clearer to others in the alcoholism field. For example, in an editorial in the *Journal of the American Medical Association,* Forest Tennant, a medical researcher, remarked:

> The serious problem of alcoholism has been lost in the competitive hype among alcoholism treatment centers. Any sophisticated critic using statistical analysis to measure treatment effectiveness is appalled by the display of a media or sports star claiming cure thanks to a specific treatment center's help—which proclaims 80% to 90% cure rates.[17]

Another poorly informed person Madsen will clearly want to educate is the current Director of the National Institute on Alcohol Abuse and Alcoholism, Enoch Gordis, an alcoholism researcher, who believes:

> In the case of alcoholism, our whole treatment system, with its innumerable therapies, armies of therapists, large and expensive programs, endless conferences . . . and public relations activities is founded on hunch, not evidence, and not on science. . . . Yet the history of medicine demonstrates repeatedly that unevaluated treatment, no matter how compassionately administered, is frequently useless and wasteful and sometimes dangerous or harmful. The lesson we have learned is that *what is plausible may be false, and what is done sincerely may be useless or worse.*[18]

One survey of therapies that have been tested in comparison with alternative treatment in controlled research studies found a number of therapies that had been shown to work better than not doing anything—and better than standard treatments that attempt to educate alcoholics by explaining to them they can't drink normally because they have a disease. These useful therapies are stress management, aversion therapies, social skills training, family therapy, a comprehensive job- and family-oriented treatment called the community reinforcement approach, and controlled drinking treatments. The authors of this survey—who had investigated every single comparative study on alcoholism treatment ever published in English—noted one strange thing about alcoholism treatment in the United States:

> As we constructed a list of treatment approaches most clearly supported as effective, based on current research, it was apparent they

all had one thing in common: . . . they were very rarely used in American treatment programs. The list of elements that *are* typically included in alcoholism treatment in the United States likewise evidenced a commonality: virtually all of them lacked adequate scientific evidence of effectiveness.[19]

Madsen—through his abstinence monomania; through his self-certain claims that he knows which treatments work and which don't (while failing to support his personal knowledge with concrete evidence); through his cut-and-burn attacks on any alternatives to standard American disease concepts and medical practices in the alcoholism field; through his totemic reference to science when he means only to air his own prejudices and those of the people with whom he agrees—actually makes the strongest case possible for Herb's claim that alcoholism treatment in the United States is controlled by a group of individuals who, for emotional and economic reasons, have made what should be a scientific field into a personal preserve of pride and prejudice.

If (as many people like Madsen believe) conventional treatments for alcoholism work so well, we might wonder why so many people refuse to go to them and why there continue to be so many active alcoholics. The true believers have an answer—denial! These alcoholics deny that they are alcoholics or that they need the help of AA and similar treatments. And Fingarette's worst crime, shared by others of his ilk who won't jump on the disease bandwagon, is in facilitating this denial. Madsen and others, on the other hand, know through personal experience and/or revealed knowledge what is true, what is right, and what people must accept for themselves before they can be cured (or saved). What Herb had run up against is a religious zealotry and bigotry, and the attacks on him resemble nothing so much as a modern Inquisition. Madsen wrote:

> Fingarette has no trouble demanding responsibility of others, alcoholic or non-alcoholic. . . . Do crusades like his which urge the alcoholic to drink and even accept drunkenness show any responsibility at all? Does he not also have moral and legal responsibilities? He states that it is too bad statistics don't show the actual blood, suffering and cadavers produced by alcohol. Yet, I am convinced his crusade will increase this carnage.
>
> I worry about the responsibility of a reputable academic press publishing the Fingarette book—which would seem to authenticate

its contents to the public. When others worry about the state of the nation, I, in particular, worry about how the Supreme Court could soberly consider Fingarette's "research" as possibly valid.[20]

People need to be protected from Herb's ideas; publishers need to be warned of their complicity in publishing what Herb writes; the Supreme Court has to be persuaded that what Herb says is dangerous (although presumably able lawyers on the other side did their best to make this clear to the justices).

Madsen calls, simply and straightforwardly, for suppressing Herb's point of view, one which Madsen rightly indicates runs counter to orthodox thought in the United States. The whole debate is one Madsen clearly feels should never have taken place. Even to publish a book questioning the disease theory is so dangerous a proposition, one that leads to more deaths of alcoholics, as to be reprehensible and possibly to create a legal liability for the writer and publisher. Here, on the other hand, is the writing of a distinguished disease theorist of alcoholism, psychiatrist George Vaillant, in his 1983 book, *The Natural History of Alcoholism*:

> It seemed perfectly clear that . . . by inexorably moving patients from dependence upon the general hospital into the treatment system of AA, I was working for the most exciting alcohol program in the world. But then came the rub. Fueled by our enthusiasm, I and the director . . . tried to prove our efficacy. Our clinic followed up our first 100 detoxification patients. . . . [and found] compelling evidence that the results of our treatment were no better than the natural history of the disease.[21]

Should Vaillant be penalized for not using the correct treatments that Madsen knows to be successful in treating alcoholism, since Vaillant's patients did no better than alcoholics who received no treatment? Or should Vaillant (and Harvard University) be punished for publishing the finding that the results of standard hospital and AA treatment "were no better than the natural history of the disease"? Actually, Vaillant escapes the wrath of Madsen and people like him by simply affirming the verities of the field which say that alcoholism is a disease and AA is the treatment of choice, no matter how futile Vaillant's own data indicate this approach to be! In this environment

of intimidation and double-talk, we must be thankful that someone like Herb Fingarette, a calm and dignified figure who values dispassionate reasoning and evidence, has the courage to put the brake to this runaway train of disease imagery and treatment for alcoholism.

Consider that compulsive gamblers now have their own national organizations and support groups to argue that gambling is an uncontrollable disease and that the former scientific director of the National Council on Alcoholism, Dr. Sheila Blume, calls for treatment of gamblers in hospital wards; that there are similar groups and treatments for sexaholics, compulsive shoppers and spenders; that the standard defense when mothers kill their infant children is post-partum depression; or that jurors refused to convict Joel Steinberg of murder because they felt his judgment was impaired by cocaine, while many people feel his partner Hedda Nussbaum was suffering from "battered-wife syndrome," so that nobody was fully responsible in this case as a little girl's life ebbed away on the bathroom floor while two adults smoked cocaine nearby. We need people like Herb Fingarette to question this madness.

This volume marks the end of Herb's struggle with the alcoholism establishment, unless he plans any post-retirement work in the field. He might be forgiven if he decided after his exposure to Madsen and others that he deserves a rest from ill treatment and irrationality and from the attacks of people whose methods contrast so starkly with the reasoned exchanges of the philosophical discourse Herb Fingarette embodies. It is the shame of the alcoholism field that sooner or later this is the fate of most good, intelligent souls who contemplate our alcoholism mess. To research a question only to be accused of being an unscientific parvenu or, worse, of being a dissembler and murderer is really too much.

One of Madsen's central criticisms of Herb's work is that Herb is not an alcoholism researcher or scientist, only a philosopher. But those who actually work in the alcoholism field let themselves in for far more serious attacks (if that can be believed!) than Madsen's on Fingarette. Consider the following, very ominous warning issued by John Wallace (clinical director of the Edgehill Newport Hospital that treated Kitty Dukakis) for psychologists who consider controlled drinking a possible outcome of alcoholism treatment:

With regard to the controlled drinking issue, I feel that the alcoholism field has too long suffered these outrageous attacks by certain members of the "Anti-Traditionalist" crowd. In the interests of our patients and their families, and in the interests of alcoholics who still suffer, we must begin to scrutinize more closely the activities of this group and to take steps to ensure they do no harm. . . . When thousands of lives and so much human tragedy is [sic] at stake, as they are in alcoholism and chemical dependence, then we must demand that the right to freely express our opinions be tempered by reasonable caution, healthy skepticism, fairness, and attention to scientific method and data. We must not forget that it is the duty of members of the various professions to defend the public against quackery.[22]

This article was entitled "Waging the War for Wellness: II. The Attack upon the Disease Model." Note the war imagery; this imagery is maintained in an editorial by the managing editor of the journal in which the Wallace article appeared. This editor entered the field "as an alcohol/drug counselor and program administrator soon after embarking on his own recovery":

I would find a way to take up the banner against the forces of wealth and cunning who promote behavioral retraining as a means to avoid the "penalty" of abstinence borne by those of us who have chosen the "traditionalist" route to recovery—the only known route, by the way. . . . The most effective means of spreading truth and enlisting soldiers to fight the wars against incompetence and deception is the mass media.[23]

Incidentally, the author of this call-to-arms received a degree in alcohol/drug studies and counseling skills from the University of California at Los Angeles. He will, in turn, teach others in university programs. What kind of reasoned consideration of the issues can we expect to find in the many programs run by people like this man in major universities around the country?

In the long run, unless more of those outside the alcoholism field become involved in this debate, Madsen and his ilk will prevail with their slanders and assaults, their crusades against apostasy. The alcoholism field actually resembles a dysfunctional home dominated by alcoholic parents where irrationality becomes the norm, where those inside

the home—even those who don't behave this way themselves—accept the crazy way things are done as normal, and where those who blunder in from outside get out as quickly as they can. Those who step outside the home, as by traveling to another country, confront another reality:

> The ten men and women who live at the Thornybauk recovery home in Edinburgh have all had trouble with alcohol, but don't call them alcoholics or suggest that they have a disease.
>
> They're problem drinkers. They developed a dependence on alcohol. They aren't being treated for alcoholism but are trying to learn to deal with personal problems in a way that avoids getting drunk. If they want to try to drink again and control it, their counselors at Thornybauk wouldn't object.
>
> Thornybauk would be considered a novel, if not dangerous, course of treatment for alcoholism in the United States, where the traditional disease concept of alcoholism makes total abstinence the widely accepted goal of treatment. In England and Scotland, and much of the rest of the world, it's the other way around. The majority of medical and psychiatric practitioners frown on the idea that persons who have once lost control of their drinking must, above all, avoid a "first drink" if they expect to sustain their recovery. In the eyes of these doctors, it is insisting on abstinence that may jeopardize alcoholic recovery. They prefer to work with a concept of alcohol dependence which has varying degrees of severity and may leave the door open for a return to social drinking by some patients.[24]

Of course, it is hard to escape your culture to "put on" the perspective of another nation or, for that matter, of the rest of the civilized world. It is particularly interesting that Madsen, a cultural anthropologist, should show the prejudice and narrow-mindedness that provoked George Bernard Shaw to define a barbarian as one who "thinks that the customs of his tribe and island are the laws of nature." On the other hand, it is an act of courage and defiance to shed one's cultural blinders through the sheer power of one's own thought. That Herb has accomplished this—and at the same time exposed the peculiarity of the American system to a broad readership at the cost of attacks on his person and his professional competence—may be the most commendable of the many good things he has accomplished in his long and distinguished career.

# REFERENCES

1. H. Fingarette, *Self-Deception*, (Atlantic Highlands, N.J.: Humanities Press, 1969).

2. H. Fingarette, "The Perils of Powell: In Search of a Factual Foundation for the 'Disease Concept of Alcoholism,' " *Harvard Law Review* 83 (1970): 793–812; H. Fingarette and A. F. Hasse, *Mental Disabilities and Criminal Responsibility* (Berkeley: University of California Press, 1979).

3. H. Fingarette, *Heavy Drinking: The Myth of Alcoholism as a Disease* (Berkeley: University of California Press, 1988), pp. 111–12.

4. H. Fingarette, "Alcoholism and Self-Deception," in *Self-Deception and Self-Understanding: New Essays in Philosophy and Psychology*, ed. M. W. Martin (Lawrence, Kans.: University Press of Kansas, 1985), pp. 60–61.

5. Fingarette, "Alcoholism and Self-Deception," p. 61.

6. W. Madsen, *Defending the Disease: From Facts to Fingarette* (Akron, Oh.: Wilson, Brown & Co., 1988).

7. J. E. Helzer, L. N. Robins, J. R. Taylor, et al. "The Extent of Long-Term Moderate Drinking among Alcoholics Discharged from Medical and Psychiatric Treatment Facilities," *New England Journal of Medicine* 312 (1985): 1678–82.

8. E. Gottheil, C. C. Thornton, T. E. Skoloda, and A. L. Alterman, "Follow-Up of Abstinent and Nonabstinent Alcoholics," *American Journal of Psychiatry* 139 (1982): 564.

9. G. Nordström and M. Berglund, "A Prospective Study of Successful Long-Term Adjustment in Alcohol Dependence: Social Drinking versus Abstinence," *Journal of Studies on Alcohol* 48 (1987): 95–103.

10. H. Fingarette, "Alcoholism: The Mythical Disease," *The Public Interest* (Spring 1988): 3–22.

11. W. Madsen, "Thin Thinking about Heavy Drinking," *The Public Interest* (Spring 1989): 112–18.

12. S. Peele, *Diseasing of America: Addiction Treatment Out of Control* (Lexington, Mass.: Lexington Books, 1989).

13. M. Pendery, I. M. Maltzman, and L. J. West, "Controlled Drinking by Alcoholics? New Findings and a Reevaluation of a Major Affirmative Study," *Science* 17 (1982): 169–75.

14. B. M. Dickens et al., *Report of the Committee of Enquiry into Allegations Concerning Drs. Linda and Mark Sobell* (Addiction Research Foundation of Toronto, 1982), pp. 14–16.

15. R. L. Trachtenberg, *Report of the Steering Group to the Administrator of the Alcohol, Drug Abuse, and Mental Health Administration Regarding Its Attempts*

*to Investigate Allegations of Scientific Misconduct Concerning Drs. Mark and Linda Sobell* (Alcohol, Drug Abuse, and Mental Health Administration, 1984).

16. W. Madsen, "Thin Thinking about Heavy Drinking," p. 117.

17. F. S. Tennant, "Disulfiram Will Reduce Medical Complications but Not Cure Alcoholism," *Journal of the American Medical Association* 256 (1986): 1489.

18. E. Gordis, "Accessible and Affordable Health Care for Alcoholism and Related Problems: Strategy for Cost Containment," *Journal of Studies on Alcohol* 48 (1987): 579–85.

19. W. R. Miller and R. K. Hester, "The Effectiveness of Alcoholism Treatment: What Research Reveals," in *Treating Addictive Behaviors: Processes of Change,* ed. W. R. Miller and N. K. Heather (New York: Plenum, 1986), p. 123.

20. W. Madsen, *Defending the Disease,* p. 32–33.

21. G. E. Vaillant, *The Natural History of Alcoholism,* Harvard University Press, 1983, pp. 283–84.

22. J. Wallace, "Waging the War for Wellness: II. The Attack upon the Disease Model," *Professional Counselor,* March/April 1987, pp. 25–26.

23. C. Creager, "Calling All Counselors: Special People, Special Causes," *Professional Counselor,* January/February 1987, p. 4.

24. R. Zimmerman, "Britons Balk at U.S. Treatment Methods," *U.S. Journal of Drug and Alcohol Dependence,* January 1988, pp. 7, 18.

# Talmudic Reflections on Self-Defense

*George P. Fletcher*

*[Sometime in the early 1980s, I was inspired by a lecture that Herbert Fingarette gave at the University of Judaism on questions of ethics and Judaism. For that reason I am dedicating this essay, concerned about issues that recur in his work, to him.]*

The ordinary citizen looking at the law from the outside generally expects to find a relatively clear set of rules defining our rights and duties. In the field of self-defense, the man or woman on the street, or in the subway, wants to know when it is permissible to use force, particularly deadly force, to stop an aggressor. Can you shoot a burglar? Can you rig up a spring gun to protect your property? If you disable an aggressor and he is bleeding to death in front of you, do you have an object to come to his aid? These are the questions to which lay-people want answers, and they expect to find them in the law.

Lawyers can sometime provide answers to these troubling questions, but more typically the answers turn out to be contingent and provisional. The reason for the law's hesitancy is that all these questions arise at the cusp of conflict between our commitment to protect the rights of the potential victim and the recognition that the aggressor, for all his wrongdoing, still must be treated as a human being. And at minimum, treating the aggressor as a human being means that regardless of wrongdoing, his or her life still has value.

Even if answers are possible, therefore, the only way to gauge the stability of the law's position is to trace the answer back to the basic

philosophic arguments that give rise to answers to borderline situations of conflict. The question is not only what you may do, but what the freedom or the constraint governing your action says about our basic views on human life and the moral significance of crime and aggression.

What I am referring to, in the Jewish context, is the difference between the fifteenth-century codification *Shulchan Aruch* and the *Talmud* as it evolved in the first five centuries of the common era. The former consists of a set of rules, a crystallized body of answers, for living as a Jew under *Halakha*. The rules are more important than their grounding in philosophic argument. The greatness of the Talmud, particularly of the *Gemara* (the commentary on the laws stated in they *Mishna*), is that it turns this relationship between answer and argument on its head. What counts in this basic text of Jewish civilization then is not the answers, but the reasoning that has led subsequent generations of rabbis to find answers in the Talmud. The profundity of studying Talmud is not that one thereby derives algorithms for daily life, but rather one fathoms the depths of the rabbinic effort to complete God's task of giving the Jews law to live by.

To provide but a glimpse of this grandeur, I would like to concentrate on two areas that are problematic both under contemporary secular legal systems and in the Talmud. The first question is: What is the connection between self-defense and punishment? It would be difficult to say there is no connection at all, for both the legitimate use of force in self-defense and the legitimate use of force in punishing an offender express a response to criminal aggression. True, the former may be inflicted by a private individual and the latter, only by the state (as we understand punishment today), but the question remains whether one practice properly informs the contours of the other. For example, should we speak about defensive force "fitting" the crime as we think about punishment fitting the crime?

The second question begins where the first leaves off. If self-defense is not a form of punishment (and in the end the Talmud teaches that it is not), then what is the rationale for allowing someone to inflict harm on a fellow citizen? Is self-defense grounded in a personal right of necessity? Or does an act of self-defense vindicate a general social right to uphold the law in the face of aggression? These questions bring others in their wake: What is the difference between individuals

defending themselves (the first-party case) and other parties intervening to assist someone in danger (the third-party case)? Is defending oneself at home the same as defending oneself in public or is there a special right to preserve the sanctity of one's home?

There are numerous other questions that might engage us, but these two will serve as an introduction to talmudic thinking about defensive force. Preliminarily, we should survey the foundations of self-defense in the Bible and the first postbiblical code of laws, the Mishna.

The Bible addresses the law of self-defense in only one passage as follows:

> If a thief be found breaking in and be struck and killed [in self-defense] and he die, there shall be no blood guilt for his death. If the sun be risen upon him, there shall be blood guilt for his death. [But] he surely must make full restitution; if he have nothing, then he shall be sold for his theft.[1]

To make sense of this passage, let us start with this curious phrase "blood guilt."[2] The same words appear in Kant's discussion of why, if a community is about to disband forever, every murderer in prison must meet his due punishment. If this were not done, "blood guilt" would be "fixed on the people."[3] What he meant by this, is that if they forewent punishment, the entire community would then be complicitous in the homicide for which the murderer was sentenced. In the biblical context "blood guilt" implies responsibility for killing. This conception of guilt stems from the ancient Jewish idea that a manslayer acquires control over the victim's blood; the slayer must be executed in order to return the blood to its source, the Creator of all life.[4]

Killing a burglar leaves "no blood guilt" if it is in accord with basic principles of rightful conduct, that is, if it is what we would call today a justified killing. If the killing is unjustified, then the slayer becomes responsible for the victim's blood and some response, some atonement, is necessary to correct the perceived imbalance in the natural order.[5]

The Bible tells us nothing about the criteria for justifying the killing of a burglar except that it matters whether "the sun be risen upon him." At first glance, this appears to mean that it is justifiable to kill a nighttime, but not a daytime, burglar. This is probably the origin of the common law rule that only nighttime breaking and entering

constitutes burglary. Significantly, however, the talmudic discussion of this point takes a different turn. The passage "if the sun be risen upon him" is not taken to mean that it is all right to kill a burglar at night, but not during the sun's shining on him. Rather the reference to the sun's shining is read metaphorically to mean that killing the burglar is impermissible if it be clear as day that his intention is not to harm. The metaphor of the sun's shining is another way of saying that he be perceived in a different light, not in the shadows of the general assumption that burglars mean to harm.

The Mishna, the first codification of the oral law and custom, builds on this single passage in Exodus to a more refined body of principles on self-defense and defense of others. The first of the two *Mishnaot* devoted to the subject prescribes:

> A housebreaker is judged according to his purpose. If the housebreaker breaks a cask and there would be blood guilt for killing him [i.e. it is unlawful, unjustifiable to kill him in self-defense], the housebreaker is liable for the damage. If there is no blood guilt [i.e. it would be justifiable to kill him], he is exempt from liability.[6]

The point of this Mishnaic rule is to exempt the housebreaker from civil liability for damage done during the period that he is subject to being killed lawfully and justifiably. It does not matter whether the homeowner in fact responds with deadly force. The fact that the homeowner *could* lawfully kill him is sufficient to exempt the housebreaker from all civil liability for all acts that he might commit. It is as though by exposing himself to the homeowner's lawful response, he enters a twilight zone in which he is no longer liable for his acts.

No modern lawyer would even consider the possibility of exempting the housebreaker from liability for tort damage, whether as an intruder he is subject to being killed on the spot or not. What could have led the rabbis to formulate this curious principle of tort exemption for unjust aggressors? Before we turn to an explanation, let us look at the second Mishna on self-defense:

> The following can be saved [from sinning] at the expense of their souls. Someone who is pursuing another person with the purpose of killing him, someone who is pursuing a man and someone who is pursuing a betrothed woman. But someone who pursues a beast, someone who

desecrates the Sabbath, and someone who engages in idol worship—
these are not to be saved at the expense of the souls.[7]

This passage comes closer to delineating a right of self-defense.
There are three enumerated cases of aggression where the use of deadly
force is permissible and three where it is not. Note that the three cases
of permissible killing all involve human victims—one against homicide
and the other two, by rabbinic interpolation in the elliptic text, against
homosexual and heterosexual rape. In the other three cases, where
the defensive use of deadly force is prohibited, the relevant acts
(sex with an animal, desecration of the sabbath and idolatry) are all
capital offenses, but only when the offender is judged and condemned
by a court.

# I

Against this background of texts, let us turn first to the question whether
in the talmudic view self-defense constitutes a form of punishment.
There is much in the commentary on the first Mishna stated above
to support the claim that this is precisely the talmudic understanding
of self-defense.

According to a general principle of Jewish law (*kim le bdraba minah*),
if an individual simultaneously commits two offenses, he is liable only
for the greater offense. Thus if he breaks into a home and simultaneously
damages goods of the owner, he can be liable only for the greater of
these two offenses. If he is liable, therefore, for the burglary, he is not
liable for the lesser offense or tort of damaging property.

For this single scale to take hold in the talmudic mind, the sages
had to think of the harm inflicted by the homeowner as a mode not
only of preventing the break-in and protecting the life of the home-
owner, but of sanctioning—imposing liability on the housebreaker—for
the aggressive act. For purposes of displacing the lesser included
liability for property damage, the defensive act by the homeowner had
to appear as of a piece with the community's imposing the death
penalty after trial and judgment.

There is additional evidence in the commentaries of the Gemara
that the sages thought of killing the housebreaker as a sanction for

his act. They were troubled by the procedural implications of think-ing of defensive force as imposing liability; if certain procedural rules apply when a court metes out punishment, the same rules should presumably apply in the field when a homeowner decides to inflict harm on an intruder. For example, a Jewish court can not carry out a decree on the Sabbath; therefore, it would seem that the homeowner should not be able to "execute" an intruder on the Sabbath. It is obviously necessary, however, to allow the homeowner to protect himself or herself, whatever day of the week it may be.[8]

And there is an additional complication. A Jewish court will not execute anyone for homicide unless immediately prior to the deed, two witnesses warn the slayer that he is about to commit a capital offense and he responds that he plans to go ahead anyway. In the discussion of slaying the housebreaker, the question recurs: How can the homeowner use force if the housebreaker has not received the re-quired warning that he is about to commit a capital offense? Today we would reject this question as irrelevant. It would be like asking how someone can use force in self-defense without first according the suspect-aggressor a jury trial. The procedures governing conviction have nothing to do with the use of self-defense to protect oneself against imminent aggression. At least that is the way it seems to us.

But the discussants in the Talmud reasoned differently. Instead of rejecting the analogical extension of the required warning, they recognized the problem and sought to explain why in the case of housebreaking the requirement was satisfied in spirit, if not in form. The function of the warning, they seem to have reasoned, is to put the potential offender on notice of his capital liability. The house-breaker is also "warned" although not by the words of witnesses. To be liable to a lawful response by the homeowner, the intruder must "dig under" and "break in" to someone else's private space; this act of breaking puts him on notice, the rabbis conclude, that he might be subject to a fatal response.[9] That the rabbis indulged in this reason-ing, verging on legal fiction, reveals how seriously they took the con-ceptual links between official punishment and private self-defense.

The rabbinic institution of the "warning" and the resulting self-imposed limitation on the capital jurisdiction of the rabbinic courts are taken to reflect the rabbis' passionate opposition to capital punishment.

In a limited sense, this interpretation is correct. But the rabbis were not opposed to seeing offenders die for their deeds. They recognized liberal rights of self-defense, including the homeowner's right to slay the intruder. They thought of aggressors and housebreakers as deserving death.[10] What the talmudic discussants were concerned about, however, was a *court's* imposing the death penalty. There was nothing wrong with a private individual's killing an aggressor on the spot, but a court's assuming the power to execute an offender in the name of the entire community remained problematic.

Talmudic jurisprudence appears to have an anarchistic bent. It is a system designed to work on the basis of every male Jew's devoting his life to studying legal texts. If everyone knows the law and acts on the basis of his knowledge, judges and courts are superfluous. Of course, no legal system can ever be fully self-administering. In some extreme cases, judges must intervene to resolve disputes and punish criminal offenders. But nonetheless, I would submit, the ideal of a self-administering system infuses talmudic thinking. And an ideal self-administering legal system vests in potential victims the authority to kill offenders on the spot.

Given this ideal, the threatened homeowner functions as the primary judge of the housebreaker's deed. So far as I know, there is no mention in the Jewish legal source of judging and punishing a housebreaker after the deed is over and done. The homeowner responds and sanctions him or no one does. This is as far as one could go in realizing John Locke's conception of a right to punish in a state of nature.[11]

The inclination to think of defensive force as a form of punishment imposed against bad people for their misdeeds is not limited to the talmudic discussions. One finds the same tendency in numerous pockets of litigation today. In the *Goetz* case, for example, the insidious claim that the four young black victims got what they deserved played a major part in Goetz's successful defense. One of the witnesses in the subway car, a young black named Andrea Reid, let slip that she had said at the time of the shooting, "Those punks got what they deserved."[12] Defense counsel Barry Slotnick invoked these words over and over again in an attempt to convince the jury that it was indeed true. Yet there is no legal or theoretical basis in the contemporary law

of self-defense to treat the victim's desert as relevant to the permissible scope of defensive force.[13] Though the law may be clear that self-defense is not supposed to be a form of deserved punishment, lay juries who decided guilt and innocence are open to covert persuasion that the victim received a fitting sanction for his or her misdeeds.

In the evolution of our thinking about self-defense, two steps are critical to the separation of self-defense from the institution of punishment. The first is a consensus that only courts may judge someone guilty and impose punishment. However convinced private individuals may be about the just deserts of their neighbors, they are not entitled to act on those convictions. This is surely the law today, but for some reason the raw intuition persists that in acting in self-defense the defender inflicts punishment on the aggressor.

The reason the intuition persists may be that most people who think about self-defense do not draw a critical distinction between the intent to defend oneself and the intent to inflict harm as revenge or punishment. Defense against an attack requires a finely honed intent merely to thwart the attack; if this can be done without harming the aggressor, so much the better. Punishing an offender, however, requires an intent actually to inflict pain; no comparable move permits us to say, if this can be done without harming the offender, so much the better.

It is not clear to me when this distinction emerged in Western legal and moral thought. Some say that Aquinas was the first to work it out. Whether this is true or not, it seems fairly clear that the talmudic discussion of self-defense and punishment suffers from failing to make this distinction. There is no doubt that the sages intuited the difference between the two ways of using force against a burglar, but they had no conceptually refined way of expressing the point.

# II

In the commentaries on the two *Mishnaot* stated above, it becomes clear that two radically different cases of self-defense lie at the center of the discussion. In the first instance, the picture is one of a homeowner defending his or her space against an intruder. In the second, the scenario shifts from the private to the public arena and the actor using defensive force is not the potential victim, but a third party coming

to his rescue. The Mishna is surely not explicit about this latter point, but the Gemara assumes, without discussion, that the central case is not defense of self but defense of another.

Whether one has a right to defend oneself against aggression seems unproblematic. If there is a good candidate for a natural right that need not be officially granted by legislation, this is it. Indeed even the Talmud assumes without grounding in any authoritative text: "And the Torah holds, 'If someone comes to kill you, rise up and kill him first.'"[14] The passage suggests that Jewish law recognizes a general right to defend oneself on the street as well as within the confines of one's own home. The word *Torah* ("teaching") is used here in a wonder-fully ambiguous way. Narrowly defined, *Torah* refers to the Bible, but there is no explicit support in the Bible for this general claim of a right of self-defense. In this context the term *Torah* is understood as the entire body of Jewish law, including unwritten principles as well as the explicit revelation at Sinai. Even within the framework of a religious legal system based upon a single text, the lawyers engaged in interpreting the text may properly assume that some matters—such as the right to defend oneself—are so obvious that the lawgiver need not expressly mention the right in laying down the law.

If the first-party right of self-defense [to defend oneself] is assumed as a principle of natural law, it does not follow that the third-party right [the right to defend others in danger] may be so easily assumed. Defending others against aggression is not a matter of personal sur-vival, but rather an expression of solidarity. We could survive without this sense of interdependence and therefore the general right of a third party to intervene (or meddle, depending on your perspective) hardly seems like a sound candidate for a natural right. How does the Western legal tradition support the third-party right of intervention?

There is no simple answer, for the Western tradition draws on three distinct sources of the contemporary right to defend oneself and to defend others. The first officially recognized form of self-defense in the common law tradition was *se defendendo*, a defense that came into judicial practice by way of the Statute of Gloucester in 1278. *Se defendendo* applied when someone's back was to the wall, when there was no choice but to kill or be killed. There was no requirement that the opponent start the fight—that he bear the stigma of being the

aggressor. The commentators sometimes referred to *se defendendo* as killing in "a chance medley," thus underscoring the point that the origin of the fight remained unclarified. The defense operated by way of confession and avoidance; asserting *se defendendo* conceded the illegality of the killing, but sought to avoid the capital penalty, routine for ordinary cases of murder. If the plea prevailed, the defendant's life was spared, but, as atonement for his unlawful killing, he forfeited his property to the Crown. This form of partially sanctioned killing came to be known as excusable as opposed to justifiable homicide.

This theory of self-defense hardly supports a right of third-party intervention, for only the person who actually has his or her back to the wall may invoke the defense of *se defendendo*.

Until Parliament acted under Henry VIII, in 1532, there was no theory of self-defense that rendered a killing fully lawful, justifiable, and therefore free of the taint that affected excusable homicide. The only available theory of justification applied on behalf of killings in the name of the law, such as executions under a court order. Prior to 1532 a private party, killing in self-defense, could not make an analogous claim of lawful conduct.

With the introduction of justifiable self-defense in 1532, the common law endorsed a second rationale for acquitting private individuals of homicide. The statute was directed primarily against robbers and highwaymen. The sentiment must have been that the killing of an overt aggressor was simply not a criminal wrong—not a violation of principles governing civil life. Viewing this sixteenth-century development through the prism crafted by Kant and Hegel, we would be inclined to say that the aggressor violates the Right or *ius* [law in the sense of just social order] and that repelling the attack restores the Right, upholds the principles of *ius* and for that reason is *justified*.

This theory of justifiable homicide, based as it is not on defense of the person but on the defense of abstract Right, lends itself to universal application. If it is important that the legal order be defended against an aggressor, then everyone should be authorized to intervene.

A third theory of self-defense emerged in Blackstone's writing about justifiable homicide. The great mid-eighteenth century synthesizer of the common law was appalled by an implication of a liberal theory of justifiable homicide. Punishment may be designed to fit the crime;

but the same principle of proportionality does not apply as a limit to the amount of force that may be used in self-defense. Today, the death penalty may not be used in rape cases; but no one, so far as I know, seriously challenges whether women (or men) may use deadly force to thwart an otherwise unpreventable rape. Though we accept this discontinuity between the institutions of punishment and self-defense, Blackstone balked at permitting deadly force against petty criminals, like thieves, who would not be executed for their crimes. No act, he reasoned, "may be prevented by death unless the same, if committed, would also be punished by death."[15] Thus Blackstone drew an analogy between punishment and self-defense in order to limit the scope of self-defense.

Blackstone's principle has hardly prevailed—witness the disparity in rape cases—but it hints at a way of thinking about self-defense that has a strong following. In neither of the first two theories is one concerned about balancing the interests of the embattled parties. If a defender has no choice but to kill, he will be excused for doing so. Balancing the interests at stake is relevant only so far as protecting a relatively minor interest might indicate that the defense was less responsive to instincts of survival. If a defender may restore the Right by killing, when necessary, an unjust aggressor, he may do so without concern for the proportionality of his response. Now Blackstone comes and teaches generations of common lawyers that if an act does not merit the death penalty *ex post,* preventing that act does not justify deadly force *ex ante.* If punishment must fit the gravity of the crime, then defensive force must also fit the threatened act.

Blackstone's approach may be read as variation on the theory of justified self-defense found in Kant and Hegel. Though different limits are imposed on the use of force, the basic idea is the same: it is right and proper to stop the aggressor. If this is the case, then it should be right for anyone, whether potential victim or third party, to seize the initiative and intervene against the aggressor.

The view of the self-defense that has finally emerged in American state statutes bears the imprint more of Blackstone than of early common law sources and abstract philosophical views about defending the legal order. Most American commentators and legislators have come to see self-defense as but a special instance of the general

utilitarian justification of furthering the greater good in a situation of conflict. The Model Penal Code, which has served as the basis of reform in at least thirty states, adopts this way of enthroning the balancing of interests as the "general principle of justification"[16] and then proceeds to treat self-defense as a special instance of this general principle. Significantly, the Model code perceives no difference between the defense of self and the defense of others.

In summary, the mode of reasoning in modern secular law is to develop a right of self-defense, as Blackstone did, and then universalize this right to cover cases of third party intervention. The assumption underlying the universalization is that if it is right for the victim to thwart the aggression, it must also be right for a third party to do so.

This way of thinking in secular law is worth underscoring, for the Talmud adopts a radically different perspective on the problem of third party intervention. The basic category of analysis is not a right to intervene, derived in turn from the victim's right, but rather a duty to intervene based on a general obligation to rescue one's neighbor. The critical biblical text is Leviticus 19:16, translated by Jewish scholars as: Neither shalt thou stand idly by the blood of thy neighbor.[17]

A few lines into the Gemara to the Mishna delineating the cases of permissible deadly force against pursuers, one finds the analogy between rescuing someone from the hands of an aggressor and coming to the aid of someone endangered by a natural force, such as by drowning in a river or being dragged off by wild animals. The significant fact is not that the aggressor is violating the legal order (for neither the river nor the wild animal does that) but simply that a fellow member of the community is in danger and one is duty-bound to come to his or her aid.[18]

Grounding defensive force in the duty to rescue expresses the communitarian orientation of talmudic jurisprudence. All Jews are responsible for each other, for each other's sins on the Day of Atonement and for each other's welfare in daily life. Only hyperbole can capture the Jewish passion for interdependence: "If one saves the life of [a Jew], the Scriptures treat him as though he has saved an entire world."[19] This statement, found in the Mishna among legalistic propositions about interrogating witnesses, follows an analogous claim about the meaning of killing a single Jew: it is as though one kills an

entire world. These poetic testimonials to the value of human life derive, in part, from the view that each person carries within not only the seed of his or her offspring, but the seed for infinite generations yet to be born. These unborn generations are sacrificed by every act of killing or failing to rescue.

Alas there are limits to this communitarian approach. True, the biblical duty not to stand by while one's neighbor bleeds extends to all members of the community, but in the talmudic context, the community is limited to Jews. The sources suggest further that not even all Jews are the recipients of this concern for the welfare of one's neighbor.[20] Though modern thinking about self-defense is pitched to a multiethnic, diversified society (*Gesellschaft*), the Talmud approaches the duty to rescue and defensive intervention in the context of a closely-knit, homogeneous community (*Gemeinschaft*).

However challenging it might be to think of self-defense in the talmudic mode as a duty of concern for others, this way of thinking strains the capacity for solidarity in modern society. It is surely possible to adapt the talmudic communitarian mode of thinking to contemporary problems, but one should not be surprised that the influential thinkers in Western law (e.g., Kant, Hegel, and Blackstone) found it necessary to focus not on rescue but on the aggressor's threat to the legal order.

Yet the beauty and the depth of talmudic thinking continues to shake our confidence in modern ways. The model of human commmunity conveyed by the sages represents an aspiration that we must never forget.

# NOTES

1. Exodus 22:1-2 (translation by the author).

2. Though I think this is the best way to render the biblical passage in English, the original Hebrew text is ambiguous. It reads literally: *damim lo* or "bleeding him." This phrase could be read as: "There shall be blood shed for him" and indeed this is the translation found in many English renditions of the Bible. The Hebrew phrase could also be read to mean that as a result of the aggression, the aggressor should be treated as though he has no blood or as a dead man. See the reading by the eleventh-century commentator Rashi (note 10 infra).

3. See I. Kant, *The Metaphysical Elements of Justice*, trans. J. Ladd (New York: Bobbs-Merrill Co., 1965), p. 102.

4. See D. Daube, *Studies in Biblical Law* (Hoboken, N.J.: Ktav, 1927).

5. Whether the proper response is execution or fleeing to a City of Refuge depends on additional factors, such as whether the killing is culpable or excusable. See G. Fletcher, *Rethinking Criminal Law* (Boston: Little, Brown and Co., 1978).

6. Babylonian Talmud, *Sanhedrin* 72a.

7. Babylonian Talmud, *Sanhedrin* 73a.

8. See the discussion of this point in Babylonian Talmud, *Sanhedrin* 72b.

9. See the discussion id.

10. Rashi, the leading eleventh-century commentator, whose writings on the Talmud are regarded as authoritative and published in the standard editions in the margins around the Mishna and Gemara, interprets the phrase "there is no blood guilt" in killing the housebreaker to mean: "the housebreaker is to you as though he has no blood (i.e. life) and it is permissible to kill him." Babylonian Talmud, *Sanhedrin* 72a.

11. See J. Locke, *Two Treatises of Government*, 2nd ed., ed. Peter Laslett (Cambridge: Cambridge University Press, 1967), § 7. For an effort to turn the private right to punish into a theory of self-defense, see Hurka, "Rights and Capital Punishment," *Dialogue* 21 (1982): 647–60.

12. For details and analysis, see G. Fletcher, *A Crime of Self-Defense: Bernhard Goetz and the Law on Trial* (New York: Free Press, 1988), p. 28.

13. See id. 27–29.

14. Babylonian Talmud, *Sanhedrin* 72a.

15. W. Blackstone, *Commentaries on the Law of England*, vol. 4 (A Facsimile of the First Edition of 1765–1769, Chicago: University of Chicago Press, 1979), p. 181.

16. Model Penal Code § 2.02.

17. This is the old translation, copyrighted 1917, by the Jewish Publication Society, of the Hebrew: *Lo taamod al dam re'ekha.* The Jerusalem Bible translates the passage as "Neither shalt thou stand aside as when mischief befalls thy neighbour." The new French translation in *La Sainte Bible* (Paris: Editions du Cerf, 1972) is intriguingly misleading: *et tu ne mettras pas en cause le sang de ton prochain.* Luther rendered this passage as *Du sollst auch nicht auftreten gegen deines Nächsten Leben.* Perhaps the French and the German accurately capture the active force of the Hebrew injunction *lo taamod*, but they miss the sense of the passage captured in the English phrase "Do not stand idly by." The point of the passage is that one must intervene to save one's neighbor rather than let him die.

18. The talmudic discussion also relies on other passages, including the implicit reference to permissible third party intervention in Deuteronomy 22:23–30, addressing the question whether a betrothed woman should be punished for fornication if she was seized in the field and she cried out ("for he found her in the field and she cried out, but there was none to save her").

19. Babylonian Talmud, *Sanhedrin* (last Mishna in chapter 4). One basis for this view, discussed in the same Mishna, is that each person carries within himself the seed of all his descendants, and thus if the descendants of each person are extrapolated in the future, there is a sense in which a "whole world" is at stake in saving the life of each human being.

20. Babylonian Talmud, *Avodah Zarah* 26a and 26b.

# Rights-Bearing Individuals and Role-Bearing Persons

*Henry Rosemont, Jr.*

## Introduction

Throughout a productive and inspiring career, Herbert Fingarette has challenged received opinion on topics as diverse as alcoholism and the law, and on thinkers as diverse as Sigmund Freud and Confucius.[1] In doing so, he has combined logical rigor with sensitivity and insight into the human condition, enhancing measurably our understanding of ourselves and of the contemporary world in which we endeavor to lead meaningful lives.

His work is altogether original, and I would hypothesize that a measure of that originality can be traced to Fingarette's familiarity with, and respect for, non-Western philosophy, especially that of the early Chinese. He studied the classical language in order to read the texts on his own, and he has acknowledged a great philosophical debt to Confucius.[2] Also, some evidence for this hypothesis can be found in the fact that although he has had many important things to say about such matters as the law, treatment of disease, insanity, and criminal responsibility, Fingarette almost never employs the concept of rights—human, legal, or civil—in his analyses and evaluations; and the modern concept of rights is altogether absent in ancient Chinese thought.

In what follows, I would like to further test this hypothesis by making explicit what I thus take to be implicit but important in Fingarette's writings: a critique of the modern Western concept of rights, coupled with a sketch of an alternative view of what it is to be a person that is fundamentally Confucian. This "test," of course, is

actually an extended invitation for him to respond to these funda-
mental issues as they bear on his philosophical views.

## II.  Rights-Bearing Individuals

It is a fairly bedrock presupposition of our moral, social, and political
thinking—national and international—that human beings have rights.
Both as scholars and as citizens of the Western capitalistic democracies
we are strongly inclined to say that certain basic rights obtain independ-
ently of sex, color, age, ethnicity, abilities, time, or place; we have certain
rights solely in virtue of being human. Which rights are basic, how
conflicting rights-claims are to be adjudicated, the extent to which legal
and political rights originating in a specific nation-state are to be dif-
ferentiated from more universal moral rights, whether rights should
be the foundation of moral and/or political theory are, among others,
issues in dispute. But with a very few notable exceptions, the concept
of individual human beings as rights-bearers is not itself in serious
question in contemporary Western moral, social, and political thinking.

Nothing is more plain, however, than the facts that every one of
us does have a definite sex, a color, an age, an ethnic background,
certain abilities; that we all live in a specific time, and a specific place.
We are all born and reared in a specific cultural community, each with
its language, values, religious orientation, customs, traditions, and con-
comitant ideas of what it is to be a human being. There are not, in
short, any culturally independent human beings. Each of us has specific
hopes, fears, joys, sorrows, values, and views which are inextricably
linked to our definitions of who and what we are, and these defini-
tions have been overwhelmingly influenced by the cultural community
of which we are a part. F. H. Bradley has made this point—in another
context—well:[3]

> Let us take a man, an Englishman as he is now, and try to point out
> that apart from what he has in common with others, apart from his
> sameness with others, he is not an Englishman—not a man at all; that
> if you take him as something by himself, he is not what he is . . . he
> is what he is because he is a born and educated social being, and a
> member of an individual social organism; . . . if you make abstrac-
> tion of all this, which is the same in him and in others, what you

have left is not an Englishman, nor a man, but some I know not what residuum, which never has existed by itself, and does not so exist.

These considerations suggest a disturbing question: if, as is the case, a large majority of the world's peoples live in cultures which do not have a concept of rights, or have concepts incompatible with that concept, then how could, or should, the members of those cultures imagine what it would be like to have rights, or that it would be right and good and proper for them to so imagine?[4] It should be clear that our own concept of human rights is closely related to our own views of human beings as freely-choosing autonomous individuals, views which are at least as old as the epistemological reflections of Descartes, and which found moral and political expression in such writings as those of John Locke, the Virginia Declaration of Rights, the Declaration of Independence, and the French Declaration of the Rights of Man. To be sure, this concept of human beings is embodied in the 1948 U.N. Declaration of Human Rights, and it might therefore be seen now as a more or less universal, and not culture-bound concept. But let me quote the Preamble therefrom:[5]

> Now therefore the General Assembly proclaims this Universal Declaration of Human Rights as a common standard of achievement for all peoples and all nations to the end that every individual and every organ of society keeping this declaration constantly in mind, shall strive by teaching and education to secure respect for these rights and freedoms, and by progressive measures national and international, to secure their effective recognition and observance. . . .

Note the key expressions here: "standard of achievement;" "shall strive by teaching and education;" "by progressive measures national and international." Clearly the framers of this Declaration, overwhelmingly drawn from the culture of the Western industrial democracies, were concerned to propose a particular moral and political perspective, an ideal not yet extant, as the standard toward which all nations, and all peoples, should strive.

But now, as we approach the celebration of the forty-third anniversary of the U.N. Declaration, it remains true that upwards of 70% of the world's peoples have no intimate acquaintance with the culture of the Western industrial democracies. They never have lived, do not

now live, and, because of economic, environmental, and cultural circumstances, will not so live for a very long time, if ever.

Conjoining these two considerations, we seem to be forced to embrace what is highly fashionable philosophically these days, a form of relativism,[6] toward which two extreme responses have been given. On the one hand, we might wish to simply accept the "diff'rnt strokes for diff'rnt folks" idea, and cease believing that our philosophical efforts can find a purchase beyond our Western cultural heritage; at this extreme, it cannot ultimately make any sense to argue that a particular view of human beings is any better, or any worse, than any other, because there could be no culturally independent grounds for settling the argument. On the other hand, we can simply dig in our heels, and insist that all human beings *do* have rights even if they are not recognized in other cultures, that if other cultures don't have our concept of rights, they *should* have it, and will all of them be the worse morally and politically if they do not.

Now the first extreme has a commendable aura of tolerance about it, but has as well the untoward consequence of leaving us nothing significant to say ethically about the activities of such people as the Marquis de Sade, Aztec ritual cannibals, slave societies, or The Waffen S.S. Pessimism, cynicism, nihilism, are all predictable, if not logically necessary outgrowths of this position, evidenced, I believe, both in much of contemporary Western society, and in much contemporary Western philosophy.

The other extreme has the virtue of arguing for a moral ground from which culturally and historically independent judgements might be rendered, but has had the untoward consequence, for which there is a sorry superfluity of historical documentation, of grounding the morality in the culture of the Western industrial democracies, with the attendant chauvinism, imperialism, and, increasingly now, irrelevance for the more than three billion people who do not share that culture.

Strong words here, but I do not believe I have exaggerated, and have stated these positions in this way in order to throw into sharp relief an alternative I wish to pose for consideration: that there is a conceptual framework—what I will call a "concept-cluster"—within which both ethical statements and an ethical theory can be articulated

which can be applicable to, understood and appreciated by, all of the world's peoples, but that before such a concept-cluster can be worked out by philosophers, the Western philosophical tradition will have to incorporate in the future more of the views of non-Western philosophies than it has in the past. If our own modern ethical, social, and political philosophies, in which the concept of rights is central, are outgrowths of a culture encompassing no more than 25% of the human race, and if there are other rational ethical and political philosophies which more or less reflect the presuppositions and assumptions of the other 75%, then those assumptions and presuppositions should be incorporated, if at all humanly possible, into any ethical and/or political philosophy which claimed to be universal. All the more so is this necessary if it is now the case that our own concept-cluster surrounding rights not only separates us from our fellows in other cultures, it is increasingly separating us from each other within our own culture, a point to which I will return toward the end.

If my alternative is to be made at all attractive, I shall have to talk more about rights and associated ethical concepts within the context of our culture, and then must endeavor to partially de-contextualize—not deconstruct—those concepts by considering some issues that are usually referred to vaguely as falling under comparative studies, and simultaneously to endeavor to bracket our Western ethical concept-cluster by contrasting it with another, in this case, the concept-cluster of the early Confucian philosophers.

On any given day, somewhere in the world a number of our fellows are being confined in highly inhospitable environments, are in fear for their lives, and are being subjected to a host of physical and psychological indignities. Some are incarcerated and being tortured basically because of their color, others because of their nationality, still others are imprisoned because of their political beliefs, and others yet are being persecuted in similar ways for their religious and attendant social convictions. And we also have many instances, either undertaken independently or in concert with one or more governments, of the taking of hostages, or random acts of terrorism and torture.

We are angry at these circumstances and events, indignant that they continue to take place, and probably feel frustrated that we are personally able to do so little to bring an end to such heinous practices.

Consider, now, the accounts we would typically give to describe and explain our feelings and beliefs about these practices. They are unjust, we say: no one should be imprisoned, tortured, or held hostage, simply due to their color, nationality, political or religious beliefs, because all human beings have basic rights, rights which are clearly being violated in these instances. When, having broken no reasonable law, individuals are denied their liberty, their livelihood, their property, and are in fear for their physical well being, they are being unjustly deprived of the opportunities to freely choose their actions, and therefore stand in loss of the self-governing autonomy which makes them uniquely human.

Such an account is sufficiently straightforward that virtually every reflective citizen of the English-speaking countries would accede to it, and consequently I do not wish to challenge it as an accurate reflection of our cultural perspective; it is the same perspective incorporated in the U.N. Declaration. Rather do I want to suggest that the complex philosophical notion of the individual, the self, which underlies this account may not be the most appropriate, or the most advanced, or the most humane way to characterize the members of our species. It is certainly not the account the vast majority of the human race would give.

Moreover, within the Western industrial democracies, especially in America, the concepts of rights and autonomous, freely choosing individuals is central not only to the problems of political prisoners, hostages, terrorist acts and torture in the international arena, but to virtually all of the pressing national ethical issues of our time as well. Speaking broadly, the abortion controversy is usually couched in terms of whether foetuses may be said to have rights, and if so, whether those rights take precedence over the rights of women to control their own bodies.[7] Issues surrounding suicide and terminally ill patients are commonly analyzed by asking when, if ever, the rights of the individual to decide matters affecting his or her own life and death may be overridden by doctors or others on the basis either of sound medical practice or the premiss that where there's life, there's hope.[8]

Turning to environmental concerns, ecologists of varied persuasions commonly defend their positions by appealing to the rights of our descendants to inherit a maximally healthy and genetically

diversified natural world,[9] and with respect to animals, a number of philosophers and others are asking whether or not animals may be seen to have rights solely in virtue of their being living things, rights which place sharp constraints on our right to manipulate them and/or the natural environments in which they live.[10]

And finally, I do not believe it is too grand a generalization to say that a number of domestic, ostensibly political issues—e.g., welfare, tax reform, capital punishment, affirmative action—reduce to a more fundamental ethical tension between individual rights and social justice.[11]

If this all-too-hurried outline nevertheless seems roughly correct, we can appreciate that a great many of the major controversies of our time are described, analyzed, and evaluated within the conceptual framework of a rights-based morality. To be sure, once we move from the general public arena to the narrower domain of ethical philosophy there is much less uniformity. Here we might speak of goal-based, and duty-based moralities as well. Thinkers working in the Kantian tradition for example, accord rights a more basic place in their theories than do the adherents of any of the several forms of utilitarianism, and a few philosophers, such as MacIntyre, are turning away from contemporary moral theories altogether, forcefully arguing instead for the re-introduction of a virtue-based moral philosophy inspired by an updated Aristotle.[12]

But MacIntyre's work has not yet made significant inroads into discussions of rights, and however differently different Lockeans, Kantians, Benthamites, and others wish to ground our moral principles, the concept of rights is crucial to all of their views.

Most foundational is Robert Nozick, who states on the first line of the first page of his *Anarchy, State, and Utopia*[13] that

> Individuals have rights, and there are things no person or group may do to them (without violating their rights). (p. ix)

In his influential *A Theory of Justice*,[14] John Rawls formulates his First Principle as follows:

> Each person is to have an equal right to the most extensive total system of equal basic liberties compatible with a similar system of liberty for all. (p. 302)

And on behalf of the modern British tradition, the following passage from R. M. Hare's recent *Moral Thinking*[15] is fairly typical:

It should be clear by now how lacking in substance is the common objection to utilitarianism, which might be advanced against my own theory of moral reasoning too, that it can give no place to rights, and can ride rough-shod over them in the interests of utility. . . . If we take [rights] seriously enough to inquire what they are and what their status is, we shall discover that they are, indeed, an immensely important element in our moral thinking . . . , but that this provides no argument at all against utilitarians. For utilitarianism is better able to secure this status than are intuitionist theories. (pp. 154–55)

From these citations—chosen virtually at random—and our earlier considerations it should be clear that the concept of rights thoroughly permeates contemporary Western moral and political thinking, even for those philosophers who do not give it pride of place in their moral and political theories. And just because it permeates our thinking so pervasively, we should not be surprised that the term "rights" is seldom fully defined by those who employ the term most frequently.

The best example of this is the well-known, tightly argued work *Taking Rights Seriously*,[16] in which Ronald Dworkin reflects on this point, and deserves to be quoted at some length:

Principles are propositions that describe rights; policies are propositions that describe goals. But what are rights and goals and what is the difference? It is hard to supply any definition that does not beg the question. It seems natural to say, for example, that freedom of speech is a right, not a goal, because citizens are entitled to that freedom as a matter of political morality, and that increased munitions manufacture is a goal, not a right, because it contributes to collective welfare, but no particular manufacturer is entitled to a government contract. This does not improve our understanding, however, because the concept of entitlement uses rather than explains the concept of a right. (p. 90)

In a not unrelated way, Patricia Werhane,[17] in attempting to ground her views on moral rights, begins with:

I shall assume that all human beings, and in particular rational adults, have inherent value. Because human beings have inherent value they have certain rights. These rights are moral rights . . . (p. 3)

Now Werhane's statement may appear unexceptionable to us, but it does exhibit the question-begging problem of defining rights

mentioned by Dworkin, for one could certainly hold that human beings have inherent value without having the concept of rights at all. (The early Confucians are a cardinal example.)

If a definition of rights is not ready to hand, we may attempt to further elucidate the concept by examining how rights are distinguished, and by enumerating them. The right to life is taken to be a passive right—because it requires recognition by others—while the right of freedom is an active right because one must do something in order to exercise it. Rights are also distinguished as positive and negative, i.e., the right to security as opposed to the right not to be tortured. The most common division is between *prima facie* and absolute rights, or, as they are also described, defeasible and indefeasible rights. There is little agreement among philosophers about which rights are absolute, if indeed there are any, but the following have been defended as the most basic rights of all: H. L. A. Hart[18] and others have argued for the primacy of the right to freedom, Henry Shue[19] for the primacy of the right to security and subsistence. Many philosophers consider the right to life as the most basic,[20] but Dworkin argues that the right to equal consideration (not equal treatment) underlies all of the others.[21]

We could go on further distinguishing the differing positions in contemporary Western moral philosophies, but need not for present purposes: what links them together, tautologically, is that they are all uniformly described as moral philosophies, and in this technical sense I should like to argue that early Confucianism should *not* be described as a moral philosophy. To show why this is so, and at the same time to allay any suspicion that despite my avowed intent, a radical moral relativism underlies my position, let us consider one of the sets of arguments commonly given on behalf of moral relativism based on examinations of other cultures, the arguments from anthropological evidence.[22]

We do not need to question, at least initially, the reliability of the wealth of ethnographic data which appear to demonstrate the regularity with which a particular human action has been loathed by one people, and at least tolerated, if not applauded, by another. But this evidence, by itself, will not do what a moral relativist might think it does; there is a logical point involved.

The farther we get from modern English and related Western languages, the farther do we get from lexical items which correspond closely

to the term "moral." All languages of course have terms for the approval and disapproval of human conduct, and also have terms for concepts employed in the evaluation of that conduct; but a great many of the world's languages have no words which connote and denote uniquely a set of actions ostensibly circumscribed by the pair "moral-immoral," as against the nonmoral. In this light, we should not be surprised that morals, like rights, is a sufficiently foundational concept in Western philosophical thinking that it is almost never given a clear definition.

The simplicity of this linguistic fact should not obscure its philosophical significance: speakers (writers) of languages having no term corresponding to "moral" cannot logically have any *moral* principles (or moral theories), from which it follows that they cannot have any moral principles incompatible with other moral principles, our own or anyone else's.

Imagine attempting to describe uniquely the set of human actions which should be evaluated as moral or immoral, distinguishing them from those actions for which the evaluations would be inappropriate—to someone not raised in any of the modern Western cultures. What would be central, and possessed by all members of the set? But this question cannot be answered unless we assume the correctness of some particular philosopher's views: motives more or less for Kantians (i.e., based on the use of the categorical imperative), consequences for utilitarians, intrinsic worth, perhaps, or piety, for many Christians. The most that we could say was that under particular circumstances, virtually any human action *could* have moral consequences. This is probably true, but notice that it is not particularly helpful to someone from another culture who did not already have our modern concept of morals in advance. (What might be said of the Confucians slightly misleadingly is that every human action *does* have what we—not the Confucians—would call moral consequences.)

Put another way, *we* might disapprove of an action which members of another culture approve. But if our disapproval rests on criteria essentially involving the concept-cluster of contemporary rights-based morality, a concept-cluster absent their culture (language), and if their approval rests on criteria involving a concept-cluster absent our culture (language), then it is simply a question-begging, logical mistake to say that the members of the two cultures are in basic *moral* disagreement;

the term is ours, culturally defined, it is not theirs. The ethnographic argument for moral relativism gains force only if it can be shown that two different people(s) evaluated human conduct in the same way—invoking similar criteria grounded and exhibited in the same or very similar concept-cluster—and that one approved the action, and the other disapproved.

It may seem that a big fuss is being made over a little word: why not simply find the closest approximation to the English "moral" in the language (culture) under investigation, and proceed with the analysis from there? This is exactly what most anthropologists, and not a few philosophers and linguists, have done. But now consider specifically the classical Chinese language in which the early Confucians wrote their philosophical views. Not merely does that language contain no lexical item for "moral," it also does not have terms, for example, corresponding to "freedom," "liberty," "autonomy," "individual," "utility," "principles," "rationality," "rational agent," "action," "objective," "subjective," "choice," "dilemma," "duty," "rights," and probably most eerie of all for a moralist, classical Chinese has no lexical item corresponding to "ought"—prudential or obligatory. (And we might suspect that the vast majority of other human languages which do not have a lexical equivalent for "moral" will not have equivalents for most of these other modern English terms either; which could hardly be coincidental.)[23]

No, it is not only a term corresponding to "moral" that must be sought in other languages if we are to speak cross-culturally about morals, for the sphere of contemporary Western moral philosophy is designated only roughly by the single term itself; a clear delimitation requires the full concept-cluster of terms just adumbrated, plus a few others. Now if contemporary Western moral philosophers can't (don't) talk about moral issues without using these terms, and if none of the terms occurs in classical Chinese, it follows that the early Confucians couldn't be moral philosophers in our modern sense, and we will consequently be guaranteed to miss what they might have to tell us about human conduct, and what it is to be a human being, if we insist upon imposing on their writings the conceptual framework constitutive of our modern moral discourse. (And the same may be said, *mutatis mutandis,* of members of other cultures who spoke or wrote about basic human conduct descriptively and evaluatively.)[24]

For this reason, and for others I have argued elsewhere,[25] I should like to distinguish "morals" from "ethics;" if the full and rich history of Western ethical thought and its variants in other cultures is to be fully intelligible to us, the subject must be defined so as to be inclusive of the ancient Greeks, their Christian successors, modern Western moral theorists, the early Confucians, and the relevant concept-clusters of many other non-Western peoples as well.

> *ethics* = df. (1) The systematic study of the basic terms (concepts) employed in the description, analysis, and evaluation of human conduct. (2) The employment of these basic terms (concepts) in the evaluation of human conduct.

It might be objected that this definition is too broad. Under it, one might decide to study, for example, the descriptions, analyses, and evaluations of such human activities as slurping soup, wearing inappropriate dress, the improper performance of rituals or making crude sexual advances; and surely we must distinguish rudeness from immoral conduct? Of course we must, if we are committed in advance to contemporary rights-based moralities as the be-all and end-all of *ethical* thinking. Unfortunately, such commitment, common though it may be, begs a large cultural question, for without the vocabulary of the concept-cluster of contemporary Western moral philosophy, it is fairly difficult to state clearly the purported distinction between "boorishness" and "immorality," as everyone who has contemplated the meaning and significance of *li* (ritual) knows full well. The above definition allows greater room for comparative studies than contemporary Western philosophical usage would encourage. It also, not irrelevantly, approximates fairly closely the more ordinary usages of "ethics" as found in standard dictionaries of English, and simultaneously reflects the linguistic fact that whereas even philosophers speak of "social ethics," "medical ethics," "professional ethics," and so forth, they do not—nor does anyone else—speak of "social morals," or "professional morals."[26]

If the concept-cluster dominating contemporary Western moral philosophies is correctly seen, its variations notwithstanding, as only one among many possible ethical orientations, we must reflect on a number of consequences which follow from making this distinction.

Returning now to the issue of moral relativism, the distinction between morals and ethics of course does not completely vitiate arguments given on behalf of ethical (or cultural) relativism, but it does call into question a number of their premises; clearly the "moral" counterarguments given here are not confined to the ancient Chinese language, as already noted. Retranslations and reinterpretations must be carefully made before the extant ethnographic data can be called forth again in support of relativistic theses. Ethical relativism may be true, but it is not entailed by (rights-based) moral relativism.

Second, making this distinction shows that non-Western materials, despite the ever-increasing sophistication of comparative scholarship, continue to be approached from a strongly Western perspective. To be sure, no comparative scholar can come to another culture as a *tabula rasa*. One need not be committed to relativistic theses to admit that pure (culture-free) objectivity is a myth: again, physicists and physicians, scholars and scolds, plain men and philosopher queens are one and all ineradicably influenced by their cultural and historical circumstances. But it must equally be admitted that there are degrees of culture-boundedness, degrees which are in principle capable of being measured by all. Anthropologists of the late nineteenth century, for instance, made intelligence the determining characteristic of culture, and it was certainly a step toward reducing the Victorian English chauvinism underlying that concept when the focus shifted to learning as the determining characteristic.[27]

This approach, while cheerily optimistic, may yet appear to rest on a conceptual confusion. The vocabulary of contemporary Western moral philosophy is deeply embedded in the language we all speak both as scholars and as citizens, and it would therefore seem that Confucian ethics can't be all that different from contemporary Western moral philosophy, or else we couldn't understand accounts of it in English as ethical thinking. That is to say, in order to make a case for the Confucian persuasion, isn't it necessary to employ some at least of the English-language concept-cluster comprising contemporary Western moral philosophies? And if so, then isn't Confucian ethics after all not so very different therefrom?[28]

I maintain that the concept-cluster of early Confucian ethics is very different indeed from the philosophical concept-cluster I have been

discussing. The vocabulary of English for making normative judgements and discussing ethics, however, is far richer than is found in contemporary rights-based moral philosophy. If I may put the matter bluntly, the most fundamental challenge raised by early Confucian ethics is that contemporary Western moral philosophy has become increasingly irrelevant to day in, day out, concrete ethical concerns; utilizing an impoverished—and largely bureaucratic[29]—technical vocabulary emphasizing law, abstract logic, the formation of policy statements, and employing altogether implausible hypothetical examples, contemporary rights-based moral philosophy, the Confucian texts suggest, is no longer grounded in the real hopes, fears, joys, sorrows, ideas, and attitudes of flesh and blood human beings. Since the time of Descartes, Western philosophy—not alone moral philosophy—has increasingly abstracted a purely cognizing activity away from concrete persons and determined that this use of logical reasoning in a disembodied "mind" is the choosing, autonomous essence of individuals, which is philosophically more foundational than are actual persons; the latter being only contingently who they are, and therefore of no great philosophical significance.

What the early Confucian writings reflect, however, is that there are no disembodied minds, nor autonomous individuals; to paraphrase Fingarette, unless there are at least two human beings, there can be no human beings.[30] By their lights, the writings of virtually every Western philosopher from Descartes to the present can only be seen as incantations for exorcising the human ghost from the calculating machine, to the current extreme that we cannot any longer even be certain that we aren't brains in vats. But to advance this challenge on behalf of the early Confucians is not to decry the Western cultural tradition, nor to applaud raw feeling, nor to claim that irrationality is somehow more human than rationality—all of which would involve a misreading of the Confucian texts, and would be fairly difficult claims to establish on the basis of rational argumentation given in a language central to the Western rational tradition. Rather is it to suggest that the contemporary philosophical stereotype of a disembodied, purely logical and calculating autonomous individual is simply too far removed from what we feel and think human beings to be, it has raised problems that seem incapable of solution, and it is therefore becoming

increasingly difficult for moral, social, or political philosophies embodying this stereotype to have much purchase even on ourselves, not to mention the peoples who do not live as inheritors of the Western philosophical tradition.

We must pursue this issue in greater depth, because this stereotype does not fail descriptively merely for contingent reasons; it must fail necessarily. It is admitted on all sides that human beings are not simply self-conscious and capable of reason, they are agents, which means they can act purposefully, and will act in different ways depending on what purposes they have. Purposes are ends, and there is a great multiplicity of possible ends one might strive to achieve. The problem arises when we ask how we can decide which ends we ought to strive to achieve, because of the persuasiveness of Hume's argument that no imperative statement (encompassing values) is logically derivable from any set of declarative statements (encompassing facts). It has long remained unquestioned, that to decide how to act it is not enough to be aware of things as they objectively are. Something more is needed to get to values, but what? And from whence can it come? Hume's position (in the *Treatise* and the *Enquiry*, at any rate) entails that answers to these questions must be "nothing", and therefore "nowhere"; our values are ultimately ungrounded.

The spell of this problem of the gulf between facts and values was indeed first cast by Hume, but its enchanting powers derive from Descartes' view of what it is to be a human being, Hume's anti-Cartesianism notwithstanding. The plausibility of this form of skepticism about values requires that we see human beings as having bodies, each with a specific shape, weight, color, and spatial and temporal location, bodies which generate a mixed set of impulses, emotions, passions, attitudes, and so forth. Hovering over and above each of these lumps of matter and messy assemblages of psychological states is a pure (because disembodied) mind, supremely competent to ascertain how things are (the objective word of fact/science), and how things must be (the necessary world of logic/mathematics), but—Hume's contribution—altogether worthless for determining how things ought be (the world of ends/values). The break between mind and body is total. Moreover, the bodies we have are obviously contingent upon the way the world happens to be, and are subject to all of the causal laws which govern this contingent world;

and how could such contingently existing, causally determined lumps of matter have value, be the source of value?

In one sense, it is philosophically irrelevant whether we accept this general picture of human beings as literally true, or simply as a Western conceit useful for theorizing about basic issues, akin in large measure to Hobbesian capitalists in a state of nature, or Rawlsian statesmen behind a veil of ignorance, or Quinean linguists who can never be certain of the meaning of 'gavagai'. Whether seen as fact or fiction, the picture is one of a sense-absorbent and logically calculating mind altogether discontinuous with an emotively evaluating (but probably valueless) body, with no moral, aesthetic, or spiritual equivalent of the pineal gland to bring them, or facts and values, together.

This Cartesian picture of what it is to be a human being has dominated Western moral, aesthetic, and religious thinking for almost three hundred years. Kant accepted much of the picture, but recoiled from a major inference Hume drew from it, namely, that reason had to be the slave of the passions. Instead, he endeavored to ground ends (and values) on purely rational grounds, insisting that reason be the master of the passions.

But Kant's reason can no more generate, or create values, than Hume's. Being purely formal, both the categorical imperative and the kingdom of ends principle do not, strictly speaking, embody values, and Kant's arguments for them do not rest on any basic values, but on the fear of logical self-contradiction which would follow from rejecting them. Reason, in short, is necessary instrumentally—to help us achieve goals—and it can be of assistance in ordering or re-ordering our values; but create values it cannot, and hence if we believe that human beings are, or can be, purposeful agents, we cannot simultaneously believe that they are altogether autonomous, disembodied, individual rational minds.[31]

To this critique any rights theorist would probably reply that of course the Enlightenment model of the rational, autonomous individual isn't to be seen as descriptive of human beings, but rather prescriptive. Obviously, people have values and just as obviously different cultures embody different values, which is what makes moral relativism the acute problem that it is today. By focusing on rationality, this reply might continue, and by showing the rationality of the concept

of rights, we can hope to overcome what separates us (cultural differences) on the basis of what unites us (the capacity to reason); and we can hope thereby to overcome most, if not all of the problems of moral relativism by establishing the reasonableness of the view of human beings as rational, autonomous individuals, and as rights-bearers, no matter what their cultural background. The view is not descriptive, but normative: we *ought* to accept it.

The force of this imperative, however, weakens as soon as we look carefully for the moral relativism it is designed to overcome. Earlier I argued, on logical grounds, that true instances of moral relativism can arise only when two peoples employed the same or very similar evaluative concepts and criteria, and that one people approved a particular human action, and the other disapproved.

How many such examples of true moral relativism there may be between different peoples around the world I don't know, but suspect the number has been greatly exaggerated. Unfortunately we do not have to trek to exotic lands to find examples, however, for they are everywhere in contemporary American society. As hinted at the outset, abortion is a prime example. Within the conceptual framework of rights-based moralities, with its concomitant concepts of duty, rationality, autonomy, choice, self, and freedom, it may be impossible to resolve the issue of abortion. One might want to argue that abortion is fundamentally a legal and not a moral issue, but for good or ill the vocabulary utilized in discussing the issue stems from the same conceptual framework. The matter could not be otherwise, for when both sides claim that basic human rights are at stake, then we cannot but have a paradigmatic moral issue. Nor can it be objected that abortion is an instance of moral conflict, not moral relativism, for this objection misses the logical point: an abortion is a human action tolerated by a fairly large number of people, and loathed by another large group; precisely the same situation described in all purported instances of moral relativism based on anthropological evidence.

The examples can be multiplied, again, as hinted at the outset; animal rights, euthanasia, the rights of the not yet born to a healthy and genetically diversified natural environment; all of these and other issues are sharply dividing the American peoples, and our inability to effect reconciliation may well be due to the conceptual framework

within which the dialogues and diatribes occur. More generally, where the moral and the political realms intersect—justice and fairness— there is even more *prima facie* evidence for irreconcilable differences, leading to the conclusion not that those who disagree with us are stupid, selfish, or evil, but rather to the conclusion that individual rights and social justice are very likely incompatible concepts when their implications are drawn out.

Other arguments can be advanced against the rational, autonomous, rights-bearing individual as a model of human beings, taken either descriptively or prescriptively. One of these is well known from work in Prisoner's Dilemma games, and from rational choice theory more generally.[32] If we add to the Enlightenment model of human beings— which virtually all thinkers since Hobbes have done—the additional quality of being self-interested, then, for a wide range of nonexcludable collective (or public) goods (or benefits), everyone behaving rationally guarantees that the collective good will never be obtained, and everyone will be worse off. To illustrate, let us consider the streets of our major cities. They are filthy, drug-filled, and dangerous. It would be a great collective or public good for the people, say, of New York, to clean up and reclaim their streets. But given that no one can be excluded from the streets, no rational self-interested individual will elect to contribute to the reclamation project. The streets will either be cleaned up, or they will not. If they are, the self-interested individual will enjoy the collective good without having to pay the costs of contributing. If the streets remain as they are, the individual has saved the costs of contributing. Each rational, self-interested individual must therefore decide not to contribute. And the streets of New York will remain as they are, and every individual will be worse off.

A great many attempts to escape from this and other "free rider" or collective action paradoxes have been made, all of them unsuccessful, suggesting that the streets of New York will only continue to deteriorate unless and until some new (or very old) ways of thinking about ethical and political issues gain currency.

An enormous body of literature has been produced assuming, elaborating, and defending the view that human beings are autonomous, rational, rights-bearing, and self-seeking individuals. Clearly I have not even begun to respond to the whole of that literature in

this very brief and general critique. But because so much of that literature presupposes the model of human beings as purely rational, self-seeking, autonomous individuals, the many arguments in that literature cannot have any more plausibility than the basic presuppositions on which they rest. To be sure, that model—especially as it has been taken to imply human rights—has advanced significantly the cause of human dignity, especially in the Western democracies, but it also has a strong self-fulfilling prophetic nature, which is strengthened further by the demands of capitalist economies; and I believe that model is now much more of a conceptual liability than an asset as we approach the twenty-first century, continuing our search for how to live, and how best to live together on this increasingly fragile planet.

## III. Role-Bearing Persons

The critique of rights can be broadened and deepened considerably, but I should like to shift the focus now to an alternative view, that of the early Confucians. Describing the early Confucian lexicon[33]—their concept-cluster—is beyond the scope of the present paper, but this much should be said: the Chinese philosophical terms focus attention on qualities of human beings, as a natural species, and on the kinds of persons who exemplify (or do not exemplify) these qualities to a high degree. Where we would speak of choice, they speak of will, resolve; where we invoke abstract principles, they invoke concrete human relations, and attitudes towards those relations. Moreover, if the early Confucian writings are to be interpreted consistently, they must be read as insisting on the *altogether* social nature of human life, for the qualities of persons, the kinds of person they are, and the knowledge and attitudes they have are not exhibited in actions, but only in *inter*actions, human interactions. While reflection and solitude are necessary ingredients of our human lives, we are never alone. And our cognitive and affective qualities can never be wholly divorced.

Against this background, let me attempt to sketch briefly the early Confucian view of what it is to be a human being. If I could ask the shade of Confucius "who am I?" his reply, I believe, would run roughly as follows: given that you are Henry Rosemont, Jr., you are obviously

the son of Henry, Sr. and Sally Rosemont. You are thus first, foremost, and most basically a *son*; you stand in a relationship to your parents that began at birth, has had a profound influence on your later development, has had a profound effect on their later lives as well, and it is a relationship that is diminished only in part at their death.

Of course, now I am many other things besides a son. I am husband to my wife, father of our children, grandfather to their children; I am a brother, my friend's friend, my neighbor's neighbor; I am teacher of my students, student of my teachers, and colleague of my colleagues.

Now all of this is obvious, but note how different it is from focusing on me as an autonomous, freely choosing individual self, which for many people is the *raison d' être* of contemporary philosophy, especially rights-based moral philosophy. But for the early Confucians there can be no me in isolation, to be considered abstractly: I am the totality of roles I live in relation to specific others. By using the term "roles" here I do not wish to imply that the early Confucians were the forerunners of the discipline of sociology. They emphasize the interrelatedness of what I am calling "roles", that is to say, they are cognizant of the fact that the relations in which I stand to some people affect directly the relations in which I stand with others, to the extent that it would be misleading to say that I "play" or "perform" these roles; on the contrary, for Confucius I *am* my roles. Taken collectively, they weave, for each of us, a unique pattern of personal identity, such that if some of my roles change, others will of necessity change also, literally making me a different person.

My role as father, for example, is not merely one-to-one with my daughters. In the first place, it has a significant bearing on my role as husband, just as the role of mother bears significantly on my wife's role as wife. Second, I am "Samantha's father" not only to Samantha, but to her friends, her teachers, someday her husband, and her husband's parents as well. And Samantha's role as sister is determined in part by my role as father.

Going beyond the family, if I should become a widower, both my male and my female friends would see me, respond to me, interact with me, somewhat differently than they do now. A bachelor friend of mine, for instance, might invite me as a widower to accompany him on a three-month summer cruise, but would not so invite me so long as I was a husband.

It is in this epistemologically and ethically extended meaning of the term "roles" that the early Confucians would insist that I do not play or perform, but am and become the roles I live in consonance with others, so that when all the roles have been specified, and their interconnections made manifest, then I have been specified fully as a unique person, with few discernible loose threads with which to piece together a free, autonomous, choosing self.

Moreover, seen in this socially contextualized way, it should become clearer that in an important sense I do not achieve my own identity, am not solely responsible for becoming who I am. Of course, a great deal of personal effort is required to become a good person. But nevertheless, much of who and what I am is determined by the others with whom I interact, just as my efforts determine in part who and what they are at the same time. Personhood, identity, in this sense, is basically conferred on us, just as we basically contribute to conferring it on others. Again, the point is obvious, but the Confucian perspective requires us to state it in another tone of voice: my life as a teacher can only be made significant by my students, my life as a husband by my wife, my life as a scholar only by other scholars.

All of the specific human relations of which we are a part, interacting with the dead as well as the living, will be mediated by the rituals of *li,* i.e., the courtesy, customs, and traditions we come to share as our inextricably linked histories unfold, and by fulfilling the obligations defined by these relationships we are, for the early Confucians, following the human Way. It is a comprehensive "Way." Quickly sketched, by the manner in which we interact with others our lives will clearly have an ethical dimension infusing *all,* not just some, of our conduct. By the ways in which this ethical interpersonal conduct is effected, with reciprocity, and governed by civility, respect, affection, custom, ritual, and tradition, our lives will also have an aesthetic dimension for ourselves and for others. And by specifically meeting our defining traditional obligations to our elders and ancestors on the one hand, and to our contemporaries and descendants on the other, the early Confucians offer an uncommon, but nevertheless spiritually authentic form of transcendence, a human capacity to go beyond the specific spatio-temporal circumstances in which we exist, giving our personhood the sense of humanity shared in common, and thereby a sense of strong continuity with what has gone before and what will come

later. There being no question for the early Confucians of the meaning *of* life, we may nevertheless see that their view of what it is to be a human being provided for everyone to find meaning *in* life, and to have the possibility of becoming, to quote Fingarette on Confucius, "a holy vessel."[34]

This is a woefully brief account of one basic element of early Confucianism.[35] But if it at all accurately captures the thrust of the classical texts, I would suggest that those texts reflect a view of what it is to be a person—Chinese or American, young or old, male or female, capitalist or socialist, past or present—that is more realistic and humane than the view of us as purely rational, autonomous, rights-bearing individuals. (As noted above, such individuals will not be able to reclaim the streets of New York. But families, friends, and neighbors might.)

I do not wish to imply that the early Confucian writings are the be-all and end-all for finding answers to the multiplicity of questions I have posed. I do want to suggest that they are a highly salutary beginning, for just as no Ptolemaic astronomer could consider seriously that there were fundamental problems with his view of the heavens until the Copernican view had been articulated, just so we cannot seriously question our concepts of rights, and of what it is to be a human being, until there are alternatives to contemplate. Is it possible to have an ethical and/or political theory that did not employ the concepts of autonomous individuals, or choice, or freedom, or rights, and did not invoke abstract principles? Could there be such a theory, grounded in a view of human nature as *essentially* involving interpersonal relations, a theory that accorded both with our own moral sentiments, and those three billion plus human beings who do not live in the Western capitalist countries? If there were such a theory, could it conceivably be conflict-free?

I do not know the answers to these questions, but do know that if the early Confucian ethical alternative can genuinely alter our perspectives, it will not only have made a contribution to ethics, it will have made an important contribution toward reconstituting the entire discipline of philosophy.

If one is still inclined to think that the Master and his followers are simply too remote from us in time, space, and culture to teach us anything of basic import, a few historical facets of Confucianism

should be borne in mind. First, simply in terms of its longevity, and the sheer numbers of people directly influenced by it—who lived and died in accordance with its vision—Confucianism is arguably the most important philosophy ever put forward; it should not be too quickly dismissed merely on the grounds of its antiquity.

Further, it must be remembered that Confucianism was attacked at its inception by Daoists, Moists, Legalists, and proponents of others of the "Hundred Schools" of classical Chinese thought. Later on it was almost totally eclipsed by Buddhism for several centuries. Later again it was challenged by Christianity, first by the Jesuits and Franciscans of the late sixteenth and seventeenth centuries, and afterward by both Protestant and Catholic missionaries of the nineteenth and twentieth, these latter being buttressed by the gunboat diplomacy attendant on the imperialistic "coming of the West" to China. And of course Western democratic/capitalist, and Marxist thought too, have contributed much to onslaughts on the Confucian philosophical tradition. From all of these past and present challenges Confucianism has recovered (and it is recovering once again in the land of its birth); it has been strengthened, it has endured.

Moreover, in responding to these challenges Confucianism has never had recourse to supernatural support. It is entirely a secular philosophy, grounded in this life, making no appeal to divinity or divinities; one need not surrender contemporary common sense nor need to be skeptical of the physical description of the world put forward by natural scientists in order to understand and appreciate Confucian thought. Yet this secularism notwithstanding, Confucianism addresses simultaneously issues taken in the West to be religious, and it offers in its secularity a means whereby what may correctly be called the "sacred" can be approached, as Herbert Fingarette has so pervasively argued in his *Confucius—The Secular as Sacred.*

And finally, Confucian ethical and social thought can be relevant today because it directly addresses the issue of how a society best distributes the basic necessities of life when these are in short supply, and how human lives can be dignified, and significant, in such circumstances. Western philosophers from the time of Plato have simply presupposed at least a minimal amount of overall affluence when constructing their ideal societies, from the *Republic* to the present. The

great majority of the world's peoples, however, do not live in affluent societies, and consequently Confucianism may have more to say to them than do most Western moral and social theories.[36]

For all these reasons, we should not think that the Confucian tradition must be irrelevant to contemporary issues of ethical concern, nor that it has been, or ought to be put to rest. Rather should we consider seriously the possibility that there might be much in that tradition which speaks not only to East Asians, but perhaps to everyone; not only in the past, but perhaps for all time.

While I do believe there is a concept-cluster within which similar ethical judgements might be made inter- and intraculturally, I do not believe that concept-cluster is now ready to hand in precisely the language I am now using. Some Western philosophical concepts will, and should, remain with us; some others will have to be stretched, bent, and/or extended significantly in order to represent more accurately non-Western concepts and concept-clusters; and still other Western philosophical concepts may have to be abandoned altogether in favor of others not yet extant, but which will issue from future research as new (and old) concept clusters are advanced and examined. If we are reluctant to participate in the requiem mass currently being offered for philosophy, if we wish instead to seek new perspectives that might enable the discipline to become as truly all-encompassing in the future as it has mistakenly been assumed to have been in the past, we must begin to develop a more international philosophical language which incorporates the insights of all of the world-wide historical tradition of thinkers who addressed the questions of who and what we are, and why and how we should lead our all-too-human lives; a tradition enriched considerably by the work of Herbert Fingarette.

# NOTES

* Portions of the present essay were taken from my "Why Take Rights Seriously? A Confucian Critique" in *Human Rights and the World's Religions*, ed. L. Rouner (Notre Dame, IN: University of Notre Dame Press, 1988).

1. See his *The Self in Transformation* (New York: Basic Books, 1963); *On Responsibility* (New York: Basic Books, 1967); *The Meaning of Criminal Insanity* (Berkeley: University of California Press, 1972); *Confucius—The Secular as Sacred* (New York: Harper and Row, 1972); *Heavy Drinking* (Berkeley: University of California Press, 1989).

2. See my review of his *Confucius—The Secular as Sacred* in *Philosophy East and West* 26, no. 4 (October, 1976), his Response and my Reply in *Philosophy East and West* 28, no. 4 (October, 1978). He closes his response with the words, "I hoped Confucius might show others the vision, as he did me." I, too, have seen this vision, owing in significant measure to Fingarette's writings, and to several pleasurable conversations with him, all of which I am grateful for, and happy to acknowledge herein. "I have been encouraged where he agrees, and I have profited from exploring our differences"—as he was gracious enough to say about my work in his Response.

3. F. H. Bradley, *Ethical Studies,* 2nd ed. (New York: Oxford University Press, 1962), p. 166. I am indebted to David Wong for calling this passage to my attention.

4. Although he endeavors to rebut it in the course of his book, this argument has been well stated by A. J. M. Milne in his *Human Rights and Human Diversity* (Albany, NY: SUNY Press, 1985), pp. 3–6. Milne wishes to ground the concept of rights in the larger concept of a community, and thus a person's "rights (what he is entitled to as a member) consist of all that is due to him;" (p. 115).

5. As cited in ibid., p. 2.

6. "Relativism" is of course a loaded philosophical term today. For fuller discussion, see my "Against Relativism," in *Interpreting Across Boundaries*: ed. Gerald Larson and Eliot Deutsch (Princeton, NJ: Princeton University Press, 1988).

7. The discussions which have contributed to the second-order account of abortion touched on here and below are Judith Thomson, "A Defense of Abortion," in *Philosophy and Public Affairs* 1 (1972); Mary Anne Warren, "On the Moral and Legal Status of Abortion" in the *Monist* 57 (1973); L. W. Summer, *Abortion and Moral Theory* (Princeton, NJ: Princeton University Press, 1981), and David B. Wong, *Moral Relativity* (Berkeley: University of California Press, 1984). With the possible exception of Wong, however, it is doubtful that any of the other authors cited here would concur with what has been said in the text on this divisive issue.

8. See, for example, James Rachels, "Active and Passive Euthanasia," in the *New England Journal of Medicine* 292, no. 2, (1975).

9. Beginning philosophically with John Passmore's *Man's Responsibility for Nature* (New York: Charles Scribner's, Sons, 1973); and now a major and diverse field of study.

10. A now somewhat dated, but still useful anthology is *Animal Rights and Human Obligations,* ed. Tom Regan and Peter Singer (Englewood Cliffs, NJ: Prentice-Hall, 1976); and there is much more recently written by both editors, and many others.

11. See A. MacIntyre, *After Virtue* (Notre Dame, IN: University of Notre Dame Press, 1981), esp. pp. 229–33.

12. The major thrust of *After Virtue,* op. cit. See also *Whose Justice? Which Rationality?* (Notre Dame, IN: University of Notre Dame Press, 1988). Although I am not convinced of the superiority of the Greek and Christian traditions over the Chinese, my debt to MacIntyre is great, evidenced herein and in other of my recent writings.

13. Robert Nozick, *Anarchy, State and Utopia* (New York: Basic Books, 1974).

14. John Rawls, *A Theory of Justice* (Cambridge, MA: Harvard University Press, 1971).

15. R. M. Hare, *Moral Thinking* (Oxford: Oxford University Press, 1981).

16. Ronald Dworkin, *Taking Rights Seriously* (Cambridge, MA: Harvard University Press, 1977). Because the concept of rights is intimately bound up with the legal systems of the English-speaking countries, and Dworkin is engaged significantly in the philosophy of law, he surely has a "right" to urge us to "take rights seriously."

17. Patricia Werhane, *Persons, Rights, and Corporations* (Englewood Cliffs, NJ: Prentice-Hall, 1985).

18. H. L. A. Hart, "Are There Any Natural Rights?" *Philosophical Review* 64 (1955).

19. Henry Shue, *Basic Rights* (Princeton, NJ: Princeton University Press, 1980).

20. See Milne, op. cit., p. 139.

21. Dworkin, op. cit., pp. 180–83.

22. These arguments begin with Westermarck, and later Herskovits, in Europe, and with Boas and his students—especially Kroebler and Benedict— in the U. S. For summary, see G. Stocking, Jr., *Race, Culture, and Evolution: Essays in the History of Anthropology* (New York: Free Press, 1968), and E. Hatch, *Culture and Morality* (New York: Columbia University Press, 1983). For both anthropologists and philosophers, a number of articles discussing moral relativism are contained in *Rationality,* ed. Bryan Wilson (Worcester, MA: Basil Blackwell, 1970); *Rationality and Relativism,* ed. M. Hollis and S. Lukes (Cambridge, MA: MIT Press, 1982); *Relativism: Cognitive and Moral,* ed. M. Krausz

and J. Meiland (Notre Dame, IN: University of Notre Dame Press, 1982). A recent anthropological statement is Clifford Gcertz's "Anti Anti-Relativism," in *The American Anthropologist* 86, no. 2 (1984). For a recent philosophical statement, see Wong, op. cit.

23. The notion of "concept-cluster" is important for translation matters here, because arguments endeavoring to show that *dao*, or *li*, or *yi*, or some other single Chinese graph, might appropriately be translated as "morals," cannot succeed unless one is also willing to offer Chinese lexical candidates for "subjective," "rights," "choice," and so forth—an altogether question-begging philological effort. See note 33 for further discussion.

24. For further discussion of the relations between concepts and terms, see my "Against Relativism," op. cit., esp. fn. 11.

25. Ibid.

26. This is undoubtedly so because the basic vocabulary of the concept-cluster of contemporary Western moral philosophy is not sufficient for describing and analyzing issues that fall within these areas, and in some cases—e.g., religious ethics—it isn't necessary either.

27. For the history of this development in anthropology, see Stocking, op. cit., and Hatch, op. cit.

28. This argument can also be put as a paradox of exposition and/or advocacy for claims of incommensurable belief systems. In the present case of ethics, it can be stated thus: if two ethical conceptual frameworks (concept-clusters ) are taken to be total, and as sufficiently dissimilar as to be irreconcilable, then we could only make a case for the superiority of one framework over the other by assuming or presupposing the correctness of some at least of the ethical concepts embedded in the framework claimed to be superior. But on the first horn, if these assumptions or presuppositions are accepted by one's audience, it would seem that arguments wouldn't be needed to command conviction. On the other horn, if the relevant assumptions or presuppositions are not accepted by one's audience, it would seem that no arguments could command conviction. Either the assumptions or presuppositions will be accepted by one's audience, or they won't; in either case, it would seem that arguments are not simply irrelevant, but altogether worthless for commanding conviction. It is something akin to those considerations that led Davidson ("On the Very Idea of a Conceptual Scheme") to say "Most of our beliefs must be true." And if what is meant by "alternative conceptual frameworks" are totally and incompatibly different, then the claim is correct, and does imply the conclusion of the paradox. However, Davidson's use of "our" is ambiguous. If it simply refers to mature, English (and related modern Western language) speakers, it is unexceptionable. But if "our" refers to

contemporary Western moral philosophers, his claim is suspect; and it is only the latter, and not the former that the Confucians challenge, dissolving the seeming paradox, as the text goes on to maintain. (*Proceedings and Addresses of the American Philosophical Association,* no. 47, 1974.)

29. The expression "bureaucratic rationality" is from Williams, *Ethics and the Limits of Philosophy* (Cambridge, MA: Harvard University Press, 1985), p. 206.

30. "The Music of Humanity in the Conversations of Confucius," in the *Journal of Chinese Philosophy* 10 (1983).

31. For fuller discussion of these points, see Angus C. Graham, *Reason and Spontaneity* (London: Curzon, 1985), and my critique of the book, "Who Chooses?", in *Chinese Texts and Philosophical Contexts,* ed. Henry Rosemont, Jr. (La Salle, IL: Open Court, 1991).

32. Beginning in its present form with Mancur Olson's *The Logic of Collective Action* (Cambridge, MA: Harvard University Press, 1965). A good statement of the problem(s) is in *The Politics of Private Desires,* by Michael Laver (New York: Penguin, 1981), which contains a bibliography.

33. Some comments on the early Confucian lexicon: Categories of persons—i.e., the *shi* 士, *jun zi* 君子, and *sheng ren* 聖人, especially as they are distinguished from *xiao ren* 小人, I have endeavored to describe briefly, along with the *shan ren* 善人 and *cheng ren* 成人, in "Kierkegaard and Confucius: On Following the Way," in *Philosophy East and West* 36, no. 3 (1986).

*Dao* 道 I think is translated well by "Way," so long as it is understood to also mean "to speak," and consequently "doctrines," as it must be rendered, for example, in Lun Yu 14:30 and 16:5. For *de* 德, I reject, as does Munro, "manna," Waley's "power," and everyone else's "virtue." *De* approximates "dharma" in denoting what we can do and be if we realize (i.e., make real), the full potential of our concrete physical, psychological, and cognitive endowments. This being a rather lengthy gloss for *de,* I would not translate, but transliterate the term.

Similarly for *li* 禮, for which "customs," "mores," "propriety," "etiquette," "rites," "rituals," "rules of proper behavior," and "worship" have been offered as semantic substitutes. If we can agree that appropriately contextualized each of these English terms can translate *li* on occasion, we should conclude that the Chinese graph must have all of these meanings on every occasion of its use, and that selecting only one of them can only lead to the result, to cite the shibbaleth, that "something is lost in translation." *Li* can only be *li.*

*Ren* 仁 is commonly translated as "benevolence," occasionally as "human-heartedness," and less occasionally by the clumsy and sexist "manhood-at-its-best." I would render the term in English as "human kindness," which I believe

captures the spirit of the Chinese original even if less lofty than "benevolence," and it moreover gives greater play to the richness of English by simultaneously making reference to *Homo sapiens*—humankind—and to a characteristic of that species, human kindness.

*Zhi* 知, with or without the sun radical beneath it, is usually translated as "knowledge" or "wisdom." Donald Munro comes closer, I believe, by rendering it "moral knowledge," but this would return us to our own concept-cluster. Consonant with the arguments of Roger Ames I would render *zhi* as "realize." "Realize" has the same strong epistemic connotations as "know" or "knowledge." Just as a person cannot know that today is Thursday if it is indeed Friday, so a person cannot realize that today is Thursday if it is not. Furthermore, by translating *zhi* as "realize," a link is forged between the early Confucians and their post-T'ang successors with respect to the doctrine described as the "unity of knowledge and action." If to personalize is to make personal, and to finalize is to make final, then "realize" must mean "to make real," again, an expression which exploits the richness of English without recourse to the vocabulary of rights-based moral theories.

*Xin* 信 has been described by Ezra Pound, following his teacher Ernest Fenollosa, as a picture of a person standing by his word. No small number of people have excoriated Pound for his philological Chinese flights of fancy, but every sinologist must analyze this particular graph in the same way: the character for "man," 亻 or "person" stands to the left of the character for "speech," or "words" 言. When it is now appreciated that the written language in which the early Confucians wrote had a very high percentage of terms which were pictographic or ideographic in nature, we might be willing to allow Pound and Fenollosa their translation of *xin* as "trustworthy," "sincere," or "reliable."

Next is *yi* 義, the graph D. C. Lau will render—counter-intuitively—as "right" here, "duty" there, and as "moral" or "morality" more generally. Now if one is committed to following Lau in his description of the early Confucians as moral philosophers, then *yi* is admittedly the best candidate for a Chinese lexical equivalent of "morals" or "morality." However, several variants of the original Shang graphs for *yi* suggest other interpretations. *Yi* is commonly described as an adumbrated picture of a sheep 羊 over a graph referring to the speaker, i.e., a first-person singular pronoun 我, the origins of which are unknown. But this pronoun *wo* is itself, in many of its representations, a picture of a human hand 手 holding a dagger-axe 戈. If it is now remembered that sheep were offered (cf. Lun Yu 3:17) as sacrifices at large communal gatherings, we might wish to gloss *yi* as the attitude one has, the stance one takes, when literally preparing the lamb for the ritual slaughter.

This attitude, this stance, must be one of attempted purification, to make oneself sacred, thereby purifying and making sacred the sacrificial victim. If this be so, then clearly *yi* should not be translated as "moral" or "morality;" "reverence" is the closest English analogue, even though it is regularly used to translate *ching* 敬. But the latter connotes fear—*pace* the club-wielding hand of the right side of the graph 攵 —in a way absent in the usage of *yi*, and therefore I would translate *yi*—most frequently found in a noun-form—as "reverence," and *ching*—most frequently encountered verbally—as "to fearfully respect."

*Xiao* 孝 is straightforwardly "filial piety," and the dual strands of Confucius's. "One thread"—*zhong* 忠 and *shu* 恕—are, I think, just as straightforwardly to be rendered as "loyalty" and "reciprocity" respectively. *Zhi* 志 I would translate as "will," or "resolve," and as a modifier, "resolute," instead of the more common "upright," or "uprightness."

There are, of course, other lexical items in the early Confucian concept-cluster, but I only wish to consider one more at this time, the graph *xin* 心. Even though the early forms are clearly pictures of the human heart, the term has often been translated as "mind." There is much justification for this, because a number of passages in the texts can only be rendered intelligible on the basis of the *xin* thinking. Nevertheless I believe it is closer to the mark to render *xin* by the more awkward "heart/mind." With this translation it will seem somewhat less perverse to claim that the concept of choice is absent in the early Confucian texts.

There are other lexical items—*xue, wen, su,* etc.—included in the early Confucian concept-cluster, but the above are at least a beginning. For fuller discussion, and citations of philological sources, see my *Classical Confucianism and Contemporary Ethics,* forthcoming from Open Court, 1992.

34. *Confucius—The Secular as Sacred,* op. cit.

35. A fuller account will be forthcoming in *Classical Confucianism and Contemporary Ethics,* op. cit. Classical Chinese society was certainly patriarchal, and thus to a significant extent misogynous. Arguably, patriarchal privilege extended far beyond what Confucius and his followers would have condoned, but it cannot be denied that the classical texts see women in basically subordinate roles. It is thus all the more paradoxical that what I am attempting to describe as the Confucian interdependent person very nearly approximates what some contemporary researchers describe as a *female* concept of persons. For example, Carol Gilligan has said:

> Consequently, relationships, and particularly issues of dependency, are experienced differently by women and men. For boys and men,

separation and individuation are critically tied to gender identity since separation from the mother is essential for the development of masculinity. For girls and women, issues of femininity or feminine identity do not depend on the achievement of separation from the mother or on the progress of individuation. Since masculinity is defined through separation while femininity is defined through attachment, male gender identity is threatened by intimacy while female gender identity is threatened by separation. The males tend to have difficulty with relationships, while females tend to have problems with individuation. (*In a Different Voice* [Cambridge, MA: Harvard University Press, 1982], p. 8)

Relatedly, in "Feminism and Epistemology: Recent Work on the Connection Between Gender and Knowledge," Virginia Held writes:

. . . [N]on-Western [epistemological] approaches have often been based far more than the Anglo-American views with which we are most familiar on a relational and more holistic view of reality. Such continental and non-Western views have usually been more misogynous than have Anglo-American views, yet they seem epistemologically closer to what is now being suggested as a more characteristically feminine approach. (*Philosophy and Public Affairs* 14, no. 3 [1985], p. 300)

If these feminist arguments can be sustained, the case for a Confucian-like concept-cluster of ethics and the *li*-governed person is even stronger than is suggested in this text.

36. I have argued for the importance of these economic constraints in "State and Society in the *Hsün Tzu*," in *Monumenta Serica*, vol. XXIX, 1970–71.

# Reflections on the Confucian Self: A Response to Fingarette

*Roger T. Ames*

Herbert Fingarette, in his research and published work on Confucius, has done more to stimulate discussion on Confucian philosophy among philosophers than any other contemporary Western scholar. The surge in philosophical studies on Confucius since the appearance of Fingarette's small book, *Confucius—The Secular as Sacred,* reflects the extent to which Fingarette, in lending the authority of his name and reputation to this area of research, has helped to make Confucius a respectable area of philosophical inquiry.

There are undoubtedly several reasons that would shed light on why Fingarette has been drawn to someone as exotic and irrelevant as Confucius would seem to be for most contemporary American philosophers. One of these reasons must certainly be Fingarette's own temperament and sense of what is philosophically important. If we catalogue his career contribution to date, it is an interesting coincidence that as a philosopher, Fingarette worries over the same basic themes and problems that frame Confucius's reflections: self and transformation, self-deception, moral responsibility, social and political institutions for effecting communal order, guilt, shame, and suffering.[1] And often, it is where Confucius diverges from what Fingarette takes to be our cultural presuppositions that Fingarette's insights become controversial, and are most rewarding.

In this essay, I want to do what most of us in Confucian studies seem to do—I want to begin from a careful reading of Fingarette on the Confucian conception of self, and to take issue with certain elements in his interpretation.

Fingarette, in his attempt to define the Confucian conception of self, isolates and explores that cluster of concepts which are familiar to us in translating our concept of self:[2]

> I will lay the foundation for my own theses by examining in some detail four terms that are used with frequency in the *Analects* that seem explicitly to refer to self and to willing: *chi, shen, yü,* and *chih.*

Because Confucius does not use these specific terms as the basis for a doctrine of self-cultivation, Fingarette concludes that Confucius did not regard self-cultivation as a central concern:[3]

> It is the *commentator,* rather than Confucius, who is tempted to generalize these teachings by focusing on the "self" as an overarching or basic rubric, and summing it all up in terms of "self-cultivation."
> . . . Would Confucius himself have generalized on his own teachings, or summarized them, by taking the consummately cultivated self as his focal concept? The fact is, of course, that he did not. Why not?
> . . . My answer is that he did not say it because he did not mean it.

Although I have reasons for taking issue with aspects of Fingarette's analysis—particularly several of his conclusions—I begin by reviewing this interpretation carefully because there are many insights which can be disengaged from his conclusions that have importance for any interpretation of the Confucian self, and certainly for mine.

One of Fingarette's insights is revealed when he puzzles over the seeming absence of an "inner psychic life" in the Confucian model of self:[4]

> . . . Confucius' usage reveals no explicit doctrines of a metaphysical or psychological kind about the details of structure of will, or the processes internal to the individuals' control of the will. There is, for example, no reification of a Faculty of Will, . . . no theatre in which an inner drama takes place, no inner community with ruler and ruled. This absence of an elaborated doctrine of an "inner psychic life" is consistent with theses that I have argued elsewhere.

Fingarette's explanation is that it is because the exemplary person (*chün tzu*) in Confucius does not express his own egoistic will, but wills the non-contingent, non-personal *tao.* In Fingarette's own words:[5]

> If one seeks to understand deeply the content of an egoistic will, one must necessarily understand that particular person, the motives, anxieties, hopes, and other personal data that go to make intelligible

the conduct of that person. But the more deeply one explores the *chün tzu*'s will, the more the personal dimensions are revealed as purely formal—the individual is the unique space-time bodily locus of that will; it is *that which* controls, but it is nonsignificant regarding why, specifically, or in what specific direction, the control shall be exercised. To understand the content of the *chün tzu*'s will is to understand the *tao,* not the *chün tzu* as a particular person. The ego is present in the egoist's will. The *tao* is present in the *chün tzu*'s will.

Fingarette's conclusion, then, is that the "self" of the exemplary person, insofar as we may call it a "self," is an empty room, a transparent medium through which the *tao* is expressed:—"Not my will, but Thine be done."[6] In these terms, argues Fingarette, Confucianism is consistent with the pan-Asian ideal of selflessness.[7]

Much can be made of Fingarette's analysis if, instead of assuming that the Confucian "self" is to be defined by our cluster of terminologies, one insists on giving more weight to the correlative notion of self peculiar to this tradition. That is, Fingarette might be begging the question of his analysis by assuming that if Confucius has a notion of self importantly different from our own, it is still to be found in the same set of terms which we would appeal to in explanation of what we mean by self. In looking to our glossary of terms for self, Fingarette might be underestimating the magnitude of the problem in the translation of Chinese culture into our own tradition.

In the Confucian context, order, whether it is personal, social, or political, must begin from oneself as the most immediate and concrete locus of action. This being the case, "authoritative person" (*jen*) as a unique, person-specific goal can also be taken as a term denoting "self." In fact, given that *jen* is always a unique and particular achievement, it can only refer to a self. It is not a generic term. "Self" as Confucius defines it is irreducibly interpersonal. It is not the case that *jen* refers to "other" in counterdistinction to "self." The answer to Fingarette's problem—why do we not find an "inner psychic life" in Confucius and the psychology that would attend it?—is that in the absence of a notion of discrete and isolated "self," "self" is alternatively articulated in a robust sociological language.

This same point— that one's "self" and one's person are inseparable in the Confucian model—can be made by reference to an occasion

cited in the *Hsün Tzu* in which Confucius grades several responses to the question: what is the *jen* person like?[8]

> Tzu-lu came in and Confucius asked him, " . . . What is the authoritative person (*jen che*) like?" He replied, " . . . The authoritative person is one who causes others to love him (*shih jen ai chi*)." Confucius remarked, "Such can be called a refined person (*shih*)."
>
> Tzu-kung came in and Confucius asked him the same question. He replied, " . . . An authoritative person is one who loves others (*ai jen*)." Confucius remarked, "Such can be called a consummately refined person (*shih chün*)."
>
> Yen Yüan came in and again Confucius asked him the same question. He replied, " . . . An authoritative person is one who loves himself (*tzu ai*)." Confucius remarked, "Such can be called the truly enlightened person (*ming chün*)."

The lowest level entails conducting oneself in such a manner as to occasion other people taking one's concerns as their own. While this is praiseworthy conduct, there is a selfishness here. The next level is for one to take the concerns of others as one's own. This is perhaps higher, but is self-effacing: one's own legitimate concerns are not properly served. The highest level, then, is necessarily reflexive, incorporating in one's own person appropriately the entire field of self-other concerns. In none of these descriptions of one's person can self be separated out from others: one is, to use Wayne Booth's language, invariably "a field of selves."[9]

The description of self elaborated by Booth's precursor, George Herbert Mead, is helpful here. In describing the integrity of "self," Mead claims:[10]

> The "I" is the response of the organism to the attitudes of the others; the "me" is the organized set of attitudes of others which one himself assumes. The attitudes of the others constitute the organized "me," and then one reacts toward that as an "I." . . . The "I," then, in this relation of the "I" and the "me," is something that is, so to speak, responding to a social situation which is within the experience of the individual. It is the answer which the individual makes to the attitude which others take toward him when he assumes an attitude toward them. Now, the attitudes he is taking toward them are present in his

own experience, but his response to them will contain a novel element. The "I" gives the sense of freedom, of initiative.

To isolate *chi* from "other" (*jen*) in the definition of the Confucian "self" would be tantamount to insisting that what George Herbert Mead *really* means by "self" is the isolated "I" when he would claim that any adequate conception of self would require both the "I" and the "me" as interdependent explanatory categories.[11]

Mead is a social scientist, and insofar as he is concerned to define analytically the parameters of the phenomenon of self, he differs from Confucius who is ultimately concerned with the qualitative transformation of self. The conception of self in Confucius is dynamic as a complex of social roles. It is the quality of these roles that focuses one's identity, and which is constitutive of oneself as a self. Not just role playing, but *good* role playing, creates a self. The "we" is embedded in and reinforced by the relations that define self. Given that "other" is thus a necessary condition for "self," the notion of autonomous individual does not arise. Ironically, in this tradition, the more individualistic and narcissistic one is, the less one is a "self."[12]

Another way of making this case for the correlative self is to look at *chi*. If *jen* is "self, " what then of *chi*, which we conventionally render "self" in a seemingly standard self/other (*chi/jen*\*) distinction? For example, in the *Analects* we read:[13]

> To discipline oneself (*chi*) through ritual practice is to become authoritative as a person. If for the space of one day one were able to accomplish this, the world would turn to one as an authoritative person. However, becoming an authoritative person emerges out of oneself (*chi*); how could it emerge out of others (*jen*\*)?

We must remember that Confucian distinctions are mutually entailing and interdependent correlatives, and are not dualistic in the sense of representing some underlying ontological disparity. A *yin* is always "becoming *yang*" and *yang* is always "becoming *yin*," just as "day" is a "becoming night" and "night" is a "becoming day." For the *chi/jen*\* distinction, a "self" is always a "becoming other," and an "other" is always a "becoming self."

The function, then, of disciplining *chi* through ritual practice is to take up the appropriate place (*wei*) for oneself in relationship to

other persons in community. Importantly, this is *not* to say that *chi* defines a relation between "self" and "other." The language of relation easily suggests the ground between things, with the implication that the things themselves are remaindered. The Confucian language, on the other hand, denotes the concrete pattern of self-other, with no remainder.[14]

It is at this juncture that I would express a second fundamental reservation about Fingarette's analysis. I believe that he falls prey to an equivocation between autonomous individual and unique individual.

It can be argued that any conception of "self" necessarily entails some notion of individuality. But there is an unnoticed conceptual equivocation on the term "individual" which plagues this whole discussion. Individual can mean either one-of-a-*kind*, like a human being, or *one*-of-a-kind, like John Turner's "Seastorm." That is, "individual" can refer to a single, separate, and indivisible thing that, by virtue of some essential property or properties, qualifies as a member of a class. By virtue of its membership in a "kind," it is substitutable—"equal before the law," "entitled to equal opportunity," "one of God's children," and so on. The metaphor of the atom is frequently invoked to illustrate this notion of individuality. By virtue of its separability and indivisibility, it relates to its world only extrinsically, and hence, where animate, has dominion over its own interiority. It is this definition of individual that generates notions like autonomy, independence, equality, privacy, freedom, will, and so on.

Individual can alternatively mean uniqueness: the character of a single and unsubstitutable particular, such as a work of art, where it might be quantitatively comparable to other particulars, but where it has literally nothing qualitatively in common with them. In the human community, such a notion of individual is defined contextually, in terms of one's contribution to the character of one's social environment. This notion of unique individual is describable in a relational vocabulary that is clearly aesthetic: enrichment, harmony, edification, poignancy, intensity, efficacy, and so on. Under this definition of individual, a term such as equality, for example, could only mean parity, and freedom would mean creative efficacy.

In the model of the unique individual, determinacy, far from being individuation, lies in the achieved quality of one's relationships. A

person becomes "recognized," "distinguished," or "renowned" by virtue of one's relations and their quality. Much of the effort in coming to an understanding of the traditional Confucian conception of self has to do with clarifying this distinction between the autonomous and the unique individual, and re-instating this notion of unique individual in the Confucian picture. It is the centrality of unique individuality that explains how classical Confucianism can discourage "selfishness" within its project of self-realization. To eschew "selfishness" does not necessarily entail a doctrine of "selflessness." While the definition of self as "irreducibly social" certainly precludes autonomous individuality, it is entirely consistent with the less familiar notion of unique individuality.

Mark Elvin, in pursuing an understanding of the Chinese conception of self, is sensitive to the importance of unique place in the traditional Chinese world:[15]

> The Chinese believed, by and large, in a unique personal existence, no doubt fortified by the concept of a structure of kinship ascendants and descendants, stretching indefinitely forward into the future, in which the individual occupied his unique place.

This Chinese conception of unique individuality stands in contrast to the autonomous individuality which attends "the isolation of the European soul" from other souls, and ontologically, from the illusory world of sensual perception. The uniqueness of the person is immanent within a ceaseless process of changing relationships.

Another condition that militates against understanding the Confucian self as autonomous is, as Fingarette has observed, the absence of any individual faculty of "will" distinct from the act of "willing." This would suggest that, for Confucius at least, no distinction is drawn between a superordinate and individuating faculty of intentionality, and what is intended. Under this assumption, both intentionality and specific intentions are, like one's self, social facts. What one's correlative self "wills" and *how* it "wills" are mutually determining. This is not to suggest that Confucius would deny the biological basis of human experience, but only to claim that, in Confucian terms, the structure of human action is patterned by contingency. It is an ongoing process specific to social, cultural, as well as natural conditions.

This claim explains why Confucian ethics is not one of choices made by autonomous subjects—another important insight of Fingarette's. The effect of "will" being fundamentally social is that decisions tend to be dispositional rather than clearly discernable choices. It should further be noted that, given our distinction between autonomous individual and unique individual, while the intentions of the correlative and social self are not autonomous, they are, nonetheless, unique.

But we must take one more step back. It is a real question whether *chih*, the term that is being translated here with the very modern Western concept of "will," can be so rendered without challenge. Etymologically, *chih* combines "heart-and-mind" with "to go to" (*chih\**) or "to abide in" (*chih\*\**), and means "to have in mind" or "to set one's heart on"—one's sense of purpose. In the classical *Shuo-wen* lexicon, it is glossed as "meaning" (*yi*). It is much closer to the notion of "spirit" or "disposition" than the very contemporary concept of "will."[16]

What has been said here in respect to will holds true for the other essential categories or faculties that have been posited as the "hard-wiring" of the human being—a defining "deep structure" such as a given nature or soul or reason. Jacques Gernet makes the distinction between the traditional Chinese notion of self and the Western concept in precisely these terms:[17]

> Not only was the substantial opposition between the soul and the body something quite unknown to the Chinese, all souls being, in their view, destined to be dissipated sooner or later, but so was the distinction, originally inseparable from it, between the sensible and the rational. The Chinese had never believed in the existence of a sovereign and independent faculty of reason. The concept of a soul endowed with reason and capable of acting freely for good or for evil, which is so fundamental to Christianity, was alien to them.

If self is defined in terms of the consciousness of an autonomous will or reason, "self" refers to one's individual consciousness in relation to itself. "Self" in other words, is self-consciousness. Self-consciousness requires that one is able to objectify one's thoughts, feelings, and so on. Such a notion of self-consciousness is a modern invention in the West.

In the Confucian model where "self" is contextual, it is a shared consciousness of one's roles and relationships. One's "inner" and

"outer" (*nei/wai*) are inseparable. Here, one is "self-conscious," not in the sense of being able to isolate and objectify one's essential self, but in the sense of being aware of oneself as a locus of observation by others. The locus of self-consciousness is not in the "I" detached from the "me"—but in the consciousness of the "me." It is face, a sense of shame, an image of self that is determined by the esteem with which one is regarded in community.

Self-deception, at least in the Sartrean sense, requires that one can construe self merely as an object, and in so doing, deny one's own freedom and hence one's responsibility for what one is. One deceives oneself by being other than oneself. It is a failure of integrity, because one is made two. There is a disjunction between self and self-consciousness, and a failure to conform with one's ontic self.

In the *Analects,* there are passages that might be construed as referring to this kind of self-deception. For example,[18]

> To know that you know something when you do, and to know that you do not when you do not—this then is knowing.

Now this passage can have two meanings:

1. to pretend to others that you know while knowing that you do not know, and

2. to deceive yourself in thinking you know something that you do not.

It is the former that is of real concern to Confucius. He not only condemns dissemblance in others, but is clear as to what he himself knows and does not know.[19]

That there is little concern for individual-based self-deception in the *Analects,* and the Confucian corpus generally, corroborates Fingarette's observation that there is a decided absence of an "inner psychic self." It is also a signal of the correlative notion of unique individuality that dominates these texts. Self-deception in this tradition is a communal rather than an individual affair. It is dissemblance. And dissemblance—someone pretending to be what he or she is not for the sake of others, someone occupying the wrong place and performing rituals inappropriate to one's status—is a major theme in classical Confucianism.[20] Where self is contextually defined, self-deception involves a counterfeiting of interpersonal transactions, thereby corrupting and demeaning the character of the community.

In these reflections on the Confucian conception of self, it is clear that one does not have to agree entirely with Fingarette's conclusions to benefit from the sensitivity of his observations and the quality of his insights. Fingarette's understanding and explication of the fundamental differences that distinguish a Confucian self from those models familiar to us in our own culture is a warning to be aware of our own philosophical parochialism, and an encouragement to give the classical Confucian position its difference.

# NOTES

1. This includes even Fingarette's most recent work on alcoholism. In his expressed attitude to spirits, Confucius encourages moderation (*Analects* 10/8):

Only in drinking his wine did Confucius have no set limit, although he never drank to the point of becoming confused with it.

2. Herbert Fingarette, "The Problem of the Self in the *Analects*" in *Philosophy East and West* 29, no. 2 (April, 1979): 131.

3. Ibid., p. 130.

4. Ibid., p. 133.

5. Ibid., p. 135.

6. Ibid., p. 136.

7. In fairness to Fingarette, he does qualify his position, using the distance between a musical score and a personal performance of it as an analogy for the distance between the *tao* concept and the particular manifestation of it. See ibid., p. 137.

8. *Hsün Tzu* in the Harvard-Yenching Institute Sinological Index Series, Supplement 22 (Peking: Harvard-Yenching Institute, 1950): 105/29/29.

9. See Wayne C. Booth, *Modern Dogma and the Rhetoric of Assent* (Notre Dame: Notre Dame University Press, 1974): 114, 132, 134. The appropriateness of Booth's language to capture the Confucian model was first suggested by Tu Wei-ming in "*Jen* as a Living Metaphor in the Confucian *Analects*," *Philosophy East and West* 31, no. 1 (January, 1981): 45–54.

10. George Herbert Mead, *Mind, Self and Society*, ed. Charles Morris (Chicago: University of Chicago Press, 1934): 175, 177.

11. Ambrose King recognizes this interdependence as the defining characteristic of the Confucian self. In his own language:

What should be stressed here is that in the relational context, the individual relations with others are neither independent nor dependent, but interdependent. . . . In a word, the self is an active entity capable of defining the roles for himself and others and, moreover, of defining the boundaries of groups of which the self is at the center.

See Ambrose Y. C. King, "The Individual and Group in Confucianism: A Relational Perspective" in *Individualism and Holism: Studies in Confucian and Taoist Values,* ed. Donald Munro (Ann Arbor: Center for Chinese Studies, University of Michigan, 1985): 63.

12. As reinforcement for the fundamental nondiscreteness of self, A. C. Graham has pointed out that in the classical language, there is no distinction between the first person singular, "I," and the first person plural, "we." This would suggest that an "I" is always a "we." Equally significant, if we remember Mead, is the absence at this period of any explicit distinction between the subjective "I" and the objective "me."

13. *Analects* 12/1.

14. A. C. Graham rightly takes me to task for such infelicitous "relation" language in his response to my paper, "The Mencian Conception of *Renxing*: Does it Mean 'Human Nature'?" He observes: "As for 'relationships', relation is no doubt an indispensable concept in *exposition* of Chinese thought, which generally impresses a Westerner as more concerned with the relations between things than with their qualities; but the concern is with concrete patterns rather than relations abstracted from them, as Ames knows well." See "Reflections and Replies" by A. C. Graham in *Chinese Texts and Philosophical Contexts: Essays Dedicated to Angus C. Graham,* ed. Henry Rosemont, Jr. (La Salle, IL: Open Court, 1991).

15. Mark Elvin, "Between the Earth and Heaven: Conceptions of the Self in China" in *The Category of the Person,* ed. M. Carrithers, S. Collins, and S. Lukes (Cambridge: Cambridge University Press, 1985): 170.

16. Indeed, the concept of "will" is a late arrival in the West. Until the period of Augustine's and Cicero's discussions of *voluntas,* one can find little evidence that such a concept as "will" is viably present. See Alasdair MacIntyre's *Whose Justice? Which Rationality?* (Notre Dame: Notre Dame University Press, 1988).

17. Jacques Gernet, *China and the Christian Impact: A Conflict of Cultures* (Cambridge: Cambridge University Press, 1985) [first published as *Chine et christianisme* by Editions Gallimard in 1982]: 147.

18. *Analects* 2/17.

19. See *Analects* 3/11, 5/8, 7/28, 9/8 and 13/3.

20. See, for example, *Analects* 3/1, 3/2, 3/6, 3/18, 3/22, 5/25, 9/12, 12/20, 14/31, 17/17, 17/18. D. C. Lau discusses this concern at some considerable length in the introductory essay to his translation of the *Analects*. See *Confucius: The Analects,* trans. D. C. Lau (Hong Kong: Chinese University Press, 1983).

## CHARACTER GLOSSARY

*ai jen* 愛人

*chi* 己

*chi/jen\** 己人

*chih* 志

*chih\** 之

*chih\*\** 止

*chün tzu* 君子

*jen* 仁

*jen\** 人

*jen che* 仁者

*ming chün* 明君

*nei/wai* 內外

*shen* 身

*shih* 士

*shih chün* 士君

*shih jen ai chi* 使人愛己

*Shuo-wen* 說文

*tao* 道

*wei* 位

*yi* 意

*yü* 欲

# Honesty with Oneself

*Mike W. Martin*

What is the meaning of honesty with oneself? This is actually two questions, given the ambiguity of "meaning": (i) What is the concept or idea of honesty with oneself? and (ii) What is the significance or worth of being honest with oneself? Specifically, does honesty with oneself forbid all self-deception? Is it focused solely on truth, or does it imply trustworthiness and moral integrity (as does honesty with other people)? Does it have value as a secondary virtue, perhaps implied by the Greek virtues of wisdom, courage, temperance, and justice, or the Christian trinity of faith, hope, and charity? Or is it a fundamental virtue, even a paramount ideal, as Nietzsche thought?

> *The good four.*—*Honest* with ourselves and whoever *else* is our friend; *courageous* with the enemy; *magnanimous* with the vanquished; *courteous*—always: thus the four cardinal virtues want us . . . . [1]

> Honesty, supposing that this is our virtue from which we cannot get away, we free spirits—well, let us work on it with all our malice and love and not weary of "perfecting" ourselves in *our* virtue, the only one left us.[2]

Section I clarifies honesty with oneself by exploring its links with other forms of honesty. Section II shows its central role in evaluating self-deception. Section III illustrates its contributions to self-knowledge and self-fulfillment. And section IV offers some concluding remarks about its importance as a virtue and a moral ideal.

# I. Truth, Truthfulness, and Trust

Construed as a general characteristic of persons, honesty is an admirable trait that has several interconnected dimensions.[3] (1) *Candor* is the habit of being admirably frank in communicating. (2) *Intellectual honesty* is the tendency to inquire and to reason on the basis of a commitment to truth. (3) *Genuineness* means being authentic and exerting effort in resolving personal problems. (4) *Trustworthiness* is keeping one's commitments and heeding rules against cheating, stealing, and deception. (5) *Self-disclosure* is voluntarily revealing important information about oneself, primarily within relationships based on caring and trust. (6) *Self-honesty* is honesty with oneself. (7) *Truthfulness* is caring about truth and manifesting that care in belief, reasoning, speech, conduct, and relationships. It should be distinguished from knowing particular truths (truth-awareness) and stating truths (truth-telling); we can be truthful while unintentionally believing and uttering a falsehood.

In my view, truthfulness is central in understanding honesty, although truthfulness must be understood in terms of the other dimensions of honesty. Instead of being a separate aspect of honesty, truthfulness draws together the other dimensions, functioning as their unifying thread and central motif. In turn, honesty with oneself can be understood as truthfulness with oneself. Self-honesty consists in having a truthful relationship with oneself, rather than by reference to any specific subject matter about which one must be truthful. At most we can say that self-honesty implies truthfulness about important aspects of oneself and the world—"important" in light of the values relevant to particular situations.

Truthfulness with oneself entails avoiding objectionable instances of self-deception. I will construe self-deception broadly. As an activity, it is the purposeful evasion of unpleasant truths, suspected truths, or topics. Its tactics include a vast array of distorted reasoning, selective ignoring or exaggerating of evidence, refusing to make pertinent inquiries, allowing biases to operate without scrutiny, and engaging in self-pretense. As a mental state produced by these activities, self-deception includes lack of awareness, false beliefs, conflicting beliefs, poorly-grounded convictions, confusion, inappropriate emotions, and unwarranted attitudes and commitments.[4]

Truthfulness with oneself involves tendencies to be forthright with oneself, to reason on the basis of concern for truth, to be genuine, to be worthy of trusting oneself, and to reveal to oneself important truths that contribute to self-understanding. In short, it incorporates analogs or elements of all the other dimensions of honesty, as I will next suggest in more detail.

(1) Candor, with respect to other people, is the disposition to be forthright in communication. Candid people disclose sensitive (disturbing, controversial) information and attitudes directly and freely, unconstrained by timidity or shyness. Not all outspokenness is admirable, of course. When it is tactless, inconsiderate, and cruel we hesitate to speak of honesty—since "honesty" connotes praiseworthiness. Honesty-as-candor is outspokenness that is admirable for some reason, whether because it contributes to getting at the truth or because it contributes to relationships built on trust.

Candor with oneself is, metaphorically, frankness in communicating with oneself. Just as interpersonal candor is the tendency to acknowledge to others sensitive information and attitudes, self-candor is the willingness to acknowledge to oneself sensitive information readily available to one's consciousness. As with interpersonal candor, intrapersonal candor is admirable as a form of honesty only insofar as self-awareness is admirable for some reason. For example, everyday effectiveness in acting appropriately requires awareness of our emotions and attitudes. So too does successful therapy, as Freud stressed with his "basic rule" that patients be willing to put into words whatever comes to mind and convey it to the therapist.[5]

Even with this caveat, however, intrapersonal candor is a limited form of self-honesty.[6] It is restricted, after all, to honesty about things readily accessible to consciousness. Beyond it lies the more arduous task of uncovering self-deceptions about mental states and activities not immediately available to consciousness. Moreover, the basic resource of self-candor is introspection which unfortunately tends to focus on the self in isolation, away from social contexts essential for self-understanding. Honest self-understanding requires comprehension of the world, drawing on resources from common sense, science, art, and the humanities. In short, self-honesty demands more than acknowledging conscious beliefs and attitudes; it implies a willingness

to subject them to critical self-scrutiny. This brings us to the next aspect of honesty.

(2) Intellectual honesty is the disposition to engage in reasoning and inquiry based on a deep commitment to truth. It implies habits of clear thinking, cogent argument, respect for evidence, effort to understand things correctly, disgust for prejudice, and delight in discovery.[7] Perhaps its most prominent sign is "a sustained willingness to consider informed objections" to one's views.[8] With respect to scientific inquiry, for example, it entails "a kind of utter honesty—a kind of leaning over backwards" to avoid fooling oneself; "if you're doing an experiment, you should report everything that you think might make it invalid—not only what you think is right about it."[9] It is also the type of honesty that Wittgenstein meant in relating philosophy to everyday living.

> What is the use of studying philosophy if all that it does for you is to enable you to talk with some plausibility about some abstruse questions of logic, etc., and if it does not improve your thinking about the important questions of everyday life. . . . I know that it's difficult to think *well* about 'certainty,' 'probability,' 'perception,' etc. But it is, if possible, still more difficult to think, or *try* to think, really honestly about your life and other people's lives.[10]

Intellectual honesty does not entail honesty with other people; a person can be honest about truth but not honest with other people. Intellectual honesty, however, is essential to self-honesty. In fact, the two notions are so intimately connected that it is tempting to equate them. Yet they are not the same. Honesty *with* oneself suggests an internal moral relationship (with oneself) that is not reducible to intellectual honesty *about* oneself and other matters. Moreover, intellectual honesty can become distorted into a form of dishonesty with oneself—the dishonesty of emotionally detached and intellectualizing self-spectators (including intellectualizers who are intellectually honest about their state).[11] Honesty in thought and inquiry is one thing; honesty in other areas of life requires in addition genuineness.

(3) Genuineness (or authenticity) means being honest *in* one's emotions, attitudes, and conduct. It entails autonomy, which pertains to the origin and role of mental states, commitments, and activities. I

will say more about autonomy in section III. Here I wish to note that under one heading or another, autonomy has been a central concern of many major thinkers. According to Sartre, most of us engage regularly in bad faith and self-pretense in order to avoid expressing our own, autonomous, attitudes. According to Freud, we constantly repress feelings and ideas that arise spontaneously in us as expressions of basic instincts. According to Marx, most of our responses within a capitalist society constitute self-alienation and a false consciousness that denies genuine needs. And according to Mill, Nietzsche, and Kierkegaard, few of us have the gumption to pursue our individual and better self. All these thinkers build upon and systematize the common-sense insight that we can be profoundly out of touch with who we 'really' are.

There are, to be sure, other senses of "genuine" that have no direct connection with honesty.[12] In speaking of a genuine emotion, for example, we may simply mean that the emotion is present, rather than some other emotion with which it might be confused. Thus, to feel genuine grief is to feel grief (a traumatic sense of personal loss), rather than ersatz depression or self-pity. Other times "genuine" indicates the intensity or the duration of an emotion. Genuine joy is intense, deeply felt, and enduring. And sometimes "genuine" refers to the purity of an emotion, that is, the absence of inconsistent emotions or attitudes.[13] In this sense, confidence riddled by self-doubt is impure. None of these senses of "genuine" implies dishonesty or phoniness.

Self-honesty as genuineness implies exerting effort in dealing with important problems—important in terms of one's commitments and the values one ought to embrace. Authentic individuals have commitments which they identify with, which evoke their care and concern. They assume responsibility for their lives, making an "honest effort" to overcome obstacles, as opposed to passively waiting for someone else to remove their difficulties. Thus, charges of being dishonest with oneself are often targeted at laziness and procrastination (irrational postponement) with respect to an important personal problem.[14] This idea of honest self-exertion is linked to the idea that we should have a relationship of responsible and trustworthy stewardship over our own lives, a metaphor made explicit by the next aspect of self-honesty.

(4) Trustworthy people keep their commitments and adhere to rules against cheating, stealing, and objectionable instances of deceiving. They do so (at least in part) out of respect for people. In fact, these rules specify part of what it means to respect people, while laying a foundation for the trust essential to social practices and institutions.[15] Dishonest individuals, by contrast, are "free riders" on social practices. They violate trust by taking advantage of the general understanding surrounding appropriate conduct, whether by violating fair play in mutual endeavors (cheating), failing to respect property (stealing), or engaging in untruthful communication (deception, promises made in bad faith).

Trustworthy individuals can be counted on not to abuse trust, where trust takes two forms.[16] One form of trust is relying on someone to keep a commitment. Often it is based on a decision to risk depending on someone to pursue a particular line of conduct. A second form of trust is general confidence. This is faith in a person's integrity; as such it is an attitude not entirely subject to choice. Both forms have intrapersonal analogs. An intrapersonal analog of the first form, specific reliance, is illustrated by recovering drug addicts who struggle with self-doubts about whether they can rely on their responses in situations that trigger urges to use drugs. The analog of the second form, general confidence in one's integrity, is a central component of self-respect—respect for one's personal and moral integrity.

Self-trustworthiness, as I will construe it, is warranted general confidence in one's integrity (that is, in one's willingness to live by moral and other values). Thus, self-honesty has a substantial moral content: it implies truthfulness about one's moral commitments. Just as deceiving others undermines their agency, deceiving oneself can erode moral agency; insofar as it does, it is prohibited by the need for trusting one's moral care and concern. Self-trustworthiness also suggests loyalty to one's better self. It forbids self-cheating, self-betrayal, and other violations of Polonius's (Shakespeare's) injunction, "To thine own self be true."

(5) Self-disclosure (to others) is voluntarily communicating revealing information about oneself, especially within relationships based on caring and personal trust. Often this dimension of honesty is guided by the mutual understanding of the nature and degree of intimacy

in a relationship, but it also serves to create new intimacy. Self-disclosure requires something much more positive than merely avoiding deception. It implies conveying information that enables certain other people to understand us. Dishonesty in this context is also a violation of trust, although here the trust is based on personal ties rather than the rules sustaining social practices and institutions.

Degrees of intimacy are defined in part by the extent of self-disclosure. Friendships, for example, are deeper insofar as friends are willing to make self-revelations.[17] The importance of self-disclosure is shown by its multiple roles within relationships based on caring and intimacy: building trust, contributing to mutual understanding, enabling individuals to help one another in light of pertinent information, contributing to self-fulfillment and mental health.[18] In addition to promoting these ends, self-disclosure is itself an inherent aim in intimate relationships.

Self-honesty, construed as the intrapersonal analog of self-disclosure, is truthful revelation of oneself to oneself, based on caring about oneself. It suggests a detailed self-revelation aimed at achieving a creative self-understanding of the sort that promotes well-being and self-fulfillment. In this sense, it is disclosure of the self, to the self, for the sake of the self.

To sum up, honesty or truthfulness with oneself has the following dimensions: (1) self-candor in acknowledging to oneself sensitive information readily available to consciousness, (2) habits of reasoning based on a commitment to truth, (3) genuineness, both authenticity of acts and mental states, and effort in meeting problems, (4) warranted general confidence in one's integrity, and (5) self-disclosure (to oneself) of truths that yield self-understanding.

## II. The Ethics of Self-Deception

Honesty with oneself, I suggest, is the central virtue for understanding the moral status of self-deception.[19] It prohibits self-deceiving evasions of moral responsibility, while allowing that not all self-deception is dishonest. It also allows that the degree of harm caused by dishonesty varies according to the context in which self-deception arises.

"Dishonesty" and "deception" are not synonyms, either in their interpersonal or intrapersonal uses. "Dishonesty" is a pejorative term used to censure immoral instances of deception (and cheating, stealing, promise-breaking). "Deception," by contrast, refers to purposefully misleading someone, which may or may not be dishonest. On occasion, deceiving other people is permissible or even obligatory, and hence not dishonest. It may serve to preserve privacy against malicious intruders, prevent harm to children unprepared for harsh truths, mislead thieves, or save innocent lives. There is a moral presumption against deception, but the presumption is frequently overridden.[20]

Similarly, some self-deception is morally permissible. Temporarily deceiving oneself may be the best way to cope with a crisis, to bolster self-confidence in meeting a difficult challenge, or to maintain faith in a friend. It may be altruistically motivated and have good consequences, as when giving encouragement based on somewhat excessive optimism provides essential support to someone. And it may be trivial and humorous, as with self-deceiving exaggerations of one's discrimination in clothing or music. Hence, W. K. Clifford was grossly exaggerating when he condemned all self-deception: "It is wrong always, everywhere, and for anyone, to believe anything upon insufficient evidence" instead of "honestly earning it in patient investigation."[21]

To call a self-deceiver dishonest is to make a substantive moral criticism, rather than to utter a redundancy. It charges that the individual has been untruthful by evading truth in an objectionable manner. When is this charge appropriate?

No simple answer can do justice to the moral complexity of self-deception. Judgments of dishonesty, of guilt and blameworthiness, must take into account many aspects of the self-deceit: motives and intentions, the target or subject matter, the degree of harm caused, whether the harm was foreseeable, the extent of control over it, availability of help to overcome it, whether it is isolated or pervasive, and so on. Yet, as Joseph Butler pointed out in the eighteenth century, there is one primary consideration: the degree to which self-deception threatens good character.

Butler condemned self-deception as dishonest when it contributes to wrongdoing and character faults. We are accountable for whatever is under our control in meeting our obligations, including exercising good moral judgment obtaining relevant information, and avoiding

self-deception about obligations. We must prevent self-interested biases from operating in gray areas of morality that call for impartial judgment. And we must resist self-serving excuses for our moral failings, while seeking honest reform of our character.

According to Butler, self-deception about immorality is blameworthy for two sorts of reasons. First, it fosters wrongdoing by blurring awareness, and it prevents moral reform by camouflaging character faults. In this respect it is a derivative wrong: wrong because it supports other wrongs. Second, it is intrinsically objectionable because it constitutes "inward dishonesty."[22] It is "essentially in its own nature vicious and immoral. It is unfairness; it is dishonesty; it is falseness of heart: and is therefore so far from extenuating guilt, that it is itself the greatest of all guilt in proportion to the degree it prevails."[23] This harsh pronouncement should not be mistaken for Clifford's condemnation of all self-deception. Butler is condemning only that self-deception which involves evasion of moral responsibility. He condemns it, again, because (1) it fosters wrongdoing and prevents moral reform, and (2) it constitutes dishonesty.

In what way(s) is self-deception dishonest? Butler makes several suggestions, all centered around the idea of untruthfulness about morality. By putting our conscience to sleep, it enables us to sin without offering deserved guilt or shame. It also leads us to judge ourselves differently than how we judge others, and to do so from selfishness or "self-partiality." These failures of impartiality are a kind of moral cheating or "unfairness of mind." In addition, self-deceit about immorality is "internal hypocrisy": self-pretense used to maintain an unjustifiably high estimate of our character. And finally, it is "falseness" in that it betrays our own moral commitments.

Perhaps it seems obvious that self-honesty should enter prominently into the moral assessment of self-deception. Yet the notion has not entered prominently into recent discussions of the ethics of self-deception.[24] It is absent, for example, in the writings of most psychologists who have downplayed the moral import of self-deception. For example, a recent collection of essays by prominent psychologists has a one-sided theme: "Self-deception is a normal and generally positive force in human behavior."[25] This theme echoes earlier writers who champion the benefits of self-deception as a source of

"vital lies" promoting peace of mind, self-esteem, happiness, and even kindness.[26]

Jean-Paul Sartre, by contrast, harshly criticized self-deceivers. Yet he charged them with inauthenticity, in a technical sense, rather than dishonesty. The difference is important. "Authenticity," according to Sartre, "consists in having a true and lucid consciousness of the situation, in assuming the responsibilities and risks that it involves, in accepting it in pride or humiliation, sometimes in horror and hate."[27] By "responsibilities" Sartre meant the burden of giving meaning to one's life; he did not mean moral obligations. Inauthenticity is not the dishonest evasion of objectively-binding obligations, since for Sartre there are none. Sartre was a moral skeptic who recognized no moral value as warranted by objective reasons: "nothing, absolutely nothing, justifies me in adopting this or that particular value, this or that particular scale of values."[28]

Sartre's moral skepticism was accompanied by philosophical intolerance. He stipulated that authentic individuals affirm alleged truths about radical human freedom and the subjectivity of values. Acknowledging the value of honesty, by contrast, allows recognition of honest differences in moral outlook and metaphysical belief. Without placing all moral standards in doubt, we can view other people as truthful, with respect to both themselves and us, even though they do not precisely share our view.

The concept of honesty is also lacking in the work of philosophers who, unlike Sartre, recognize an objective basis for moral values. Ronald D. Milo, for example, regards self-deception about wrongdoing as blameworthy negligence, but he does not emphasize dishonesty.[29] Nor does Marcia Baron when she portrays self-deception as immoral when it causes wrongdoing or erodes the capacity for rational belief and conduct.[30] And Lloyd H. Steffen explicitly denies that self-deceivers are mendacious.[31]

Most noteworthy, honesty is not emphasized in Herbert Fingarette's *Self-Deception*—by far the most illuminating treatise on the topic.[32] Fingarette focuses on self-identity: our own sense of who we are. He shows how self-deception protects self-identity while camouflaging engagements that are incompatible with it. An engagement is any aspect of how we respond to the world, such as an activity, desire, emotion, or belief. Self-deception arises when we strongly desire an engagement

that violates the guiding principles (values) at the core of our identity. Rather than forego the engagement, and rather than acknowledge it and thereby suffer conflict and anxiety, we pursue the engagement while disavowing it. To use Fingarette's metaphor, the threatening engagement is cast out of the community of avowed engagements that comprises our self-identity; while not destroyed, it assumes an alien existence.

Disavowing an engagement is refusing to treat it as our own. We systematically ignore it ("refuse to spell it out"), shun responsibility for it, and pursue it in a rigid (often neurotic) manner in isolation from other engagements. We also ignore these aspects of disavowal. The result is a loss of full control over the engagement, thereby rendering self-deception morally ambiguous. As self-deceivers we are neither clearly responsible nor clearly not responsible for our disavowed engagements, for any harm involved, and for the activity of disavowal itself. It follows that ordinary moral concepts like "honesty" do not apply, at least not straightforwardly.

This cursory summary, which barely hints at the richness of Fingarette's book, is insufficient as a basis for raising criticisms. Elsewhere I have argued that Fingarette's appraisal of self-deceivers works well for severe cases of neurosis in which individuals lack substantial self-control, but it runs into difficulty with more garden-variety forms of self-deceit of the sort Butler had in mind. Here I wish to suggest that Fingarette's theme of self-identity leads naturally to issues concerning honesty with oneself.

Self-identity is not the mere sum of avowed engagements, not even as structured and interrelated. Our sense of who we are—our self-image or self-conception—is formed by selecting and highlighting some avowed engagements as most revealing of who we are, and downplaying others as insignificant. Typically we select and evaluate these engagements (activities, relationships, accomplishments) with an eye to maintaining self-esteem—a sense of our worth. Self-deception enters easily and regularly into these selections and evaluations. Thus, alcoholics may avow their tendency to abuse alcohol while refusing to evaluate the tendency as an important ingredient in assessing themselves.[33] Self-deception can also enter into our guiding principles (or values) themselves, rendering the core of our identity dishonest.

How are we to understand dishonesty in these values and evalua-
tions which comprise the core of self-identity? And what does it mean
to form a truthful self-conception, based on an honest selection and
assessment of avowed engagements? I will not attempt a full answer,
beyond suggesting the following criteria for honest values and self-identity.

(1) The values are not formed or held in self-deception of a kind
that is morally objectionable. Relevant objective truths about morality
and the world, as well as about our engagements, need to be taken into
account. Thus, the bigot's identity and guiding principles are dishonest
insofar as they are based on preventable bias, prejudice, and self-deceiv-
ing *ressentiment* (unconscious hatred and anger irrationally aimed at
degrading members of a group).[34] (2) The values are autonomous ones
to which we are committed and with which we identify in a personal
way. (3) The values are applied to ourselves fairly, in a manner com-
parable to how we apply them to others. (4) In applying values to assess
ourselves, relevant facts are not ignored or discounted. (5) Finally, a
pragmatic criterion: Our self-conception and values contribute to, rather
than detract from, self-fulfillment. This brings us to our next topic: the
connection between self-honesty and self-fulfillment.

## III.   Self-Knowledge and Self-Fulfillment

Virtues tend to benefit individuals who have them, in addition to benefit-
ting other people.[35] This is true, for example, of courage, self-control,
patience, and wisdom. It is also true of honesty with oneself. Self-honesty
contributes to self-fulfillment by helping us to avoid and overcome forms
of self-deception that are harmful to us. More positively, it puts us in
touch with what is most "truly" ourselves—that sometimes elusive balance
of what is most desirable and what we most desire upon reflection.

Self-fulfillment is a process of personal development, largely guided
by oneself on the basis of understanding and caring about oneself, and
cumulatively leading to a meaningful and happy life. It is development
of the self, by the self, for the sake of the self (at least in part). In
numerous ways, only a few of which will be illustrated here, self-honesty
contributes to each of the three main aspects of self-fulfillment: (i) self-
development, (ii) self-direction based upon self-knowledge and self-
caring, and (iii) happiness and meaning.

(i) Self-development is a normative process. Desirable talents, skills, and relationships emerge and mature; undesirable ones are left fallow. General human capacities, such as reasoning, perceptual discrimination, and emotional sensitivity are exercised in valuable directions. And individual interests, aptitudes, and propensities are strengthened in worthwhile ways.[36]

Self-deception can handicap development in many ways. One is by supporting complacency. Effort is conveniently postponed with the self-deception that there is unlimited time for development later. Jane Addams offered an illustration which involved both personal and moral aspiration. She spent eight years after college dreaming of ways to help the poor, on ambition fostered since childhood. During a period of honest self-scrutiny, she realized she was using leisurely study and travel as excuses to delay action. She remarked how easy it is "to become the dupe of a deferred purpose, of the promise the future can never keep, and I had fallen into the meanest type of self-deception in making myself believe that all this [philanthropic dreaming] was in preparation for great things to come."[37] Within a few months she founded Hull-House in Chicago, an inner-city community center serving the poor. Thus began the lifetime of service for which she received the Nobel Peace Prize and in which she testified to finding self-fulfillment.

Another way that self-deception handicaps self-development is by concealing from ourselves our primary desires, interests, and talents. Self-deception can put us out of touch with what we care most about. Stephen Dedalus, for example, came close to embarking on a disastrous vocation as a priest owing to self-deception about his motives. He confused religious devotion with a desire for power: "How often had he seen himself as a priest wielding calmly and humbly the awful power of which angels and saints stood in reverence!"[38] He also confused altruism with winning rewards: "he seemed to feel his soul in devotion pressing like fingers the keyboard of a great cash register and to see the amount of his purchase start forth immediately in heaven."[39] In a moment of self-honesty, however, he envisaged the priesthood as a "grave and ordered and passionless life."[40] This insight opened the way to identifying his deepest creative impulses in art and writing.

(ii) Only some valuable potentials can be developed in a lifetime, and autonomy plays a key role in selecting a meaningful and happy

combination. Autonomy is self-determination, not in the sense of being free from social influences, but in guiding one's life on the basis of rational self-understanding, self-control, and caring about oneself (as well as others). "The prerequisite to self-fulfillment is a certain amount of clear-eyed, non-deluded *self-love*."[41] Self-caring is a positive attitude toward oneself, a commitment to satisfy one's needs and important desires, and a positive emotional investment in one's well-being.[42] Specific courses of action are autonomous when they are freely assented to and bring with them "feelings of enthusiasm, approval, interest, urgency, and ambition, and if these feelings and the intellectual assent spur us to engage in the appropriate activities."[43]

Self-deception can undermine autonomy by concealing the extent to which we are acting second-hand, more in response to the expectations of others than to our own aspirations. For example, the unnamed protagonist in Ralph Ellison's *Invisible Man* is eager to accept the perspectives offered by white authority. He is the "good boy" who never questions the authority of white bigots who offer him a college scholarship as a reward for not challenging the racist community. While at college he is oblivious to the hypocrisy of the black college president who unjustly expels him and subverts his attempts to find a job. Only gradually is he able to break the cycle of willing dupery in allowing himself to be manipulated by others. He begins to ask himself, "But what do *I* really want" and use his answer to guide his activities.[44] As he does, his past life appears as a dream in which he was as oblivious to himself as he was invisible to others who saw him through racist stereotypes.

Masochism and insensitivity to one's dissatisfaction are further threats to autonomy based on self-caring. As a contrast with Jane Addams's autonomous service, consider self-depreciating forms of self-sacrifice and self-insensitivity that Sonia Johnson ascribed to herself. Johnson's odyssey of self-scrutiny began when her husband of twenty years divorced her after duping her into signing a document forfeiting some of her property.[45] During a period of painfully honest self-confrontation, she recalled how she had suppressed her emotions about her subservience and self-denigration.

> I was living a sort of half life, in half light, a grayish, half-awake limbo of neither clouds nor sunlight, a gray same numbness. . . . I accomplished this . . . by lowering the threshold of my awareness, allowing

very little stimuli into my consciousness for fear of inadvertently letting in the scary things. At the same time I unconsciously dulled my percep-tion of the stimuli I did choose so that I would not see clearly what I did not want to see, would not feel what I did not want to feel, would not have to face what I feared to face.[46]

Addams and Johnson, offer relatively clear contrasts between self-fulfil-ling service and self-deceiving self-denial. Often the distinction is less easy to make, both in practice and in theory.

(iii) To be fulfilling, endeavors and relationships must create a sense of meaning, a confidence that they (and one's life) are worthwhile. They must also generate a significant degree of happiness, an attitude of overall satisfaction with one's life. Earlier I acknowledged that self-deception can contribute to happiness and meaning, such as when it serves to bolster confidence. But while self-deception sometimes offers life-promoting vital lies, self-honesty offers vital truths. Happiness is more than "a perpetual possession of being well deceived,"[47] and self-honesty makes an important contribution to happiness and meaning.

Consider Mr. Ramsay in *To the Lighthouse,* a character modeled after Virginia Woolf's father, Leslie Stephen. Ramsay erodes his happiness through preoccupation with his fame as a writer and philosopher, always "worrying about his own books—will they be read, are they good, why aren't they better, what do people think of me?"[48] Fear that his work will not endure causes recurring cycles of depression and self-pity that ruin the pleasure in his work. His need for constant reassurance from his wife and children results in missed opportunities for deeper enjoy-ments with them. He was "a man afraid to own his own feelings, who could not say, This is what I like—this is what I am."[49]

Mrs. Ramsay is far happier, largely because of her greater honesty with herself about the sources of satisfaction in her life. While her hap-piness is not perfect, she is sustained by the everyday pleasures of family and community. Amidst ongoing threats of conflict, she manages to create opportunities for interpersonal communion. She is also sustained by a mystic-like sense of connection with nature. In both ways, she created meaning not through philosophical schemas, but through "daily miracles, illuminations, matches struck unexpectedly in the dark."[50]

These examples merely hint at the contributions of self-honesty to self-fulfillment. Honesty with ourselves about our relationships, work,

abilities, interests, health, and death, helps to generate the kind of self-understanding essential for self-fulfillment. In as many ways, dishonesty with oneself leads to self-betrayal.[51]

# IV.   Self-Honesty as a Fundamental Virtue

We have seen how honesty with oneself often serves as a supportive virtue, a virtue that helps sustain other virtues. In particular, it serves conscientiousness, integrity, and practical wisdom. It also contributes vitally to other goods such as self-fulfillment. Nevertheless, its precise importance in a particular life varies according to other values and interests, as well as specific situations.

For example, here are four interests that have led various thinkers to give special emphasis to honesty with oneself. (1) Emphasis on individualism, autonomy, and personal fulfillment, such as found in Nietzsche and Kierkegaard. (2) Attention to the creative role of individuals in shaping their moral values. Nietzsche made this a central theme, but so too did Sartre: "moral choice is to be compared to the making of a work of art."[52] (3) Appreciation of the need for exercising judgment in discerning objective moral truths. Witness Butler with his keen understanding of how dishonest forms of self-deceit flourish in the gray areas of morality, and Kant with his emphasis on the duty of self-respect that requires maintaining the ability to discern duties clearly, without self-deceit.[53] (4) Concern to overthrow biases that prevent acceptance of new perspectives, as illustrated by Clifford's attack on intellectual sloppiness as part of defending a scientific worldview.

Is self-honesty valuable only because (and when) it serves other values? Or is it perhaps a "dependent virtue," that is, a virtue (a) only when accompanied by other virtues or at least (b) in the absence of certain vices?[54] Consider the egotistical honesty of Clamence in Camus's *The Fall*. Clamence is honest with himself and others as part of an elaborate drama of self-glorification (including self-glorification for his honesty). Also consider a demonic Nazi sadist who augments his effectiveness in hurting others by being strictly honest with himself about his own feelings and aims. Should we deny that their honesty is a virtue, or perhaps withhold the label "honesty" altogether given its suggestion of praiseworthiness? Isn't their so-called self-honesty a vice rather than a virtue since it serves immoral ends?

It might be suggested that truthfulness and honesty imply caring about truth for its sake. Clamence and the Nazi are not honest with themselves since they care about truth only from ulterior reasons of selfish pleasures or cruelty. Yet surely an egotist and a sadist may have some interest in truth for its own sake. Indeed, this interest may be an aspect of their detachment of truth from its humane import. Conversely, a humane person may be truthful from motives of moral concern, rather than a love of truth for itself.

It might also be suggested that honesty (with oneself and others) is a virtue only when it is present in appropriate degrees and circumstances. As an Aristotelian might propose, self-honesty is a mean lying between too much and too little concern about truth, a mean discerned with practical wisdom. Thus, honesty is always a virtue and Clamence and the Nazi are not honest with themselves. Yet this view removes us too far from ordinary language. We do speak, quite intelligibly, of excessive honesty with oneself, meaning a narrow and one-sided concern for self-honesty at the expense of other values. When self-honesty has bad consequences, perhaps destroying love, hope, and community, it is self-honesty nevertheless.

Perhaps, after all, ordinary language is too inexact to settle what should be said in all such instances. The important issue remains a moral one. When self-honesty promotes evil ends we may justifiably feel no admiration and simply refuse to call a person honest (since the speech act of calling them honest would convey praise). Alternatively, if we call them honest we may qualify our remark so as to strip away the usual honorific connotations of "honest." Or we might stipulate that we admire the honesty considered in isolation, but do not admire the role it plays in the individual's life. Self-honesty is a dependent virtue in that to be admirable without qualification it must not serve solely to promote evil.

When self-honesty is a full-fledged virtue, and admirable without qualification, is it admirable only because it serves other good ends? No: it is admirable for and by itself. How can this be shown?—In part by displaying what honesty with oneself is, as I tried to do in section I, and in part by considering examples where self-honesty serves no further good ends.

Consider O'Neill's *Iceman Cometh,* which as Fingarette observed, "is one of the great and humane contemporary sermons on the inhumanity wreaked by imperfect man when he attempts to abjure his 'pipe dreams' [i.e., self-deception] and accept himself as he is."[55] At the end of that

play Larry is in death-like despair because he has honestly confronted the truth about himself and the tragic truths about the people he loved. His self-honesty does not serve evil (immorality), but it is life-threatening, perhaps life-destroying. It renders him unfit to continue living on the basis of his previous compassion for his friends. His honesty serves no further good ends, neither moral nor personal. Nevertheless, it remains honesty and we admire him for it, even while recognizing that he would be more admirable if alongside it he could rekindle his life-giving compassion.

In this essay I have emphasized how self-honesty supports further values, just as self-honesty is itself supported by virtues like humility and courage in confronting unpleasant truths. At the same time, the examples used here suggest that self-honesty guides the exercise of other virtues. In particular, it places limits on the kinds of faith, hope, and charity (humanitarian giving) that can honestly be sustained, as the examples of Jane Addams, Sonia Johnson, Stephen Dedalus, Mrs. Ramsay, and the Invisible Man imply. Self-honesty is part of a web of virtues that balance, support, focus, guide, and limit each other. But within that web it constitutes one primary strand. Nietzsche was mistaken when he sometimes viewed self-honesty as the only strand left for "free spirits," thereby reducing a supportive web to a dangerous tightrope. But he correctly identified its proper status as a fundamental virtue—"fundamental" in its importance and in being nonreducible to other values.

A final caveat. Exhortations to be honest with ourselves can be abused, abusive, and dishonest. They lapse easily into excessive moralizing which overlooks the difference between dishonest and permissible self-deception. Worse, they become rhetorical weapons for furthering the dogmatism of those who confuse truthfulness with conformity to their view of the truth. Honesty with oneself includes honesty about honesty.

## NOTES

1. Friedrich Nietzsche, *Dawn* (1881), section 556.
2. Nietzsche, *Beyond Good and Evil*, trans. Walter Kaufmann (New York: Vintage, 1966), section 227.
3. These aspects of honesty are defined as general traits of persons. The traits involve, but are not reducible to, episodes of honest self-scrutiny.

4. Robert Audi draws attention to the distinction between acts and states of self-deception in "Self-Deception, Action, and Will," *Erkenntnis* 18 (1982): 133–58.

5. Freud's emphasis on honesty with oneself goes deeper than employing this therapeutic rule. See Philip Rieff, "The Ethic of Honesty," chap. 9 of *Freud: The Mind of the Moralist* (Chicago: University of Chicago Press, 1979).

6. Nietzsche pointed out that candor can be used as a ruse to conceal deeper forms of dishonesty and insincerity: "Perhaps the German of today knows no more dangerous and successful disguise than this confiding, accommodating, cards-on-the-table manner of German *honesty:* this is his true Mephistopheles-art." *Beyond Good and Evil,* section 244. Also see David E. Cooper, *Authenticity and Learning* (London: Routledge and Kegan Paul, 1983), chap. 1; and Jean-Paul Sartre's critique of sincerity in *Being and Nothingness* (New York: Washington Square Press, 1966), pp. 100–13.

7. Cf. R. S. Peters's discussion of "the values of reason" in "The Justification of Education," *The Philosophy of Education* (New York: Oxford University Press, 1973), pp. 251–52.

8. Walter Kaufmann, *The Faith of a Heretic* (Garden City: Anchor, 1963), p. 12.

9. Richard P. Feynman, *Surely You're Joking, Mr. Feynman!* (New York: Bantam, 1986), p. 311. Also see William Broad and Nicholas Wade, *Betrayers of the Truth* (New York: Simon and Schuster, 1982), pp. 107–25.

10. Quoted by Norman Malcolm in *Ludwig Wittgenstein: A Memoir* (New York: Oxford University Press, 1958), p. 39.

11. Søren Kierkegaard was concerned with this danger throughout his writings.

12. In a different context, J. L. Austin explores the senses of "real," a close synonym for "genuine": *Sense and Sensibilia* (New York: Oxford University Press, 1962).

13. Cf. Stuart Hampshire on "sincerity": "Sincerity and Single-Mindedness," in *Freedom of Mind* (Princeton: Princeton University Press, 1971).

14. John Sabini and Maury Silver, "Procrastination," chap. 7 of *Moralities of Everyday Life* (New York: Oxford University Press, 1982).

15. James D. Wallace, *Virtues and Vices* (New York: Cornell University Press, 1978), pp. 107–10.

16. H. J. N. Horsburgh, "The Ethics of Trust," *The Philosophical Quarterly* 10 (1960): 343–44.

17. George Graham and Hugh LaFollette, "Honesty and Intimacy," in *Person to Person,* ed. G. Graham and H. LaFollette (Philadelphia: Temple University Press, 1989), p. 167.

18. Sidney M. Jourard, *The Transparent Self* (New York: Van Nostrand Reinhold, 1964).

19. I explore the ethics of self-deception more fully in *Self-Deception and Morality* (Lawrence: University Press of Kansas, 1986).

20. Sissela Bok explores the ethics of lying in *Lying* (New York: Vintage, 1979).

21. W. K. Clifford, "The Ethics of Belief," in *Lectures and Essays*, vol. 2, ed. Leslie Stephen and Frederick Pollock (London: Macmillan, 1879), pp. 186, 178.

22. Joseph Butler, *Fifteen Sermons*, ed. W. R. Matthews (London: G. Bell and Sons, 1964), pp. 118, 163.

23. Ibid., p. 158.

24. Two notable exceptions are D. W. Hamlyn, "Self-Deception," *Aristotelian Society* 45 (1971): 45–60; and David Wood, "Honesty," in *Philosophy and Personal Relationships*, ed. Alan Montefiore (London: Routledge and Kegan Paul, 1973).

25. Joan S. Lockard and Delroy L. Paulhus, eds., *Self-Deception: An Adaptive Mechanism?* (Englewood Cliffs, NJ: Prentice Hall, 1988), p. 2. Also see Shelley E. Taylor, *Positive Illusions: Creative Self-Deception and the Healthy Mind* (New York: Basic Books, 1989). Daniel Goleman provides a more balanced treatment of this issue in *Vital Lies, Simple Truths: The Psychology of Self-Deception* (New York: Simon and Schuster, 1985).

26. The expression "vital lies" was used by Henrik Ibsen in *The Wild Duck*. Philosophers who have drawn attention to the possible good of self-deception include Béla Szabados, "The Morality of Self-Deception," *Dialogue* 13 (1974): 24–34; John King-Farlow and Sean O'Connell, *Self-Conflict and Self Healing* (New York: University Press of America, 1988); and Jerome Neu, "Life-Lies and Pipe Dreams," *The Philosophical Forum* 19 (1988): 241–69.

27. Jean-Paul Sartre, *Anti-Semite and Jew*, trans. George J. Becker (New York: Schocken, 1965), p. 90.

28. Sartre, *Being and Nothingness*, trans. Hazel E. Barnes (New York: Washington Square Press, 1966), p. 76.

29. Ronald D. Milo, *Immorality* (Princeton, NJ: Princeton University Press, 1984), pp. 106–14.

30. Marcia Baron, "What is Wrong with Self-Deception?" in *Perspectives on Self-Deception*, ed. Brian P. McLaughlin and Amélie Oksenberg Rorty (Berkeley: University of California Press, 1988), pp. 431–49.

31. Lloyd H. Steffen, *Self-Deception and the Common Life* (New York: Peter Lang, 1986).

32. Herbert Fingarette, *Self-Deception* (Atlantic Highlands, NJ: Humanities Press, 1969). Other writers who view self-deception as morally ambiguous are R. G. Collingwood, *The Principles of Art* (New York: Oxford University Press, 1958); and M. R. Haight, *A Study of Self-Deception* (Atlantic Highlands, NJ: Humanities Press, 1980).

33. Fingarette portrays alcoholics as self-deceivers in "Alcoholism and Self-Deception," in *Self-Deception and Self-Understanding*, ed. Mike W. Martin (Lawrence: University Press of Kansas, 1985): 52–67.

34. Cf. Sartre, *Anti-Semite and Jew*.

35. Philippa Foot, *Virtues and Vices* (Berkeley: University of California Press, 1978), p. 3.

36. Joel Feinberg distinguishes general and individual human nature in "Absurd Self-Fulfillment," in *Time and Cause*, ed. Peter van Inwagen (Dordrecht, Holland: D. Reidel, 1980), pp. 265–72. The related concept of human potential is refined by Israel Scheffler in *Of Human Potential* (Boston: Routledge and Kegan Paul, 1985).

37. Jane Addams, *Twenty Years at Hull-House* (New York: Signet, 1981), p. 73.

38. James Joyce, *A Portrait of the Artist as a Young Man* (New York: Penguin, 1976), p. 158.

39. Ibid., p. 148.

40. Ibid., p. 160.

41. Feinberg, "Absurd Self-Fulfillment," p. 275. Also see Michel Foucault's discussion in *The Care of the Self*, trans. Robert Hurley (New York: Vintage, 1986), pp. 37–68.

42. "Caring" is analyzed by Milton Mayeroff, *On Caring* (New York: Harper and Row, 1971); Nel Noddings, *Caring* (Berkeley: University of California Press, 1984); and Harry G. Frankfurt, *The Importance of What We Care About* (New York: Cambridge University Press, 1988).

43. John Kekes, *The Examined Life* (London: Bucknell University Press, 1988), p. 29. For two other illuminating accounts of autonomy as stressing competent self-guidance see Lawrence Haworth, *Autonomy* (New Haven: Yale University Press, 1986), and Diana T. Meyers, *Self, Society, and Personal Choice* (New York: Columbia University Press, 1989).

44. Ralph Ellison, *Invisible Man* (New York: Vintage, 1972), p. 562. For a fuller discussion see my "*Invisible Man* and the Indictment of Innocence," *CLA Journal* 25 (1982): 288–302.

45. Simone de Beauvoir discusses self-deception in unequal love relationships in "The Woman in Love," in *The Second Sex*, trans. H. M. Parshley (New York: Vintage, 1974), pp. 712–43. For a general philosophical analysis of masochism see Virginia Warren, "Explaining Masochism," *Journal for the Theory of Social Behavior* 15, no. 2 (1985): 103–29.

46. Sonia Johnson, *From Housewife to Heretic* (Garden City, NY: Anchor, 1983), p. 161.

47. Jonathan Swift, *A Tale of a Tub*, in *The Portable Swift*, ed. Carl Van Doren (New York: Viking Press, 1948), p. 66.

48. Virginia Woolf, *To the Lighthouse*, (San Diego: Harcourt Brace Jovanovich, 1927), p. 177.

49. Ibid., p. 70.

50. Ibid., p. 240.

51. Self-betrayal, especially betrayal of our moral aspirations, is explored by Ilham Dilman and D. Z. Phillips in *Sense and Delusion* (New York: Humanities Press, 1971).

52. Jean-Paul Sartre, *Existentialism and Human Emotions* (New York: Philosophical Library, 1957), p. 42.

53. Immanuel Kant, *The Doctrine of Virtue* (Philadelphia: University of Pennsylvania Press, 1964), pp. 92–108. A somewhat different explanation of Butler and Kant's interest in self-deception is offered by Stephen L. Darwall, "Self-Deception, Autonomy, and Moral Constitution," in *Perspectives on Self-Deception*, ed. Brian P. McLaughlin and Amélie Oksenberg Rorty (Berkeley: University of California Press, 1988), pp. 407–30.

54. The notion of dependent virtues is developed by Michael Slote in *Goods and Virtues* (Oxford: Clarendon Press, 1983), 61–75.

55. *Self-Deception*, p. 139.

# Self-Knowledge and the Possibility of Change

*Ilham Dilman*

This paper is a continuing discussion of a topic in which I share an interest with Professor Herbert Fingarette. We have both been interested in understanding what it means to know oneself and what it means to deceive oneself, thus turning away from knowing oneself. I think we agree that the knowing and the deception in question characterize the self itself; that is the person as he is in himself. I am thinking especially of Fingarette's two books *The Self in Transformation* (1963) and *Self-Deception* (1969). This has obvious implications for the way coming to know oneself involves becoming different in oneself. This is the topic of my book *Freud, Insight and Change* (1988).

The present paper is a further working out of this topic in the face of some criticism by Professor D. Z. Phillips and the late Rush Rhees of a previous paper on this same topic, 'Self-Knowledge and the Reality of Good and Evil', published in a book *Value and Understanding* (1990), edited by Rai Gaita. I feel confident that Fingarette would be sympathetic to the line I am taking here and so I am very pleased to offer it in a volume intended to honour his work.

## I.

A person is the person he is as a result of where and when he was born, who his parents are, what he has met, been subjected to, and later sought or shunned, and so experienced in life. He is the person he is as a result of what kind of person he has mixed with, admired

and loathed, and so what influences have been active in his life. He acquires his personality, his very being, in the course of a development in which he himself participates and through which he also changes. He participates in the way he puts himself into his responses to what he meets, in his active part in the learning in which he engages, the interests he develops, and later in the judgments he makes, the decisions he takes, and his reflections on matters that are of concern to him—reflections in which he weighs things, questions and criticizes himself, accepts or rejects things.

Although he owes his being to a great deal that is external to him—the language he speaks, the culture in which his life unfolds, the values he assimilates in the course of his interactions with people—the part he plays in his own development is not a passive one. There is a lot that comes to him from outside, without which many of his responses and most of his thoughts would not be possible. Yet it is equally true that he brings what all this makes possible to bear on the influences he meets and later courts or keeps at bay in his life. The interaction between what comes from outside and what increasingly comes from him in the course of his development is constant and continuous, and such that soon it is not possible to draw the line between the two, each being impregnated with the other.

Certainly it would be a gross over-simplification to think of the development of a person and the formation of his character on the analogy of the completion of a manufactured product. If we speak of 'influences that have shaped him' we are not talking of anything like the shaping of clay into pots and jugs. Much of what is covered by this expression is not something which forces him into this or that shape, perhaps against the grain of the 'given' elements of his pre-existing nature. Indeed, the very idea of anything 'given' in this context, of a clay of human nature so to speak, shaped into individual human beings by external, cultural influences, is a highly problematic one. Rather much of what we refer to as 'influences' creates the possibility of the exercise of his developing powers. And if it is true that he could not have come to value and want the things he does value and want in life independently of these 'formative influences', nevertheless the significance of things which condition his desires is subject to his reappraisal.

What a man wants is not something that is simply *given*. It is something to the formation of which he enters reflectively, something which—once he has acquired the capacity for judgment and sufficient independence—he can search for: 'I wish I knew what I wanted', 'what do I want in life?'. This is a search for what things mean to him, for what he can make sense of, and it involves a reappraisal of the value which things have for him, as well as his relation to the values by which he judges their value. As the significance and value which things have for him change in the process, so does what he wants for himself as well as the person he is change—the person who wants and judges and is the locus of particular convictions, commitments, and loyalties.

I spoke just now of 'a person being the person he is'. This involves what he is like, his character, and who he is, his identity. I do not mean this in the common-or-garden sense in which you may ask of a person you have just met who he is, to which the answer may be that he is the son of the village postman. I mean it in the sense that you may say of someone, 'he doesn't know who he is, he has never been himself, he has not found himself'. You may also say, 'he doesn't know himself'.

In this sense what determines *who* one is, what makes a person *himself*—as apposed to a fake, a copy, or a cardboard cut-out—is not his history: where he was born, who his parents are, etc. What determines his identity in this sense, what makes him an individual, who he is, are his allegiances, convictions, loyalties, commitments—that is, his relation to what belongs to his history. It is these which constitute the place where he stands, and it is from that place that he looks at things, appraises their significance, and acts. A man who does not know where he stands, one who has not found a place on which to stand, is lost to himself. There is no solid core to him—the kind peculiar to human beings—and he is at the mercy of the external influences that act on him. The place exists independently of him; but just as it makes it possible for him to stand, so equally it is his standing on it that makes it *his* place. The place as 'his' and his standing on it are inseparable.

Let me develop this a little by contrasting bravery and cowardice. The brave man is someone who has something for which he cares, something to defend. He is himself; in his bravery he is not divided from himself; even though he may be afraid, he acts as one, as a whole. He is behind his actions when he comes to someone's defence in the

face of danger. If he were not behind his actions he would not be a brave man. If, for instance, he had his back to the wall and could not help but take what was coming, we would not describe him as brave.

It is otherwise with cowardice. If there really was nothing at stake for him and he backed in front of danger, we would not think of him as a coward. His retreat from danger could be mediated by considerations of self-preservation. If he did not rise to what we regard as a challenge this would still not make him a coward: not unless he himself regarded the challenge as a challenge. For the coward is someone who out of fear backs down before what he himself regards as a challenge. He is someone who yields before pressure, gives in because he is afraid to take on some force opposing his will, endangering someone he cares for or something to which he attaches importance.

What gives substance, solidity, or shape to the brave person, in contrast with the coward, is that you can depend on him. Such solidity is radically different from rigidity of character; indeed it is compatible with and easily accommodates flexibility. Rigid people are usually rigid because letting go or bending is for them tantamount to disintegration or loss of self. Flexible people, however, can bend without breaking just because there is a backbone to their personality. One must not confuse genuine flexibility with shapelessness.

There is, surely, a different kind of solidity to people than the rigidity which, for instance, comes from their clinging to images which may be created by labels which suffuse the immediate culture in which their life bathes. It is the solidity of a moral integrity that comes from caring for things, from having something to care for, something one wants to preserve. Thus the solidity of the friend on which you can depend, of the adversary you can count on to defend his corner, of the person whose promises and threats are not uttered in vain. You know where you are with him, as he knows where he is with that for which he cares. You know where he stands, and in doing so you may know *him*.

This trustworthiness or reliability of a person is very different from the reliability of a material—a cloth that will not shrink, for instance, a colour that will not fade, floor boards that will not give way under your weight, a car that will not break down when it is driven hard. You trust the material on the basis of certain tests, calculations, and

predictions. We may call this 'inductive trust'. But you trust a person who makes a promise because you know him, so that you can see that he *means* what he says—see that he is sincere, honest, responsible.

The car, the train, cannot mean to take you from A to B. They do not tell you anything, or serve you because they have committed themselves to the job. Your expectations with regard to them are based on their past performance, or on the past performance of like or similarly built vehicles or machines, similarly constituted materials; not on their word.

It is true, of course, that we sometimes rely on people in a similar way and on a similar basis. This is when we are using them. Thus, to take an extreme case, Hitler created a reign of terror and relied on young people to 'betray' their parents when they were not good Nazis. Big firms employ advertisers to manipulate public opinion so as to ensure people will buy the products advertised. Indeed, their advertisements are often directed to undermining what in people makes them individuals. Incidentally, this is the only way you could rely on a coward to do your dirty work for you: through fear. This is radically different from personal trust. Such trust is involved when someone signs a contract and says, 'as long as you produce materials of the said specifications we shall buy so much from you every year'. The signatories put their trust in each other. But the moment you say to yourself, 'the penalties are high, he dare not break the contract', you have stopped trusting him.

It is this kind of trustworthiness and integrity that gives people solidity in the proper sense. Freedom comes into it in the sense that the man has given his word or signed the contract freely, not under duress—which does not mean that he is free to break his word. Just because he has given his word freely and has integrity, if someone else offers him materials of the required specification at a cheaper price, he will not buy them from him. He will say: 'I have given so-and-so my word and I *cannot* break it; I am not free to buy from you.' 'I cannot' here does not mean 'I am forced to'; it is an expression of commitment of will. I have touched on the conditions presupposed by the possibility of such commitment. The person himself is behind his refusal to go along with the commercially more advantageous offer: 'He is not free because he has given his word—freely.'

This links with what I said about courage and bravery. You *trust* the brave man to defend you, not to run away. What you trust is *him*, the integrity and loyalty that makes him who he is, and you do that in the face of the danger that confronts him, despite the fear he has for his own safety. But when you say of the coward, 'when the fighting heats up, he will desert his post, or surrender', this is *not* trusting *him*. It is a prediction; it is like trusting that the explosives will go off. Cowardice is a character trait, it is part of *what he is like*. Bravery, in contrast, is intimately linked with *who he is*—that which makes it possible goes to constitute his identity.

'He is a coward' means 'he cannot be trusted to defend you in the face of danger'—just as 'he is impulsive' means 'he cannot be trusted to resist temptation, or to take into account certain considerations before acting', and equally just as 'he is a liar' means 'he cannot be trusted to speak the truth'. This is what makes these character traits character defects. 'He is brave', 'he is responsible', 'he is honest' have a different kind of meaning. For instance, 'he is honest' means 'he can be relied on or trusted to speak the truth'. What you rely on is *him*, the person; not any regularity in his behaviour.

To know a person and to know what he is like are not the same thing. You know a person when you are exposed to his will, when you make contact with him. Thus you make contact with a person when you are exposed to his courage or to his malice, to his good will towards you or to his hostility. But his lies or his cowardice do not bring him in contact with you, unless he feels guilt or shame. For he is not behind his cowardly acts, nor behind his lies if he is a habitual liar. I am thinking of the case where in lying he takes the easy way out, he gives in to temptation or habit, so that in this kind of lying he is not himself. It is the downhill slope that determines his actions, his lies; they do not come from him. Consequently, they do not bring you in contact with *him*, you only come to know *what he is like*, namely a coward, a thorough liar.

Similarly for self-knowledge. This should not be equated with knowing what one is like. Thus if I am a coward, I am not behind my acts of cowardice, and I have not found myself, come to be or know myself. There is no difference between *being* and *knowing* here—as there is no difference between virtue and moral knowledge, between being good

and knowing goodness. The movement from naivety or self-deception to self-knowledge is, therefore, necessarily a change in me. This is also true when I find the courage to stand and fight. In finding such courage I find or recover myself.

In doing so I become true or authentic. I become myself, I act from conviction; in being myself I acquire autonomy. I shall return to this. At the moment I want to point out briefly that being oneself is not coinciding with something ready-made, and that finding oneself is not discovering something waiting to be discovered—like gold in a derelict mine or one's gold watch in the lost property office.

If we find this difficult to understand we should remember that we speak of 'finding' and 'discovering' in many different connections. One such connection which will shed some light on what we are considering is where we speak of a poet discovering what he wants to say or a painter discovering the right colour for the sky he wants to paint. The line, the colour, do not pre-exist the poem or the painting. They come into existence as the poem grows, as the painting begins to come to its own. They have no existence independently of the whole which is the finished poem or painting and, therefore, their existence cannot precede the completion of the work. Yet in the context of the completed work nothing else is right, and without it the work lacks the perfection which the writer, the artist, is trying to achieve. It is this which makes the language of *finding* intelligible and appropriate here.

When it comes to the sense of 'finding oneself', though the analogy is of help, its limitations must be born in mind. An artist or poet, though he is painting or writing within an artistic tradition, starts with an empty canvas, a blank sheet of paper. True, he cannot just paint or write anything; he has to paint as himself and within the confines of his talent, experience and knowledge. All the same he starts from scratch, invents. This is not true in the case of self-discovery.

By the time a person asks himself 'who am I? where do I stand? where do I go from here? what do I want out of life?'—and not everybody asks himself this—he has already learned a great deal, lived through experiences that have shaped him, he has acquired particular propensities and character traits, he has formed various allegiances. Yet he asks himself this question, because he has lost his way, realizes he has been false or pursued chimeras, no longer knows what matters to him,

or is confused about the sense things make for him. No one who is in this situation will speak of what he is embarking on, if he is serious, in terms of 'making', 'fashioning', 'inventing' or 'creating'. One will have to *find* a sense, a way, a way of living one can go along with, be oneself in, be happy with, one to which one can give oneself fully, *given* one's talents, limitations, background, experiences, allegiances. One may withdraw from some of one's allegiances, reappraise one's values, but one cannot jettison the lot and have anything left with which to search, to make sense, to judge, reappraise, make choices and decisions.

The way one is looking for is not ready-made, and the person's inclinations do not determine it. Indeed, in the course of the search many of his inclinations will acquire a new significance in the light of his changing values, and so his relation to them will change. So as he finds his way *he* will change; he will be more at one with himself, more of him will be behind what he does. If this does not happen, then whatever he has *found out about* himself, he has not found *himself*. Thus while the process in question is not one of wholesale revision, in the course of it the person recognizes and comes to accept much about himself and his circumstances that cannot be changed. He learns to come to terms with, use, make the best of at least some of it, instead of ignoring or denying it, and he finds greater freedom in doing so. Indeed learning to do so is itself a change in him. As Rush Rhees puts it in his 'Personal Recollections' of Wittgenstein: ' "Try to become a different man" would often be, "Try not to deceive yourself about what you are" ' (Rhees 1981, p. 211).

I will sum up this part of the discussion by quoting a paragraph from an earlier paper:

> Just as the truth of a moral belief is not its correspondence with an independent reality, similarly a person's truth, when we describe him as 'true to himself', is not his coincidence with a pre-existent self. If I may put it provocatively, there is no such pre-existent self, nor any pre-formed pattern particular to the person, pre-dating him as an individual. What he meets in life from the outset, what he makes of it, both open up his horizons and also set the direction in which he can move without falsity, determining what are real choices for him. There is no one, predetermined direction in which he must advance if he is to find greater authenticity. But as he makes his choices—

friends, occupations, interests—commits himself in what he takes on, the direction in which he is to find such authenticity becomes more determinate. Unless he has been deceiving himself all along or chosen a life of pure conformity, it is within these limits that he will find himself. (Dilman 1990, pp. 205–6)

## II.

In a discussion of the paper from which I have just quoted and in a subsequent paper he wrote in response to it entitled 'Self-Knowledge and Pessimism' (Phillips, forthcoming), Professor Phillips objected to the way I tied up self-knowledge with autonomy and to the way I spoke about the development in which a person comes to greater self-knowledge. I have spoken in the same way here. Thus to quote some of my words above:

> . . . as he finds his way *he* will change; he will be more at one with himself, more of him will be behind what he does. . . . Thus while the process in question is not one of wholesale revision, in the course of it the person recognizes and comes to accept much about himself and his circumstances that cannot be changed. He learns to come to terms with, use, make the best of at least some of it, . . . and he finds greater freedom in doing so.

Phillips finds this way of talking, this view of self-knowledge, 'optimistic,' and he believes that it does not pay sufficient attention to a deeper aspect of human life. This is part of what he says:

> The overall impression I have in reading Dilman's paper is one of optimism. The person who has self-knowledge is said 'to take charge of his life' . . .
> Difficulties begin to arise when we notice what is missing from Dilman's paper. Despite referring to moral limitations, he seldom mentions *the price* they exact. His emphasis is very much on what we can achieve despite them. It is in this context that Dilman speaks of a person taking charge of his life. But when a person reflects on his limitations, he may find that he cannot speak of himself in this way. Coming to know himself has been, for him, deeply discouraging. When he looks at his relationships with others, his children, say, the record drives him to despair . . .

The failure may be such that a person would not dream of speaking of his being in charge of his life. He knows himself too well to speak in this way . . .

If one is deeply discouraged about what is central in one's life, one can be said to be discouraged about the way most of one's life has gone. In such circumstances, it would be even more strained to speak of autonomy or of being in charge of one's life. Yet, one would have come to self-knowledge . . . (Phillips, forthcoming)

Now clearly insofar as a person has failed in his life in fundamental ways that matter to him he has lacked autonomy. Perhaps he had deceived himself about this up to now, but he has finally come to admit his failures and is understandably deeply discouraged. Such a person has stopped deceiving himself, he has stopped running away and is, therefore, more himself than he was before. He has gained self-knowledge. So far I agree with Phillips.

Phillips now imagines this person considering his past failures and reaching the conclusion that it would be fooling himself to go on trying to change: 'He sees that in some respects he is not going to change, cannot change.' This is an 'ordinary reaction' with which we are familiar and if he puts it into words he would be 'making remarks we are well acquainted with in the normal course of human life. Surely, it is our philosophical assumptions which are leading us astray if we want to deny or explain away these ordinary reactions.' Phillips continues: 'The person who says he cannot change may say so with *good reason*. After all, he has tried again and again, but the catastrophic results cannot be denied.' He then adds: 'If someone, despite this record, says, "He can change" or "There is always the possibility of change", the *a priori* tendency seems to be on his side, since he seems to need *no reason* for his reaction.'

It is true, of course, that here 'he can change' may mean no more than '*anyone* can change', and as such this is an *a priori* claim. It can, however, also function as a reminder: 'an unfavourable prognosis is only an unfavourable prognosis; where human life is concerned the possibility of change cannot be finally ruled out'. But this is not an expression of optimism. It says: even when you can see no ground for hope, you should not despair. In any case, a person may give up his desire to change and find that he has changed in a way that had never

entered his mind before. There may be certain things in one's past, for instance, which can never be undone. But one may find a way of bearing them without going to pieces. One does not change one's view of their gravity, one does not take them less seriously, but one changes one's attitude towards them. I am thinking of a person who after having been oppressed by guilt for his past misdeeds finds a way of making amends for them in the way he changes his life. This does not cancel the misdeeds, but it releases him from the immobilizing hold they had over him for a long time. He now finds, for instance, that he can enter into relationships from which he had felt excluded. The rebirth of Raskolnikov which Dostoyevsky sketches in the Epilogue of *Crime and Punishment* is an instance of the kind of thing I have in mind.

Another kind of case is where someone has felt unhappy with the way he is for a long time, dreaming and seeking to become different. He comes to see the 'falsity' of what he had longed for and is no longer bothered by being the way he is. Such a person too has changed in that he has given up false ideals and the longing they created in him, and he has come to accept himself. He can now be himself: he has come to self-knowledge. Kitty Scherbatsky's change during her stay in a watering place in Germany depicted by Tolstoy in *Anna Karenina* is a case in point.

But let me return to the kind of case where a person comes to confront his past emotional failures and limitations and he is 'deeply discouraged about what is central in his life'. I shall take as an example a case which was originally suggested to me by Phillips himself a few years ago, that of Viktor Tausk as presented by Paul Roazen (1973) in his book *Brother Animal*. Tausk had failed in what was central in his life. He had been unable 'to bear another person's dependency' and so had been unable to take on the commitment of love and establish 'a secure relationship with a woman'. His need to be accepted by an older man whom he could look up to had stood in the way of his growth 'into independent manhood'. As Roazen puts it: 'Running from many different women, Tausk was fleeing from his own inner passivity' (p. 115).

'Tausk had sought salvation in psycho-analysis, for himself and for those he loved' (p. 127). When that failed him, he lost all hope. He 'realized that he was . . . going to have his dilemmas with him to the

end' (p. 121). 'He had failed in his search for a solution to his conflict. . . . With this woman [Hilde] he had wanted more than ever to succeed in love, yet he knew that he had seen it all happening to him before' (p. 122). This time he did not have the hope that had so far sustained him: Freud and psycho-analysis. He writes in the suicide note he left on the eve of his marriage to Hilde:

> The recognition that I cannot gladly enter into a new marriage, that I can only keep myself and my beloved fiancée in conflicts and torments, is the true conscious motive of my suicide. (Roazen 1973, p. 126)

As in the example Phillips and Rush Rhees gave me in discussion, on the one hand Tausk saw that he could not marry Hilde without putting her happiness into jeopardy, yet on the other hand he could not think of life without her, or at least without a stable relationship with a woman he could love and who could love him. In his despair and discouragement he killed himself.

Now is *this* an example which shows that self-knowledge need not be liberating, that it does not always coincide with autonomy? I do not think so. Tausk's analysis failed him and he could no longer bear his discouragement with himself. Someone in a similar situation—quite understandably and reasonably—may say: 'my past failures don't give me much hope to think that I could be different, that I should go on trying to change'. But if he gives up, as Tausk did, that is a counsel of despair and goes well beyond what knowledge of his own past justifies. There were reasons which explain Tausk's despair, but that is not to say that they justify it.

He had tried again and again, and failed. According to Phillips this justifies the conclusion: 'I cannot change.' Certainly, he was stuck, he could not see a way ahead. But 'I cannot change', as Phillips means this, is an *objective* judgment, it is meant to be an expression of a piece of knowledge based on past experience. It is a conclusion which *anybody* who was intimately acquainted with the course of his life could have come to. 'I am stuck', as I am thinking of it, however, is the expression of a *subjective* condition and it may shade into or merge with despair. If I say, 'this does not mean that there is no way ahead, even though perhaps he would never find it', am I saying something idle or empty?

Is the possibility which I suggest exists even here a merely theoretical one? I do not believe so.

Certainly Tausk's hopes with regard to what Freud and psychoanalysis could do for him were unrealistic and coloured by his 'phantasies'. But this matter should have been worked out in Tausk's analysis which was terminated prematurely. Certainly he got a raw deal in that analysis with Helen Deutsch, and Freud did fail him. Tausk did not get the chance to resolve his conflicts in the analysis which did not succeed in opening up a new perspective for him in which he could see a way ahead. So he gave up in despair. Yet this giving up was *his* choice and we could not say that it was a clear sighted one.

Phillips would say: 'He saw the record of his past failures and this made him see—in the only proper sense applicable here, an inductive one—that there was no way ahead for him, that he could not, or would not ever change.' I would put it differently: 'He could not see a way ahead, he lost all hope of changing, and he gave up.' This is not a conclusion, and therefore not one that could be well-founded or fail to be so. It is an expression of his condition and mental state at the time. Certainly I would not say that he came to self-knowledge and it was that which brought him to despair. It is clear—or at least so I believe—that whatever he may have come to see about himself, Tausk was far from having *found* himself and, in that sense, far from having come to self-knowledge. For while coming to see something new *about* oneself is certainly a step in the direction of self-knowledge, it is not the same thing as coming to self-knowledge. Whether or not it adds up to self-knowledge depends on what one does with it, how one takes that piece of knowledge about oneself into one's life.

Self-knowledge, in the sense under discussion, involves authenticity, emotional learning and growth, and that includes the resolution of inner conflicts, the achievement of greater unity of self. It is through such learning, resolution, and growth that a person moves towards autonomy. To be in charge of one's life means to be in control of *oneself*, in the sense in which Socrates meant this, *not* to be in control of the different things that enter or impinge on one's life: all the things that one cares for and all the things that make a difference, for good or ill, to the things one cares for. Much of this is beyond one's control and often a source of deep pain and distress to one. To come to know

this is the beginning of wisdom, to learn to live with it is an important part of self-control.

The change in a person from setting himself against this to learning to accept it is a deep-going change in him. Sometimes, especially in later life, this is the only kind of change that a psycho-analysis aims at in the patient. I am sure that this is what Freud meant when he said, 'there is *other* misery in the world besides neurotic misery—real unavoidable suffering' (Freud 1949, pp. 319–20). Obviously the more sensitive a person is the greater such suffering is likely to be. Even if this is the only kind of change which is open for a psycho-analysis to bring about in a particular patient one should not minimize it: 'much will be gained (as Freud put it to a patient) if we succeed in transforming your hysterical [neurotic] misery into everyday unhappiness, against which you will be better able to defend yourself with a restored nervous system' (Freud 1950, p. 232). By 'defend yourself' he meant 'you will be able to take it without going to pieces'.

Such a change is one kind of change in which a person finds himself and comes to self-knowledge. In contrast, coming to see the catalogue of one's failures without understanding the inner conflicts which lie at their source, and so without being able to work through them, is *not* coming to self-knowledge. Of course one of its prerequisites is that one should shed one's illusions about oneself, see how consistently one has failed and how troubled one is about it. But that is not the end of the line as far as coming to self-knowledge goes.

Now for the question of optimism. I am well aware of how vulnerable human beings are to suffering, of the transitory nature of the good things of life, and that one has to pay for them sometime or other. I am aware too of how much evil there is in life, the extent to which this evil is an integral part of human life, and I know that one cannot be open to the good and enriching things which life has to offer if one hides from the evil and from the suffering it brings. I know, furthermore, how much in us limits our capacity to give up what we hold on to and find security in, and how much, therefore, all this works against our ability to change. But I do believe that it is often worth working towards it. This is obviously a *personal*, moral conviction. I also believe, and I hope I have said something to support it, that to work towards self-knowledge is to work towards such

a change, one that lies in the direction of greater autonomy. This is a *philosophical* claim which expresses a logical point, and it involves neither optimism nor pessimism.

I have never said that self-knowledge is easy to acquire or that it is available to anyone who tries hard enough. I would not say that everyone ought to try to acquire it. To commit oneself to the search for self-knowledge is to embark on a hazardous journey which calls for much unity of self and autonomy.

In *Freud, Insight and Change* (1988), in a section where I discuss Tausk, I wrote: 'There is nothing final about failure. If one cannot make a go of what one has tried time and again, one can at least turn in a different direction, succeed at something else, learn to accept and live with failure' (p. 188). This is no light or easy matter.

Of course in most cases a person cannot be what he wants to be—at least not without becoming false. But this does not mean that he cannot be different. Concentrating on his failures and allowing himself to be taken up by his longing to get away from them will keep his mind closed to very different possibilities of change which he could otherwise work towards. He has to turn right around before he can see that there is a way ahead. This way need not be all roses, it may involve much pain which has to be born. But it is one which allows greater initiative and openness to life. And what one chooses here is a matter of what one values.

# REFERENCES

Dilman, Ilham. (1988) *Freud, Insight and Change*. Oxford: Blackwell.

———. (1990) 'Self-Knowledge and the Reality of Good and Evil', in *Value and Understanding*, ed. Raimond Gaita. London and New York: Routledge.

Fingarette, Herbert. (1963) *The Self in Transformation*. New York: Basic Books.

———. (1969) *Self-Deception*. Atlantic Highlands, NJ: Humanities Press.

Freud, Sigmund. (1949) *Introductory Lectures on Psycho-analysis*. Winchester, MA: Allen and Unwin.

———. (1950) *Studies in Hysteria*. Boston: Beacon Press.

Phillips, D. Z. (forthcoming) 'Self-Knowledge and Pessimism'. *Interventions in Ethics*. London: Macmillan.

Rhees, Rush. (1981) *Ludwig Wittgenstein, Personal Recollections*. Oxford: Blackwell.

Roazen, Paul. (1973) *Brother Animal*. Harmondsworth: Penguin.

# Mysticism and the Question of Private Access

*Angus C. Graham*

The great obstacle to the man of reason in coming to terms with mysticism is its appeal to the authority of an experience outside the public domain, and least accessible perhaps to the analytic cast of mind. He may be struck by the apparent agreement of so many East and West whom it is customary to call mystics that in the ultimate enlightenment everything turns out to be one, or perhaps rather that all distinctions fall away, between the one and the many as well as between self and other, and in theistic doctrines between the soul and God. But what meaning can he ascribe to such claims, admitted to be no more than approximations to a finally unverbalisable revelation? It is true that we acknowledge the formulae of quantum mechanics as meaningful to a privileged few although meaningless to most of us, lacking as we are in, not only the knowledge, but possibly the innate mathematical ability as well; this however is a matter only of a more complicated use of a language which, at the level of 2 + 2 = 4, we all understand. It is not plain that mystical affirmations would assume a meaning for the critical mind even if he did share the experience. He may concede in theory that he may lack the equivalent of a sixth sense possessed by mystics, as a person blind from birth lacks even a conception of what sight is. But the blind man learns by experience that others have an independent and superior access to the same world which he discerns by hearing, touch, taste, and smell; what is a philosopher to make of a sense giving access to a world otherwise inaccessible? It is as though one were to make the vacuous claim that

dream is of real events occurring, not even on some remote planet where in principle a space traveller could witness them, but in a realm unvisitable except in dream itself.

The objection assumes however the traditional Western conception, with Neo-Platonism at the back of it, of mysticism as the quest for Being, Reality, conceived after the analogy of a search for propositional truths even when the mystic explicitly refuses to verbalise. Granted that Indian philosophy may be fitted to this conceptualisation, the Far Eastern doctrines such as Taoism and Zen have nothing to say about truth or being; they promise only that with the liberation from all dichotomies we shall find ourselves moving spontaneously on the Tao, discovering not an ineffable Reality but a Way without rules on which to navigate the reality we already know. They turn our attention from the supposedly experienced to the experience itself, dimly evoked through poetry, aphorism, and parable, and offered as attainable by ourselves through prescribed techniques of meditation. To the extent that the fact/value distinction applies—a point to which we shall return[1]—the illumination is not of reality but of value. But in that case a claim to private access need not worry us. In poetry and the arts we expect to meet unintelligible language or symbolism which will assume meaning if we happen on the relevant experience. The morally or aesthetically, unlike the physically, blind, have nothing to warn them that they are missing anything; their lack is manifest only to the morally or aesthetically perceptive, who—to stick to the same visual metaphor—have the same maddening assurance as mystics of the superiority of their own vision. Whatever the dangers of élitism, the conclusion that in matters of value some can see what to others is invisible cannot be escaped even by relativism. The extreme relativist too assumes on particular issues his superiority in valuation to those with less of the relevant knowledge and experience, including his own past self, and has likewise to concede in principle his inferiority to those with more. Then the mystically unqualified should be comparable, not with the sightless, but with the small boy who thinks his elder brother silly to waste his time with girls; he cannot yet know that after his own sexual awakening his present valuation will look silly to himself. In the Western tradition we tend to think of artistic creation and appreciation, although cultivated only by a minority, as inside

the generally accessible mainstream of experience but of mysticism as outside, and to treat aesthetics as a rather uneasily acknowledgeable branch of philosophy by the side of ethics, but mysticism as too exceptional and too problematic for a classified place within the discipline. It may be however that our culture has been especially unfavourable to the recognition and education of the states called mystical. It is remarkable that in every philosophical tradition except our own the mystical is central and is not sharply distinguished from the aesthetic; indeed it tends to puzzle Westerners by appearing in such fields as martial arts and the government of the state.

But even if there is no objection in principle to accepting the private mystical experience as relevant to the philosophy of value, there remains the practical difficulty of introducing it into public discussion. In 1963, in his first book, *The Self in Transformation*, Professor Fingarette proposed a direction from which the man of reason can begin to make sense of mystical discourse. He made an illuminating comparison between its paradoxes and those of the report of a woman on her self-reconstruction under psycho-analysis, and suggested that, in spite of the glaring contrasts in theory and method, mysticism and psycho-analysis pursue rather similar states of psychic well-being. I shall here approach the problem from a different angle. Among the private experiences highly valued by those who share them, there is one which seems especially well suited to verbal communication. I have the impression that a description of it is recognisable to most who are acquainted with psychedelic drugs or with meditative practices and to many who are not. It may or may not deserve the label 'mystical', however that word is understood, but those who claim to be on the mystic ladder seem generally to acknowledge it among the lower rungs, as 'nature mysticism' perhaps. To start with a crude summary, it is a state of exceptional tranquility and harmony with surroundings, in which attention detaches itself from one's habits and projects to become autonomous and intensely focused, so that all perception is peculiarly lucid, detailed, and vivid. Its advantage for public discourse is that, being wholly extroverted, it is describable in terms of the things perceived. It perhaps belongs to common experience, but in our culture, which attaches little significance to it, is seldom noticed except by people with a pantheistic or other mystical vocabulary to identify

it. To isolate it as far as possible from philosophical interpretation
before discussing its philosophical significance, I shall appeal only to
first-hand accounts by myself and others deliberately chosen as out-
side the standard literature of mysticism. The first is from Thor Heyer-
dahl's account of the earliest and best months of his flight from civiliza-
tion to the Marquesas with a Girl Friday in 1937.[2]

> Sitting in the pool it sometimes happened that shades we are unaware
> of seemed to fall from our eyes, whereby everything around us took
> on a breath-taking beauty. Our sense of perception seemed to be tuned
> in to a different and clearer reception, and we smelt, saw and listened
> to everything around us as if we were tiny children witnessing nothing
> but miracles. All these little things were everyday matters, such as a
> little drop of water shaping up to fall from the tip of a green leaf.
> We let drops spill from our hands to see them sparkle like jewels
> against the morning sun. No precious stone polished by human hands
> could shine with more loveliness than this liquid jewel in the flame
> of the sun. We were rich, we could bale them up by handfuls and let
> them trickle by the thousands through our fingers and run away,
> because an infinity of these jewels kept pouring out of the rock. . . . It
> was good to feel the breeze, the sun, the touch of the forest on our
> skins, rather than to feel merely the same cloth clinging to the body
> wherever we moved. To step from cool grass to hot sand, and to feel
> the soft mud squeeze up between the toes, to be licked away in the
> next pool, felt better than stepping continually on the inside of the
> same pair of socks. Altogether rather than feeling poor and naked,
> we felt rich and as if wrapped in the whole universe. We and everything
> were part of one entirety.

This is almost a description of any childhood day by the seaside,
but Heyerdahl is aware of the experience as qualitatively different,
'shades we are unaware of' falling from the eyes, and happening only
sometimes. His concern is not with its meaning, merely with reviving
in memory the best time of an adventure of his youth. He slips however
into the kind of phrasing used by the mystically inclined; 'we and
everything were part of one entirety'. The phrase 'tune in' suggests
Timothy Leary's slogan "Turn on, tune in, drop out", still recent when
the book was first published in 1974. Have we all experienced this
tuning in, except for those of us unlucky enough never to have known
joy? If so, it would be in spells of tranquility during otherwise excited

states, in love, or in that first phase in a new country so packed with impressions that one recalls with amazement having got off the plane only yesterday morning; and since we are not in the habit of analysing joy, if only from fear of spoiling it, its distinctiveness would elude our notice. There is of course the further question whether we can speak of the experience as the same before and after it becomes an object of attention.

The next example is from Georges Bataille, a mystic no doubt but a highly idiosyncratic one for whom the annihilation of self in the void is not a serene illumination but a convulsion of alternating anguish and rapture sustained only until terminated by exhaustion. Bataille knows the experience we are discussing, but as the 'agreeable possession of a rather insipid loveliness'.[3]

> At the moment when the sun sets, when silence invades a purer and purer sky, I happened to be alone, sitting in a narrow white veranda, seeing nothing from where I was but the roof of a house, the leafage of a tree and the sky. Before getting up to go to bed, I felt how much the loveliness of things had penetrated me. I had had the desire for a violent mental upheaval, and from this viewpoint I perceived that the state of felicity into which I had fallen was not entirely different from "mystical" states. At any rate, when I passed abruptly from inattention to surprise, I was more intensely aware of this state than one usually is, and as though another and not myself were experiencing it. I could not deny that, apart from the attention, absent from it only at the beginning, this commonplace felicity was an authentically inward experience, plainly distinct from project and discourse. Without giving more than an evocative value to these words, I thought that "heavenly loveliness" was in communication with me, and I could feel precisely the state which responded to it in myself. I felt it present inside the head as a vaporous flow, subtly perceptible, but participating in the loveliness outside, putting me in possession of it, making me enjoy it.
>
> I recalled a drive on which I had known a felicity of the same order with exceptional distinctness, when it was raining and the hedges and trees, hardly covered by the sparse leaves, stood out from the spring mist and came slowly towards me. I came into possession of each soaked tree and was sorry to give it up for the next. At that moment, I thought that this dreamy enjoyment would not cease to belong to

me, that I would live henceforth guaranteed the power to take a melan-
choly joy in things and drink in their delights. I must admit today that
these states of communication were only rarely accessible to me.[4]

For Bataille the experience on the veranda is immediately iden-
tifiable, not only with previous ones of his own, but with Proust's: 'I
recall having noticed the resemblance between my enjoyment and those
described in the first volumes of the *Récherche du temps perdu*.'[5] Leav-
ing the veranda for his room, he wonders whether he has the right
to despise 'the state which I had just entered without thinking about
it', to insist on preferring his 'torturing joy'[6] to 'possibilities a little
different, less strange but more human, and, it seemed to me, equally
profound'.[7] In the quiet of his room he revives it, letting 'the flow of
which I spoke' intensify inside him.[8] But he is dissatisfied because
'this plenitude of inward movement' does not abolish self. In starting
to philosophise his language becomes abstract and strained. 'It is true
that in it I lose myself, attain the "unknown" in being, but *my* atten-
tion being necessary for the plenitude, the self attentive to the presence
of this "unknown" is only partially lost, is also distinguished from that:
its lasting presence still demands an opposition between the known
appearances of the subject which I remain and the object, which it
still is.'[9] He decides to return 'from a contemplation which referred
the object to myself (as is usual when we enjoy a landscape) to the vision
of that object in which at other times I lose myself, which I call the
unknown, and between which and nothing there is no distinction which
discourse can express.'[10]

It will be noticed that Bataille, who despises happiness, attends to
this 'commonplace felicity', and recognises it as distinctive, only because
he is in the mood for one of his self-lacerating ecstasies. Otherwise
it would have passed unnoticed, as very likely it does for most of us.
That Bataille, very unusually, describes it as, on one occasion at least,
a '*melancholy* joy in things', is in keeping with his dark view of life. Here
I introduce myself as third witness, with some background informa-
tion to put my testimony in perspective. I am among the many who
first noticed the commonplace felicity during the late sixties, when
I had a few LSD trips and sometimes joined in smoking marijuana.
It presented itself at its purest as the relaxation of body and mind

and the clarity of the senses which persisted for a day or more after coming down from LSD. I shared the common impression that the calm lucidity was the effect, not of the drug itself, but of the unknotting by the drug of hardly noticed habitual tensions which only gradually returned with the pressures of ordinary life; and that there must be, if one could find it, a certain knack of relaxation which would restore the state without resort to chemical aids. Many with this impression proceed to try out some technique of meditation. I did not, judging myself (as I still do) temperamentally unsuited to mystical exploration; although fascinated by the Taoists whom I study professionally as a sinologist I have not read seriously in any other field of mystical literature, and have never practiced meditation. But from this time I had a new respect for episodes in which attention simply freewheels to sights and sounds—watching the shadows slant on a wall in the still and cool of late afternoon, or walking home late at night from a party a little drunk and peering into the reflections in a darkened shop window of lighted windows opposite and passing cars in between, or lolling in a chair listening without discrimination to birdcalls, barking dogs, wind in the trees. These seemed tantalisingly close to the experience without reaching it. During the same period another gain from the sixties, awareness of habitual tension, led to informal ways of easing it; neck and shoulder muscles loosened, various longstanding aches disappeared, my jerky awkward swimming and dancing became freer with the trusting of the body to make its own decisions. For some years the exhilarations of sensory vividness and bodily spontaneity remained unconnected. Later they occasionally came together, for example on a warm night swimming in the blackness of air and water though phosphorescence, starlight, and lamps of fishing boats. Eventually in 1979, by the completion of some underground process of maturation, they quite suddenly fused, with the movement of attention becoming autonomous, and awareness and responsiveness interacting and enhancing each other. For the next three weeks, the last of a vacation, I had the knack of reaching this state almost at will, and did so for some or most of nearly every day. As was the case with Bataille I thought that 'I would live henceforward guaranteed the power . . .', but afterwards 'these states were only rarely accessible to me.' Nowadays they are generally less vivid and are

coaxed back perhaps twice in a year, but I have never ceased to be grateful for them. I still feel more honest speaking of them in the psychedelic slang of the sixties ('trip', 'turning on') than in a mystical vocabulary the right to which I have not earned. The experience is indeed a sober version of the wholly extroverted type of LSD trip, with undisturbed lucidity and full self-command, and anyone who wishes to think of me as having learned a knack of reviving a mild LSD intoxication without the expense and trouble of finding the drug is at liberty to do so. The point would be significant only for those who judge unusual states by their claim to uncover Reality, an enlighten-ment of which drugs treacherously give the illusion. But if the issue is not of reality but of value, approval of the experience is no more affected than would be approval of present moods of confidence, cheer-fulness, and friendliness if they improbably turned out to be after-effects of a brand of whisky one was drinking ten years ago.

In my own case, which like any other will have idiosyncratic features, the experience generally starts on the visual level from the "disin-terested vision" of aesthetics, surrendering to whatever attracts the eye without discriminating in favour of the practically relevant. There is, for example, that equalising of interest in objects and their shadows or reflections which may accompany the suspension of practical interests. In a dirty pond with wooded banks you at first see only muddy water, then the upside-down reflections of the trees becoming as plain and solid to the eye as the trees themselves, then sun, blue of the sky, moving clouds, quite distinct underneath the inverted treetops. The multiplying images enormously enhance the pleasure in the scene, but since for practical purposes most reflections are useless if not dangerous distractions, the mind in normal conditions shuts them out. When in this mood, I try to make, or rather to relax in order to *let*, the disinterested attention to sensation spread from sight not only to sounds, smells, tastes, feel, but to my own breathing, my own move-ments. (This is not a meditation in which one sits still). Too exclusive concentration on the visual hinders the play of attention from keep-ing up with the changing scene, because sights departing without leaving time to assimilate them tempt one to cling to them as they pass (Bataille's 'I came into possession of each soaked tree and was sorry to give it up for the next'); sound on the other hand, having temporal

duration without spatial distribution, pulls attention along with it. If every-day stresses are not quite released, the nerves not quite unjangled, nothing more happens, and you get bored with looking purposelessly into the spectral colours radiating from carlamps or sun, or heeding the feel and sound of your own footsteps. But once you hit on the rhythm at which attention keeps pace with change, the takeoff is unmistakable (except perhaps during a brief interval of instability). The flow of attention becomes autonomous, pulling you, not pulled by you towards goals, which is presumably that 'vaporous flow, subtly perceptible', that 'plenitude of inward movement', which puts Bataille into communication with the external scene and which resumes when he returns from the veranda to his room. Attention no longer depends on pre-existing goals to give it purpose, and anything on which it focuses, the band of light along the edge of the bathwater, the brown discoloration of an old newspaper, becomes inexhaustibly interesting for its own sake. The texture of expe-rience, when without memory or anticipation one is absorbed in the moving present, becomes so rich, varied, and transitory that the only alternatives in confronting this plethora of riches are either to turn to something new or to plunge farther and farther into the detail of the same thing. Blake's dictum 'If the doors of perception were cleansed everything would appear to man as it is, infinite', assumes a straightfor-ward, almost literal meaning. There is no longer any such thing as monotony because your own kitchen is from moment to moment as new to the eye as Venice the first day you saw it. It is hardly the mystic oneness with everything—Bataille justly complains of the continuing separation of subject and object—but in surrendering to spontaneity one is as though breathing and moving in harmony with a bee settling on a flower or water rippling over stones (Heyerdahl's "We and everything were part of one entirety"); it becomes intelligible that with experience further on in the same direction the language of mystics would deepen in meaning like Blake's 'If the doors of perception . . . '. The illumination waxes and wanes but, unless abandoned for practical reasons, lasts until the senses tire at the end of the day, and is then relatively easy to resume the next morning. It is not a matter of an ecstasy from which one must sooner or later come down but of a dishabitua-tion, Heyerdahl's 'shades falling from the eyes', the putting back of which can be delayed indefinitely.

Has this semi- or sub-mystical state any philosophical significance? We had better continue to avoid the language of conventional mystical discourse, which is inevitably, even more than other languages, debased by usage in excess of the experience which gives it meaning. One might be tempted to take a Bergsonian line and acclaim the insight as a disinterested vision of the universal flow as it is in itself, not as the intellect abstracts and classifies for human ends. Certainly this liberation from what Bataille calls 'project and discourse' involves a deconceptualisation of experience, a suspension of language. At one moment, in grinding coffee let us say, there is an equally vivid consciousness of a cobweb wavering in the breeze and throwing a shadow on the window, the red and white lights and the engine hum of a plane receding in the sky behind it, and the new-ground smell entering the nostrils with the feel of metal on the palm and of winding against the resistance of the crunching beans. To find words to fix the complex of sensations you would have to withdraw from the flow, and by the time you found them you would have been left behind. Reversing Derrida's slogans, the illusion of presence and 'Nothing outside the text', there is no text to be inside and whatever is perceived is fully present. In this heightened awareness one does not become more *observant,* more alert to the useful or dangerous; it is simply that one perceives a leaf as moving however slight the breeze, hears by day the creaks and squeaks which worry the sleepless at night, knows anywhere in the house that outside a cloud is passing over the sun. In shifting to this utilitarian viewpoint the most familiar scene becomes full of marvels. In your own sitting-room, when free of the practical necessity of remembering that among reflecting surfaces things may not be where you see them, you enjoy the sight of blossoms and creepers growing from the walls, the washing on the line in the garden behind hanging unsupported in the air in the street in front, cars driving straight through the house. The effect of opening the senses to the irrelevant image is most spectacular in the city by night, whether indoors or in the street, in a tumult of mirrors, wide windows, polished metal and plastic, contrasting colours, and glaring lights. Nothing that architects plan has the complex beauty of the astonishing collages, the endlessly changing mobiles, springing from chance conjunctions to transform the most commonplace building. It may seem surprising that a vision

associated primarily with the countryside, indeed often called "nature mysticism", adapts so easily to the landscape of the city, for this witness at least. But a man-made environment seen in a dull and even light does remain peculiarly resistant to this vision. The 'state of communication', as Bataille calls it, seems to be nourished by the interaction of the spontaneous within and without. At night one is gazing into fortuitous blends and clashes of light, glass, and colour, at the city not designed by man but recreated from moment to moment by the Surrealists' "objective chance", which might be claimed as the characteristic mode in which modernity apprehends Nature.

But in pursuing these flights of fancy it is already plain that the vision is *not* of things as they are in themselves. The doors of perception may be cleansed, but attention always takes the direction which is spontaneously pleasing, and pleasure just as much as utility is a selective human interest. The Commonplace Felicity (we need a label from neither the mystic's nor the psychologist's argot, and Bataille's phrase will do as well as any) never in my experience comes except in favourable conditions, leisure, comfort, warmth, light, and the awareness which it enhances is of the nice but not the nasty things in life, by a paradisiac vision as one-sided as the infernal. In this respect it is narrower than aesthetic vision, which can be as much or more at home in the infernal, being safely detached from the present experience in which spontaneity cannot do otherwise than flinch from the displeasing. If a visit to paradise makes some people want to climb the mystic ladder still higher, it must be because it suggests the possibility and the direction of some still higher state embracing or transcending the dark side as well as the light. It may be noticed also that granted that the experience approaches the ideal of the shedding of all verbal concepts, it is certainly being shaped by preconceptions about the aesthetically pleasing. Looking at dew on a cobweb or rust on an abandoned car, colours and textures clarify and interrelate as though in a painting in the National Gallery. To my eyes at least a scene will look Impressionist (waterlilies in a pool as though painted by Monet), or Cubist (diverging lines and planes of a table top and the corner of the wall), or Surrealist (that car driving through the sitting-room), all of them styles which start from an unlearning of the conceptualisations shaping conventional vision; but how far would I be

seeing like that if I had not seen the pictures before? The same question comes up when the ear discovers consonances in the clink of ice in a glass, a creak on the stair and the whirr of a neighbour's lawnmower, as though I were listening to Stockhausen or John Cage.

But the awareness, although one-sided, is relevant to the question of why the experience seems to impress everyone who shares it as self-evidently valuable, not merely as enjoyable recreation but as an illumination of life. Indeed it invites the language of sacred authority; Bataille speaks, 'without giving more than an evocative value to these words', of a 'heavenly loveliness', and I would myself not be more than slightly embarrassed to call its peerless serenity "blessedness" or the "peace which passeth all understanding". Bataille's testimony is especially remarkable, since even his qualified approval of it is hard to reconcile with his extremist, to some tastes positively sinister philosophy, which equates value with intensity, and conceives all intensity as expenditure of life, inherently destructive and self-destructive. The explanation of its apparently impregnable authority is, I would suggest, that you are surrendering to pure spontaneity but in abnormally intensified awareness of the things around you, on occasions when only the immediate surroundings matter. It becomes idle to dismiss the assurance of high value as a treacherous subjective conviction; you are judging not deliberate action but spontaneous reaction, and to judge the most aware reaction to be the best requires no further authority than the value of awareness itself, which will be just that which in propositional knowledge you ascribe to truth. Pronouncing it best no doubt demands the qualification 'Other things being equal', but in a state limited to occasions when no issue of prudence or morals arises, what other thing is there to take into account? This argument, which, if valid, undermines the fact/value dichotomy, I have elsewhere put in quasi-syllogistic form and debated with Professor Fingarette.[11]

But is not this high value relative only to spontaneity in lesser awareness, not to the ethical value of deliberate action? It might plausibly be claimed that the episodes into which no practical or moral consideration enters are the very ones it is least important to evaluate. The experience does not merely lack the value proper to deliberate action, it is actually incompatible with prolonged deliberation. Not

that it is abandonment of self-control, reversion to animal instinct. The submergence in the spontaneous within is, if one wishes to put it in these terms, a re-incorporation into Nature; yet one is never more in control than when both spontaneous and highly attentive, as in athletic performance. If this seems a paradox, it is of the sort (at the same time having and lacking self, desire, thought) which Professor Fingarette notices as common to mystical discourse and the report of the psycho-analytic patient whom he quotes.[12] In spite of the resemblance to the LSD trip one is not in ecstasy or trance; one is simply doing what from moment to moment one spontaneously prefers, with no need to deliberate until some opportunity or danger arises. One still thinks (including the thinking about the experience itself exemplified in this essay), and if it turns cold can walk across the room to shut the window without heeding every perception on the way; but thoughts straying too far from present sensation, or goals too long deferred, disturb the spontaneous flow until eventually it loses momentum. It is plain that to maintain permanently this immersion in a solipsistic stream of impressions would not merely be impossible in practice, it would amount to a sacrifice of most of life. This however is to say no more than that we cannot remain for long in the contemplation of pure ends forgetful of means. Here we may recall a surprising touch in Bataille's reluctant tribute to the Commonplace Felicity, his recognition that compared with the agonised intensities which he prefers it seems 'equally profound'. 'Profound' is an unexpected word for an experience which, not only for Heyerdahl and myself but for Bataille (with his rooftop seen from the white veranda and trees approaching through the mist) is not of depths but of surfaces.

But there is a sense in which the experience is indeed profound. It is a return to the foundations on which one's personal code of means and ends is built. Deliberate action as means depends for its value on ends valued for themselves, without which one is caught in that infinite regress of means to means which empties existence of all meaning. To the extent that we lose faith in the religious or philosophical grounding of ends, we seem to be left with nothing but our own spontaneous likes and dislikes. We are not in practice deterred from acting on these by the theoretical ban on inferring the value of something from the fact that one likes it; but with attention concentrated on choices of

means, on the one hand the rigidifying ends come to be taken for granted, and lag behind and obscure spontaneously changing preferences, on the other, choice of new ends is stultified by the habit of seeing in anything only what is useful to the old ones. The arts are the most easily available source from which to replenish ends. But the Commonplace Felicity, in spite of its more restricted scope, has one advantage over learning from the arts; it is not the sharing in imagination of another's experience but an intensification of one's own. For a few hours, as an individual at leisure in that particular time and place, you have the assurance that without reflection you are from moment to moment living exactly as you should. It would not be to the point to object that an enhancement of selfish enjoyment, however intense, is of negligible value compared with moral ends. Others' well-being is as much the end of moral action as one's own of self-centered, and the dependence of means on these ends is the same for morals as for prudence. In any case the experience carries with it the conviction, which we decided is rationally well grounded, that the spontaneously preferred in heightened awareness is good in itself, not merely what one happens to enjoy.

On this account the Commonplace Felicity is nothing less than a source of non-propositional knowledge, enabling its enjoyer to liquidate, reconstitute, and revitalise ends, and see the means to them in a new perspective. Speaking personally again, I had never, before catching on to this knack, guessed how much one sacrifices by immersion in the realm of means. Granted that, as moralists and practical people have always insisted, there are for much of the time compelling reasons to deny oneself the pleasures of the moment, as soon as one appreciates how much joy is being lost one begins to count up just how much one is getting in exchange. An enormous range of experience commonly dismissed as neutral, mere fodder as means to something else, or even as positively unpleasant, is revealed in enhanced awareness to be highly enjoyable. It is not that the world is disclosed to be a beautiful place after all, but that the beauties which it has seem inexhaustible. Heyerdahl and his friend letting 'drops spill from our hands to see them sparkle like jewels against the morning sun' are getting more from them than many get from the possession of real jewels. During the three weeks when I first explored the possibilities

of the experience, I was living in a flat right up against a railway. I listened with fascination to the rhythmic clang and clatter of trains passing the house, distinguishing while in one room or another the differently arching sound of arriving and departing—a noise which originally had almost deterred me from taking the flat, which I learned not to hear soon after moving in, and which I still did not hear except in this state of sharpened sensitivity. I had also not appreciated how tastes can change decisively but temporarily at peaks of awareness one is unable to sustain, and how this calls into question the value of the taste mortified by habit to which one reverts. On most mornings of my life I hurry through a breakfast which varies little and is hardly tasted. But on occasions when I have coaxed open the doors of perception while in my morning bath, I do not breakfast until the quickening of hunger, and pick only what that morning stirs the appetite. Whatever it may be, fruit, unflavoured yogurt, wholemeal bread (my tastes shift in the simple-lifer's direction), I linger over every mouthful with acute enjoyment, much more than at most banquets. It is not however, that every flavour becomes enjoyable. Certain positive distastes emerge, for example for processed fruit juices, and for sprinkling too much sugar. Next day, in a hurry to leave the house, I shall be swallowing juice and sugaring corn flakes as negligently as ever, but with a distinct sense of *Video meliora.* . . . "I see and approve the better, I follow the worse." This is not one of the more significant life-choices, but it illustrates how one may be led to revalue one's ends and consequently one's means also. Why would it be more rational for me to work for the money to pay for meals in more expensive restaurants than educate myself to become more conscious of the flavours of fruit, yogurt, and wholemeal bread?

This is the sort of question which, although of course asked in the West, not least by explorers of psychedelia and mysticism, goes decidedly against the grain of our culture. The technological progress of the West over the last few centuries depended on a choice *not* to live for the moment but for the future, not to spend but save, not to relax but stay on the move, not to trust to spontaneity but to thought and will. In terms of this basic choice, there was no point in being aware without being observant, and no point in spontaneity except of the sort rationally directed to a goal, such as manual dexterity. As

for the joy in which awareness and spontaneity evoke and enhance each other, it still happened, but without a commonly recognised category into which to fit it, except that of the pleasure which rewards work done and refreshes for doing more. Much of this has survived the puritanism which once gave it a moral meaning. Might it be that in philosophy of value our culture tends to cut us off from one of the main sources of knowledge? The fact that, for example, we find Chinese thought logically undeveloped in comparison with our own is a reminder that we have no assurance whatever that all sources of knowledge are equally open to us. A Westerner at the seaside sharing Heyerdahl's experience might miss its significance as in traditional China a thinker whose argument happened to make explicit both premisses of a syllogism would not recognise in its logical form the necessity lacking in his looser reasoning. I suspect that some states that we call mystical are as natural as the relief of sorrow by tears, and are suppressed by certain cultures much as grown men may be forbidden to weep.

# NOTES

1. Cf. p. 164 below.

2. Thor Heyerdahl, *Fatu-Hiva: Back to Nature on a Pacific Island* (New York: Penguin Books, 1976), p. 62f.

3. Georges Bataille, *L'expérience intérieure*, (Paris: Gallimard, 1954), p. 177.

4. Ut sup. 173f.

5. Ut sup. 175.

6. Ut sup. 88.

7. Ut sup. 175.

8. Ut sup. 175.

9. Ut sup. 176.

10. Ut sup. 177.

11. *Reason and Spontaneity* (London: Curzon Press and Totowa, NJ: Barnes and Noble, 1985), ch. 1. Fingarette, 'Reason, Spontaneity and the *Li*', and my rejoinder, in *Chinese Texts and Philosophical Contexts*, ed. Henry Rosemont, Jr., (La Salle, Ill.: Open Court, 1990).

12. Fingarette, *The Self in Transformation* (New York: Basic Books, 1963), ch. 7.

# PART
# TWO

# Comment
# and Response

*Herbert Fingarette*

Professor Bockover as Editor of this volume has provided me with copies of the contributed essays, and has been kind enough to invite me to contribute comment and response. My overarching response is one of profoundest appreciation and honor. No scholar can imagine a more moving and significant form of tribute. The conception and preparation of such a work, the participation of such distinguished scholars whose prior works have meant so much to me, and the effort they have committed to this particular volume of scholarship—all this evokes my warmest personal thanks to each and every one. I salute them in friendship and reciprocal tribute.

In addition to the opportunity to express appreciation publicly, this invitation offered me the opportunity to engage in specific and substantive discussion of issues raised in this remarkably rich set of essays. I have enjoyed doing so enormously. Of course I could not pretend to do full justice to each essay; a full and fair discussion of any one of them would require at the very least a full-length essay in itself. Of necessity I have limited myself to an all too small selection of issues from each.

My selection, however, is not ad hoc. I have had two guidelines. In the first place, each of the issues I have selected for discussion from any one essay is one that I see as central to that essay. And secondly, I have sought to develop a common theme by selecting issues that reveal how the particular essay engages with my general theme and its sub-themes. The theme I pursue is one that is central to my own thinking.

Such an attempt at finding unity may seem foolhardy: It is evident that the essays deal with such widely separate fields of thought as ancient Chinese philosophy, contemporary philosophy of law and jurisprudence, moral psychology, ethics, alcoholism, and addiction. And correspondingly, the authors' professional disciplinary backgrounds are, viewed as a whole, remarkably disparate. But my quest for some unity in all this variety has been warranted by several considerations. First, and most generally, it is a mark of the authors' scholarly stature that each one's perspective ranges over more than the single professional discipline to which they belong. More specifically, these writers have all in one way or another found some affinity with my own work, and, reciprocally, I have over the years particularly profited from theirs. Thus, although we do not always draw the same conclusions, a concern with certain themes that have pervaded my own work is to be found running through the essays of those who have contributed to this volume.

Always at the center of my philosophical quest, driving and guiding the enterprise, has been a closely related cluster of concerns. I have tried to deepen my understanding of personal responsibility, of personal integrity, and of the maturation and the regression of the person. The issues have been approached in a three-dimensional way: I have tried to explore the conceptual aspects, the empirical and behavioral aspects, and the subjective, experiential aspects.

Because I have at times emphasized that there is for me an important subjective dimension to my philosophical quest, I should perhaps make it clear here that on principle I have avoided making the private and personal dimension public. I also should add that the relation between the private and the public has not always been direct. Thus, to mention only one example, I have written much about the topic of alcoholism and addiction. And I suppose no one today has escaped at least having friends or acquaintances with such problems. But beyond such friend or acquaintance relationships, I have never been personally, practically, or professionally involved in any person's struggles with alcoholism or other addictions. The experiential significance of these scholarly studies has been indirect, yet significant.

Well, then, what is my theme here with regard to these essays and to my own central cluster of concerns? One could fairly expect me to

state this theme succinctly at the outset in order to orient the reader. On this occasion, however, I feel oddly loath to do this. I feel that what I want to say needs to be developed in the course of extended discussion if it is to be justly apprehended. So I beg the reader's indulgence, and I ask that if the views I will expound are deemed likely to be worthy of exploring, the reader will be patient enough to proceed a step at a time, following along with my essay-by-essay comments, which now follow.

# Ann Hasse

Ann Hasse's essay highlights something fundamental about the way we determine the limits of responsibility. She deals with liability and culpability in the context of legal doctrine, topics to which the law has given extended and self-conscious consideration. Specifically, Hasse's essay focuses on the idea that the limits of legal liability and criminal culpability are crucially determined by policy decisions. The particular form of the question posed by Hasse's essay arises out of the current law of criminal conspiracy. But the moral to be drawn is general.

Hasse examines the ruling precedent laid down in the case of *Pinkerton*. In that case, the US Supreme Court held that each co-conspirator in a particular criminal conspiracy is criminally responsible for each and every substantive crime committed by any member of the conspiracy in furtherance of the conspiratorial objective. This dramatically widens the prosecutorial net, as compared to the basic common law principle that a necessary condition of criminal guilt is that one have played some material role in the instigation, collateral preparations, or actual commission of the crime. In criminal conspiracy, however, the alternative condition of guilt is merely to have agreed to join the conspiracy. Thereafter one need have played no material role in a particular substantive crime to be guilty of that crime.

There are things to be said in favor of, and against, such a sweeping concept of criminal responsibility. In order to press the issue, Hasse poses an arcane question: If a person has agreed to join a criminal conspiracy, is that person then criminally responsible for those crimes

of the conspiracy that had already been committed prior to that agree-
ment to join?

One can argue either way. On one hand one could reason that the
new conspirator is guilty of the old crimes because of the sweeping
character of the general principle of the ruling precedents: the mere
act of agreement is sufficient to inculpate the person for each and
every one of the conspiracy's crimes even if that person did nothing
whatsoever that was specifically in furtherance of any one of them.
Why should this "vicarious liability" not extend backwards in time from
the agreement as well as forward? Furthermore, the conspiracy is
viewed by the law as a "*partnership*" in crime—and thus as a single enter-
prise with a continuous existence. In civil law, a partner is liable for
the debts of the partnership even where those debts were incurred
prior to that partner's having joined the partnership.

On the other hand, and with what is apparently at least equal force,
one can argue, as Justice Rutledge and others have, that the *Pinkerton*
doctrine must be viewed as allowing one person to be convicted for
another person's crime, or as convicting a person twice for the same
offense (conspiracy). For the doctrine punishes a person for *agreeing*
to a criminal project, and then, without anything more on the part
of that person, punishes the person again for a crime committed by
someone else. To hold a conspirator retroactively guilty of crimes
committed prior to that conspirator's agreement to join would thus
compound the confusion and injustice by punishing the person for
a crime he or she not only did not participate in but *could* not con-
ceivably have participated in as a conspirator.

The preceding remarks are not intended to be a thoroughgoing
analysis of the issues—a project that is addressed in Hasse's paper—
but simply to set in focus, as a basis for my own comments, the dilemma
her paper poses.

Hasse shows that the conceptual and moral disorder in all this goes
deep, and is not limited in its implications to the special case of
retroactive guilt with which she opens up the problem. My own par-
ticular interest is focused on the approach she takes to resolving
the dilemma.

Hasse argues that the conspiracy-partnership analogy is fundamen-
tally inappropriate because the fundamental resolution of the dilemma

requires reference to the legal policy underlying the law, whereas the analogy focuses our attention on similarities that are policy-irrelevant. To see this one needs to call to mind the policy underlying civil law partnership liability.

The civil law doctrine of vicarious liability among partners in business is not a doctrine adopted simply on the basis of some abstract, disinterested, and highly general conception of justice. It is adopted expressly on the basis of public policy. The courts have *chosen* to hold partners vicariously liable in business transactions in order to help assure that business costs will be allocated efficiently. Crudely put, it is in order to assure that legitimate debts are paid that the courts' policy has been to extend the scope of liability for debts and to sweep in as many potential payers as have some reasonable liability-relation to the incurring of the debt. A business partnership is held to create such liability, even where a partner may have had no personal part in incurring the debt (and may not even have been a partner at the time). The legal issue is based in public policy in regard to commerce, not on some perceived or inferred transcendent moral truth about responsibility. The same situation obtains—for the same policy reasons—in antitrust law (Ms. Hasse informs me in correspondence): All conspirators are jointly and severally liable for all conspiracy acts as joint tortfeasors.

Such policy choices are quite familiar in civil law. But it is Hasse's major argument against *Pinkerton* that the policy considerations underlying civil law vicarious liability for partners have no relevance to the criminal law context. With the exception of regulatory, strict liability criminal law (to which questions of conspiracy have no relevance), the criminal law is not concerned with rational distribution of costs or with marketplace efficiency. Indeed the most fundamental policies of the criminal law contrast sharply with the rational distribution and market-oriented policies underlying vicarious liability doctrine in civil law. Specifically, it has always been thought a necessary condition for imposing criminal sanctions—particularly for traditional, common law (*malum in se*) felonies such as robbery, rape, or murder—that guilt is personal and morally colored, and conviction is intended to carry a peculiarly personal stigma. Derivative from this basic policy are policies governing the grading of the seriousness of crimes, and

consequently the appropriate degree of personal condemnation and level of punishment.

It is true that other criminal law policies reflect the aim of using punishment to deter crime and to rehabilitate, as distinguished from using punishment as retribution. But the implementation of deterrent and rehabilitative aims in setting punishment is always limited by retributive constraints: Where personal guilt reaches only to a certain level of seriousness, deterrent and rehabilitative aims may not impose punishment at a higher level. And, *a fortiori,* where there is no personal guilt, punishment aimed at deterrence or rehabilitation may not be imposed. Thus personal guilt is the *sina qua non* of criminal conviction.

In the general context of conspiratorial crimes, there is ample leeway, independently of *Pinkerton,* to charge and convict co-conspirators for crimes committed in furtherance of conspiracy. But these options conform to the policy of guilt as personal. For example, one who aids and abets a criminal is personally guilty in the matter. *Pinkerton* drastically attenuates personal criminal guilt, however, in assigning guilt even where the defendant played no material role at all in commission of the crime. This extends criminal guilt to a person too remotely related to the crime. And it does so through use of policy-irrelevant analogies such as "partnership."

Of central pertinence in all this, and central to my theme in this essay, is the larger lesson implicit in Hasse's analysis: When it comes to fundamental questions about who bears responsibility, and the limits of that responsibility, rational answers require that we identify the policies that govern in the type of context under consideration; or, in the absence of settled policy, rational debate must seek to develop a choice among policies. The attempt to "discover" policy-neutral moral "fact" or "truth" as to where responsibility lies is the quest for a chimera. Hasse's analysis brings this truth out in connection with an important issue in the law, an issue around which much controversy has raged for the very reason that the underlying policies have not been carefully identified and their role appreciated.

## Ferdinand Schoeman

Ferdinand Schoeman's essay—which in my view is a model of philosophical inquiry—constitutes a remarkable complement to Hasse's

essay and the theme I wish to develop in these Comments. His essay, quite characteristically, fuses humane sensibility with intellectual rigor, and it works on several substantive levels. At one level it is an informed and insightful analysis of the responsibility of heavy drinkers for their alcohol abuse and related conduct. However this specific problem also serves as an exemplar of the substantive problem that is of central philosophical interest for the essay: Under what conditions should we hold people responsible for their behavior?

Schoeman brings out some common oversimplifications that arise in the area of alcoholism (as well as many other health-related areas). For example he calls to our attention how a category such as 'disease' does not suffice to settle the question of responsibility. Diseases may be culpably self-caused; and so we may bear responsibility for the results of our disease-related impairments. In any case, diseases rarely totally incapacitate. Therefore neither the mere existence of disease, nor even the fact that one's behavior falls in an area where the disease is operative, could ever warrant blanket absolution from responsibility for that behavior. One might add that exactly the same things can be said, *mutatis mutandis,* of mental disease or disorder.

But on the other hand, where there is no question of physical or mental disorder, it does not automatically follow that we ought to be held wholly, or even partly responsible for what we do. For one thing, the question of the voluntariness of the act must be addressed. What if the conduct is not voluntary? It might seem in the case of the alcoholic that if we exclude physical or mental impairment as crucial determinants of the abusive drinking, then the drinking is voluntary, and the drinker must perforce be responsible for such drinking.

Here again, however, Schoeman shows how matters are more complicated than that. In particular, a judgment as to voluntariness depends in crucial ways on matters external to the person—on social norms and patterns, and such judgments also require policy decisions.

In the law, for example, the slightest threat or hint of advantage designed to induce a person under arrest to confess to crime is held to render the confession not voluntary. But at the plea-bargaining phase, voluntariness is not negated even though a plea of Guilty is induced by promises of lenience, and by references (inherently threatening) to the risk of higher penalties if there is a refusal to plead Guilty, and if the trial then results in conviction.

These legal differences between the arrest situation and the plea-bargaining situation are not based merely on "the facts" about the actual state of mind in which the accused confesses guilt. There are policy-related considerations that are decisive. These pertain to the institutional settings of the admission of guilt, the institutional roles of police and attorneys, the limited resources of the criminal justice system, and ultimately the policy judgment as to where, all things considered, to draw the line. It is policies related to such factors as these, rather than the person's subjective degree of fear and confusion, which determine that the confession of guilt is involuntary in one case and voluntary in the other.

Yet even where conduct is characterized as voluntary, our conduct—as Schoeman shows in some detail—still can suffer from constraints that warrant different policies as to responsibility in different contexts. The individual's cultural background, the limits of human imagination and of the particular individual's imagination, the individual's temperament and capacities for patience and persistence, the particularities of the individual's life experience and education—all conspire to limit and direct what a person can or cannot do, indeed what we can or cannot *think* of doing. Our concept of voluntariness can fade into useless vagueness the more we enter into these matters.

Thus, however true it may be that neither disease nor genes nor other physical factors compel the drinking, still many of these heavy drinkers find it genuinely exceedingly difficult to change their alcoholic ways. For example, the task of stopping heavy drinking is much more difficult for an unemployed and ill-educated Irish youth, whose culture portrays heavy drinking as the mark of manliness, than it is for someone of high education, with a cultural background in which such drinking is seen as weakness, and whose social status, and job and family circumstances, are such as will reward self-control and offer many constructive alternatives to heavy drinking. Merely to invoke either-or slogans, such as the absence or presence of "free will," blocks insight into these aspects of the task of changing one's way of life.

Schoeman's key summary thesis is that the responsibility of the heavy drinker is "not one issue but a range of issues; answers suitable in one domain may not be appropriate in another" (p. 30). That is to say, not only do the relevant facts about the individual's physical

and psychological constitution vary from case to case, but the norms and policies applicable to those facts will vary depending on the "domain."

We may justly differ in the degree to which, and the way in which, we choose to hold the Irish youth morally responsible for his resort to heavy drinking, as compared to the moral responsibility we ascribe to the well-off person with everything else in his life in his favor. On the other hand, if we shift from the personal moral context to the context of criminal justice, we then hold both of them fully and equally legally responsible for drink-related crimes they may commit. There are reasons for this policy difference. Among these reasons are such considerations as the following.

First, the legal process of finding guilt or innocence of crime is not suited to making subtle character differentiations, elaborate analyses of motives, or analytical exploration into the defendant's life history.

Second, morality is often a personal matter, allowing those directly affected to choose for themselves how to react to the drinker. But crime is by definition a public harm, and the state's primary concern here is with protecting the larger public so long as the accused's basic rights are respected. Deterrence of crime would presumedly be weakened if individuals could generally hope to be excused on the basis of the always arguable personal psychic difficulty they may claim to have had in trying to act conformably to law.

Finally, the law is an important pedagogical tool for society. It would be counterproductive to declare officially that if a person finds it very hard to abide by the law we will not hold that person responsible for crimes he or she may commit.

Moreover policy as to whether to ascribe responsibility may vary as the time-perspective varies: Appropriate response on a particular occasion may call for confronting the individual as a responsible actor; whereas the sensible response to the problem of that person's alcohol abuse over an extended future may be more complex and call for more emphasis on the person's need for help and tolerance, as well as the expectation of responsible conduct at crucial points along the way.

Thus the question of responsibility cannot be settled—not even in the case of the so-called alcoholic—on abstract doctrinal grounds. Nor is it a question of some sort of unitary moral 'fact'—"responsibility"—to be discovered in a context-neutral way by an appropriately dispassionate

inquiry into the person's psyche, the act, and the circumstances. On the contrary, although inquiry into the circumstances there must always be, the judgment of responsibility also requires either an ad hoc decision, or a judgment that is based on criteria that are context-dependent and that themselves have been chosen as a matter of policy from among alternative possibilities in that context.

## Stanton Peele

Stanton Peele's essay elicits exploration of still further dimensions of the matter of voluntariness, a notion so crucial to an understanding of responsibility. The context, as with Schoeman's essay, is alcoholism, but what stands out, when the empirical issues are more directly addressed, is the deplorable state of the field of alcohol studies. This condition is not due to an absence of good scientists, but to the presence in the alcoholism field of a near-overwhelming population of organized, emotionally driven, economically motivated, and doctrinally committed individuals. They control the levers of power, money, politics, and organization in the nation's efforts to deal with alcohol problems. More to the present point, they prolifically generate reports, studies, and reviews, as well as a flood of publicity and popular literature, all of which either lack scientific validity, or at best present tendentious readings of valid scientific data.

However the conceptual point of Peele's essay which is the specific point I am concerned with here is his critique of the classic "disease theory of alcoholism." What Peele calls to our attention is that this "theory" represents an ideology, not a scientific report. The scientifically valid data compel a pluralistic approach to the problems.

Particularly relevant to our concerns here is one key element: The issue of self-control cannot be understood in the all-or-none terms of a formula such as "the disease of alcoholism causes loss of control." Instead, what we see in the data is that a wide variety of types of conditions significantly affect, in various ways and degrees, the drinking behavior at any particular time of a person who has a history of heavy drinking. Of particular importance to note is that for practical purposes we very often have dramatic leverage in influencing drinking behavior by manipulating psycho-social and situational variables. Such leverage

is often available to the drinker, and often to others. On the other hand, while the biochemical factors can have a significant influence, as recent evidence shows, that same evidence, plus much more, consistently shows that this influence is not so significant as to deprive the psycho-social situational factors of their potential to serve as crucial forces for change in the pattern of drinking.

All this leads logically to a re-examination of concepts such as free choice and self-control. Here we come full circle to the conceptual analysis presented in Schoeman's paper, though in this context I would now like to press the issues even further.

What we saw in Schoeman's essay is that a conscientious ascription of responsibility will reflect the complex interplay of many different relevant factors, and in the end can be decisively settled only after taking into account the social and institutional context, and making policy decisions. Now we can focus on the fact that the ascription of responsibility is one that itself encompasses several sorts of prior decisional moves, one of these being the decision whether or not to ascribe free choice or self-control to an actor in respect to some particular act.

The kind of data reported by Peele, plus related data in my own book on the topic, tell us that alcoholic drinkers have repeatedly been shown to radically change their drinking behavior if appropriate incentives or disincentives are introduced, or if the particular social setting is appropriately changed. Thus a removal from their everyday life to a hospital, or a clinical or communal setting, where the program or house rule is "Don't Drink," suffices commonly to motivate alcoholics to *voluntarily* shift to consistent, continuous abstention while in that setting. Also there have been a number of experiments in which the incentives or rules provide for self-initiated and self-controlled moderate drinking. In such situations, the expected moderation is commonly maintained voluntarily, that is without need of any other external constraints.

Some say that in such situations we are merely seeing the "manipulation," by means of "artificial" conditions, of a person whom disease had deprived of self-control. But if we adopt that stance, consistency would require that we should say that *whenever* situational changes or altered incentives are introduced for the purpose of influencing

behavior, the person is manipulated by "artificial" conditions, and therefore the behavior is not freely elected. This of course is absurd. Indeed, a *failure* to respond with changed behavior when confronted with conditions that shift the balance of good reasons, costs or benefits would be powerful evidence of *absence* of rational self-control and free choice. Moreover even if one accepts for the sake of argument that the experimental or clinical conditions are in some sense "artificial," the fact that the drinking conduct changes proves decisively that it is the *meaning* of the situation to the alcoholic, not the chemical alcohol in the body or any internal physical causation, that is crucial in shaping the drinking behavior.

On the other hand we do speak of conduct in response to coercion as unfree, even as not having any choice. And in other contexts, e.g., some legal contexts, the individual is therefore held not to have been responsible. Yet coercion, when it is not sheer physical compulsion, is a matter of altering the incentives and disincentives in the situation. Such considerations raise a theme analogous to my theme in regard to responsibility. Specifically, the question of whether and in what sense a person is deemed to have exercised choice, or to be responsible in the face of altered incentives or disincentives, is in crucial respects to be answered by a policy *and* context-dependent social decision.

For example, poverty may be crucial in leading a person to accept a job under exploitative but yet lawful conditions. In the context of contemporary socio-economic policy analysis, we will do better, pragmatically speaking, to focus on reducing poverty and on modifying the permissible conditions of employment, or on better educating the worker, than to close the matter by characterizing this as a free choice and as responsible acceptance of poor working conditions. On the other hand, we may prefer in the context of legal analysis to frame the same situation as one of responsible free choice. This is in good part because the overriding basic policy concern in this latter context is the question whether legal rights were violated, not with creating substantive social policy.

Another important aspect of the legal policy equation is sheer cost and benefit. In our legal system the cost in terms of money, labor, and

institutional complexity would mount astronomically if questions of choice, responsibility, and liability were addressed in the trial context on a highly individualized basis. Lawyers and legislators are as aware as anyone else of the crucial role that poverty can play in negotiations with the rich and powerful. Nevertheless it would be folly, except where the disparities are so unconscionably oppressive as to require no detailed inquiry, to attempt in the trial context to reach a decision that would he sensitive to the interplay of relative economic wealth, skills, power, and opportunity. To reach such judgments while conforming throughout to the stringent procedural and proof requirements of the trial process would, even aside from cost, in all probability be administratively impossible. On the other hand the criminal law's concession to our concern for individualizing factors is to deal with them in other phases than the trial process, e.g., the sentencing or damages assessment phases of the judicial process.

My thesis in the matter of choice, then, as in the matter of responsibility, is that we are pursuing a will-o'-the-wisp if we imagine that judgments as to the presence or absence of choice are discoveries, regardless of context, of some unitary, selfsame psychic event or process that is totally internal to the actor's mind. The fact is that ordinary folk have operated with such notions as choice, in matters both trivial and serious, often effectively, without ever having had to identify some unitary event interior to another's psyche.

The concepts of choice and of free choice are used on the basis of a multiplicity of complex criteria referring to the observable world and reflecting our policies in the context. Careful examination readily reveals that the ascription of choice has varied, over time and sociocultural contexts, changing when values, ideologies, and attitudes toward the person and society change.

The terms choice and responsibility are akin to the legal use of "Guilty," not to the report of a purely factual question. That is, there are facts that are legally pertinent, but the question as to which facts these are, and how they are to count, are questions that are contextual and decisional. They are policy questions whose answers, as settled by legislative or judicial decision, crucially determine the propriety of ascribing these categorial terms in one context or another.

# George P. Fletcher

Another way of approaching an understanding of the cluster of concepts centering around responsibility is by way of comparative studies. Whereas Hasse, Schoeman, and Peele analyze the concepts within the modern Western socio-cultural context in which they are at home, Fletcher adopts the comparative studies strategy, a strategy that for me, too, has been a mainstay. My own comparative study has been focused primarily on Confucius's thought, though I have also found much profit in study of the Bhagavad Gita, Buddhism, and other Asian philosophical traditions. I have indeed written about the meaning of law in the Old Testament Book of Job, but not as a scholar in substantive Judaic law. Fletcher, however, turns to Old Testament and Jewish law as the basis for substantive analysis of legal doctrine, and comparison with modern common law concepts.

As will be evident, I believe Fletcher's analysis uncovers something truly fundamental about the deep assumptions of our modern law, and indeed about our modern American conception of the individual vis-à-vis society. In this he confirms, from a different and independent standpoint, a thesis that has been central to my own work in connection with Confucius, and to the Confucian studies of Rosemont and Ames as well.

However, I do have some reservations, which I set out immediately below, about aspects of Fletcher's use of the material from Biblical-Judaic law. I do not think he has pursued his interpretive objectives consistently. I say this with trepidation; he is a scholar in the field, while I am not. But, though even angels might fear to tread the path of inquiry I take in what follows, I shall rush in.

Fletcher asserts that "In the biblical context 'blood-guilt' implies responsibility for killing." In my opinion this reflects a natural but nevertheless unwarranted equation. From a concept intricately interwoven in the web of ancient and even archaic Biblical thought—"blood guilt"—he infers a concept that is distinctive of a modern legal system evolved out of largely non-Biblical sources.

Indeed Fletcher quickly reveals how distant in connotations the two concepts are. We know that "responsibility for murder" takes its meaning within a thought-system in which the act of killing another

human being without justification or excuse under law is a wrong, a violation not only of a general rule in the legal code but also of a general moral law. On the other hand, Fletcher's own account of the Biblical concept in Exodus 22 is that it tells us of something very different: If the intruder breaks into the house when the Sun is not up, then the householder who catches and kills the intruder while in the act is to be viewed as not having seized control over the intruder's blood. The blood—as Leviticus 17:12 tells us—contains the life of the flesh, and it is the substance that is poured in sacrifice as atonement for the soul.

I believe that the latter conception must be taken, if it is properly to be understood, within the context of the theological-ritualistic imagery and doctrine in which it is at home. While I pretend to no expertise in the Biblical anthropology or theology of this doctrine, I do have some familiarity with such doctrines and imagery in various societies, including some in the Mediterranean area of the epoch. This background renders it highly implausible to me that our concept of responsibility for murder should be directly linked, as an "implication," with the doctrine that the blood is the vehicle of life, that one who draws the blood of a person or an animal thereby gains control over the "life" of that being, and that the Lord—who created the "life" in His creatures—will punish those who presume to seize control over that "life" unless they in turn shed blood as conciliation to Him.

The conceptual and symbolic connections here move in utterly different directions from the "responsibility for murder" notion. To consider a related example: Leviticus also tells us that the woman who menstruates, or who gives birth, thus shedding blood, must become ritually purified by isolation, sacrificial offering, and other ritual purification because of the pollution (Leviticus 15:19–32). Plainly the shedding of blood is not a mere metaphor for moral or legal responsibility or guilt.

Blood forms a powerful central image in Hebrew lore, as it does in a number of other cultures. Powers emanate from it, as well as dangers; pollution is as intimately linked to its shedding as is purification. And "pollution" here does not seem to me to equate with some abstract notion of moral guilt but with more or less magical, spiritual, and yet quasi-material corruption that stains the being of one who

takes control of the life-force of another being. In the Biblical tradition, it seems plain that such an act is in its central meaning an aggressive or larcenous attack on the property or dominion of the Lord, who, as the Creator and Ruler, is the only one entitled to exercise such control.

Whatever the eventual historical linkages, we lose rather than gain insight by equating an act of insult to a jealous Lord with a violation of an abstract and universal principle of justice. Later commentators, writing in much different historical epochs, influenced by Greek thought and then Christian philosophical theology, no doubt took interpretative measures akin to those that Fletcher eventually takes. They used free interpretative translation, analogy, metaphor, and argument in ways that, while anachronistic, were useful for giving the words of an ancient text a meaning that becomes plausible in the interpreter's contemporary terms. This can be a legitimate practice for those who accept a particular tradition as normative and who accordingly are practitioners within it. It is not a satisfactory method for those seeking to understand the distinctive features of a particular historical text or doctrine as it played its role at the time of its origin or original authority.

I also doubt the validity, for reasons of the preceding kind, of equating the Biblical concern with shedding blood with the "blood-guilt" remarks of Kant, writing millennia later and against a vastly transformed cultural background. And, similarly, I question the direct inference that the Biblical passages imply that killing a burglar leaves no blood-guilt "if it is in accord with basic principles of rightful conduct." This seems to me, once again, an anachronism. Indeed, as Fletcher himself notes, the Bible says nothing about so abstract a criterion as "rightful conduct" but mentions only that the sun must be risen when the householder kills the housebreaker if there is to be blood-guilt. Fletcher offers a strained, highly intellectualized reading of the notion of 'the sun is risen,' derived, he says, from Talmudic discussions. I suspect these "discussions" date from a much later period—many centuries later—than the text they purport to interpret.

Most central to Fletcher's discussion, however, is the question he raises about what possibly could have led the rabbis of the Mishna writings to hold that the housebreaker who is subject to being killed

without blood-guilt by the householder is exempt from liability for "tort damage" (Fletcher's rendering of the damages attributable to the housebreaker).

In the upshot, Fletcher's answer, if I understand it well, is that (a) Jewish law was largely self-administering; (b) the householder is, in this context, the imposer of the lawful sanction on the housebreaker; (c) there is a general principle of Jewish law that the criminal may not be punished for two concurrent offenses but only for the more serious one. From these propositions it follows that the housebreaker who may lawfully (i.e., without blood-guilt) be punished with death for the housebreaking may not also be held liable for the damages. On the other hand, if the housebreaker cannot lawfully be punished with death (e.g., because at the time of the offense the sun is risen), then that housebreaker may be sanctioned by being held liable for damages.

Fletcher, of course, wants to make the point that, given such an account, it is implicit that there is no clear discrimination here between the householder's action viewed as self-defense and that same action viewed as lawfully imposed punishment. We Europeanized moderns see the element of self-defense as a basic and distinct feature of this situation, sharply differentiated under our legal doctrine from the matter of imposing lawful punishment. The individual has the right to self-defense; imposition of punishment is reserved to the state.

Fletcher says, "There is no doubt that the sages intuited the difference "between force used in self-defense and force used in imposing punishment." But, he says, "they had no conceptually refined way of expressing the point."

I wonder if this isn't once again, a case of reading history backward, transforming a genuine difference between old and new into a seemingly inferior sophistication on the part of the ancients, who are alleged to have failed to see clearly what we so clearly see. It seems to me at least plausible that the putative basic right of self-defense arises out of our modern proclivity to make a sharp and fundamental distinction between the individual, private, personal self as the ultimate human reality, and, on the other hand, the social structure that consists of nothing more than a conceptual reification of the external relationships among persons. This distinction makes it plausible that defense of the existence of that person lies at the heart of social

existence. It then seems obvious that self-defense is what is at issue when the life of a person so conceived is threatened. But what if the individual is seen in no such ultimate role?

In fact this highly individualistic and private-istic concept of the individual is an artefact of our later culture rather than a brute fact about the Reality that grounds ultimate and universal norms. In other words it is we Europeanized moderns who have invented and sanctified the alienated, isolated, atomic self that stands in various external relationships to other items in the world rather than being organically identified with them. Therefore it is we who see self-defense as a kind of ultimate right.

However, when Fletcher sketches the idea of the "talmudic communitarian mode of thinking" at the end of his paper, he is in effect making a truly fundamental point that can guide one rightly in this matter. But what this latter mode of thinking generates is not a dimly intuited differentiation between the householder's exercising his right of self defense and his also imposing lawful punishment. On the contrary it reveals the householder as simply executing the law—whose norms in action constitute the warp and woof of the web of community, indeed the very identity and integrity of the community. The idea that somehow "*self*-defense" here self-evidently is the concern at the forefront is an anachronism. It is the communal way of life that is defended, or in some cases it is defense of the Lord's prerogatives.

I have also touched on this theme of the absence of a concept of a private atomic self as the ultimate social reality in connection with the Confucian essays in this volume. As I said earlier, I see Fletcher's essay as contributing one more confirmatory piece of evidence from ancient Jewish culture. And we meet the theme again in connection with the essays by Ames and Rosemont in this volume.

Fletcher is puzzled by the persistent intuition and impulse—which he recognizes persists even in our own day—that attributes punitive rights to one who acts in self-defense. I suggest that this appears as a puzzle just because the distinction we make between the self and all else is one that inherently embodies incoherencies. As I said, we aim to sharply divide the self from society and the Law. Then, in emergencies we assign to the threatened individual the task of taking protective measures against destructive forces to the self. But we assign

the moral-legal task of punishment to the Law. Yet this division of labor rests on the assumption that the individual and the law are inherently separate and distinct. But why not view this attack on the attacker as the law-in-action, the community-in-action in this place, time, and situation?

In making such proposals, I remain loyal to the radically pluralistic view that informs all I have been saying. I am not arguing that the Judaic "communitarian" view or the Confucian view of human nature and community is right, and that our modern Europeanized view is wrong. Nor of course am I arguing the contrary. Rather I think they all open profoundly valuable ways of thought and feeling and action to us. But none is completely adequate to reality, neither in theory nor even for practical purposes. Thus each drifts into incoherence as we trace it out with conceptual rigor and a humane sensibility. Here, as I wrote in my essay on Job, the *Book of Job* is the ultimate voice. Whether it be the perennial puzzles of free will and responsibility, or related puzzles about punishment and self-defense, we lose our footing as we move from the core area where the particular doctrine is most at home to ever more distant areas to whose topography the concepts are increasingly unfitted in spite of their claims to universality.

I do not mean to imply that I have now clearly resolved matters raised by Fletcher. Far from it. But, profiting from his probing questions, his unusual source of material, and his thought-provoking theses, I have tried to carry on, in my own way, in directions his work suggests to me as it intersects with my own.

# Henry Rosemont, Jr.

Rosemont is correct when, in the course of his very generous and deeply appreciated remarks about my work, he hypothesizes that I share his grave reservations about the concept of rights. And he is correct when he attributes this attitude on my part to a perspective greatly colored by Confucius's way of thinking about human nature and society.

I would begin my own comment in turn on Rosemont's essay by remarking that it is a natural companion to Fletcher's essay. For, as I see it, the complement to the concept of responsibility is the concept of rights. Fletcher pursues a comparative, philosophy strategy,

using Biblical law to throw light on the domain connoted by "respon-sibility," the domain of sovereign restraint distinctive of personhood. Rosemont pursues a comparative philosophy strategy using ancient Confucian thought to throw light on the complementary domain—the sovereign privileges of persons, their personal "rights."

"Responsibility" and "rights" are two concepts that are central to what Rosemont calls a "concept-cluster." And it is the reach and validity of this concept-cluster that concerns me centrally in these Comments.

Rosemont is right on target in focusing our attention on Western parochialism in moral theory and moral psychology. He argues that the basic, familiar concept-cluster that the modern West takes for granted in these areas is subject to radical questioning from radically different cultural standpoints.

Rosemont uses analysis in depth of canonical Chinese texts to develop his thesis. The gap between the two concept-clusters is so deep as to preclude even characterizing the differences as "moral." For to say that the Chinese texts reflect a different moral vision from the European would imply that the two cultures at least share a common concern: the moral life. Yet Rosemont argues there is not even this common concern, for the very concept of the moral is alien to the thought expressed in the Chinese texts.

It is not, of course, that the Chinese had no norms or standards at all. Confucius plainly taught his disciples how to live and how to think about how to live. The specific patterns of conduct he described or recommended often differ markedly from those favored in the modern West. But more to the point, Rosemont argues that Confucius and his contemporaries conceive of what they are doing and why they are doing it in terms that are not only alien to ours but that are also incommensurable with ours. We may achieve reasonable understanding of how the Confucian conceptual system works, but we cannot simply translate it into equivalent terms using the cluster of European con-cepts we subsume under the heading of the moral.

Rosemont vigorously argues that such a study reveals an alternative vision of human existence that has been viable in its essentials for millennia, dominating one of the three major civilizations of human-kind's existence during the past three millennia. Appreciating this other vision, one is better able to understand, by contrast, the Western

vision. One sees what potential riches the latter sadly lacks, as well as what virtues, some unique, that it all the more evidently has. In short the upshot of such study is to enrich, not to justify radical moral skepticism or an impoverished amoralism, as a crude relativism would have it.

I want shortly to offer some reflections that expand upon themes of Rosemont's essay, but I do wish first to express at least one of several reservations I have about some specific arguments he presents.

I agree with him in finding the origin of the concept of rights to be historically recent and local to modern European culture. On the other hand I do not think that an absence of explicit reference to it or consciousness of it in other times and places shows that the claim of universal human rights is invalid. That human beings possess fundamental rights might still be a moral truth about human beings that is independent of culture, and also independent of awareness of the concept. The refutation of either of these propositions would require argument more telling than any Rosemont provides.

On the other hand I do agree with Rosemont that there is a remarkable paucity of sound argument in favor of the thesis of universal human rights. The notion emerged relatively recently and captured the minds of Westerners, and now increasingly has spread to other peoples in the world as Western influence has spread. Its appeal is understandable. But we remain unclear as to exactly what we mean by "rights", what rights there putatively are, and more to the point here, we remain unclear on what grounds other than received dogma one can justify so confidently ascribing rights to all human beings (or for that matter to animals or trees, as some now do).

And indeed I am quite prepared to attack the doctrine of individual rights—attack it at least to the extent of arguing that it is not so purely beneficent a doctrine as we tend to assume today. Along with its major benefits it has profound potential as a socially disruptive and anti-human force. It is against the background of a Confucian vision of human life that this corrosive effect of a rights-based morality comes clearly into focus.

The Confucian vision is one in which the social relationship, not the private individual, is seen as the fundamental social reality. As Rosemont points out, even our way of putting it, using the concept

"relation", builds into the expression implicit reference to the terms of the relation as the ultimate building blocks. Yet this is un-Confucian. From Confucius's standpoint, it is the concept of the individual *person* that is an abstract conception. On this view, "person" is a creative abstraction from the host of meaningful social activities and social statuses that intersect in the region of one's physical body. And it is in the medium of social conduct, not in some inner, personal psychic region, that the distinctive values of human existence are actualized.

The more one sees how humanely this Confucian vision can be elaborated, and with what conceptual sophistication, the more one achieves a perspective on the doctrine of individual rights that high-lights the alienating character of this doctrine. One appreciates more deeply the significance of the fact that, seen in the perspective of human rights concepts, I stand *apart* from all others, protected *against* them, entitled to make demands upon them, concerned with my personal choices, my personal aims or fears *as over against* any other who may threaten to frustrate me. Rather than seeking fulfillment *through* shared and mutual engagement, the definition of the situation in terms of personal rights leads me to seek fulfillment by invoking barriers to the conduct of others, and primacy for my personal will.

This alienating impulse is readily embodied and expressed through impersonal, legalistic forms: the threat of the power of law as one's weapon for backing up one's rights against others. Intellectually generalized rights, not direct empathic and sympathetic response in action, provide the medium of thought about relations with others. The disengaged, third-party police and judicial bureaucracy provide the ultimate context and source of decision-making and decision-executing, arbitrating among conflicting claims of right.

If one feels wronged, the tendency today is to think of legal suit. If one's medical treatment fails, one considers malpractice. If one is discharged from employment, the panoply of legal protections of the employee's rights is now so all-embracing that suit for damages is an instant option. This in turn leads employers in educational institu-tions as well as businesses to alter their hiring, evaluating, and firing policies so that, for example, no negative informative comment can safely be uttered for fear of legal reprisal—a justified fear under our present law. The trend comes full cycle and feeds on itself when lawyers

(as well as all other professionals) are subjected to suit for malprac-
tice (violation of the *rights* of the client to proper service), which in
turn necessitates ever more elaborate (and otherwise unnecessary)
precautions and expenditures. The human and monetary cost, not only
among lawyers and physicians, but also in the professions generally,
saps the vitality and undermines the humanity of our society.

At one level of causal analysis one can allege that it is the ever widen-
ing influence of the legal profession that engenders this growing
corrosion of humane social relationships. We need not ascribe this
solely to crass monetary motives. Those who have committed their pro-
fessional lives to the law, and who daily practice it, inevitably tend
to see problems and situations in legal terms.

At another level of causal analysis, however, we can see that the
spreading growth of this legalistic perspective could only be accept-
able in a social setting where the people generally are prepared to
define themselves and their relationships in terms of who has the right
to do what to whom, or with whom, or against whom.

In the end, the rights-orientation in Western, and especially
American thinking and attitudes, threatens by its bureaucratic and
corrosive oppressiveness to undermine the very protections that it so
centrally values. We are beset, at times paralyzed or oppressed, by the
proliferating rules and regulations purportedly intended to protect
our dignity and our rights.

I trust it will not be inferred that I see no value in rights-protections
in the various types of situations I have been discussing. There are
indeed incompetent doctors and lawyers, negligent engineers and
architects, unfair employers, and institutional practices reflecting racial,
religious, sex, ethnic, and other biases. Nor do I mean to deny that
a rights-based approach can accomplish some good in these matters.
The doctrine of rights is a powerful and valuable one.

What I am arguing is that a *predominant preoccupation* with this approach
to solving social problems increasingly generates social alienation and,
through proliferation of procedural devices, becomes in the end self-
defeating because of its oppressiveness and unworkable ponderousness.
And it blinds us to the constructive potential of other orientations.

I am trying to suggest that if we had a complementary vision
along, say, Confucian lines, we would just as instinctively seek social

solutions through personal, direct, humane consensus-shaping, rooted in a shared commitment to the accepted forms of social life as the foundation of a way of life, and subject to amendment or refinement where the principals in the dispute jointly see this as the way to harmony. We might see the cultivated social relationship as a prime source, or the prime source, of value, rather than seeing this in the protection of one's private interests as against others who are thus conceived as potential invaders of our rights.

It may seem in our present American legalistic ambience that I am recommending some utopian ideal. If so, this only reveals how our parochial rights perspective has blinded us to the obvious. For we still have many areas of our life, including the most sophisticated institutional ones, where people rely on gatherings of those concerned, in committees, or in family or informal friendship settings, in order to probe the most complex problems and reach the most difficult decisions. We are no strangers to consensus and the spirit of shared and mutual action and interest. But the dominant mind-set that defines the situation in terms of rights has become, for all its usefulness in some contexts, a corrosive, alienating force in others.

# Roger T. Ames

To move on to Ames's essay is to appreciate still further the force of Rosemont's thesis that we deal with a concept-cluster, or, as I spoke of it in my Confucian book, a distinctive imagery in Confucius's vision of human existence. For what I am in effect doing in these Comments is to trace through the essays an interrelated web of ideas—a certain pattern of concepts, syntax, idiom. In this web the notions of responsibility, choice, individual rights, selfhood, and (as we shall see in the remaining essays) the integrity and autonomy of the self, all serve as nodal points. Some of the essays deal with these ideas primarily through analysis of their internal logic, others through analysis of comparisons with other ways of thought from other times and cultures.

I do want to preface my comments on Ames's essay, however, by saying how very much I appreciate his generous remarks about my own work. I can warmly reciprocate in regard not only to his scholarly

contributions generally, but also in regard to the illuminating essay he has contributed to this volume.

I agree with much in Ames's essay—with much more, probably, than he himself recognizes. As I see it, some of his principal "reserva-tions" about my interpretation of Confucius on the self are not really substantive differences with me at all. They only appear as differences because of a difference in our terminology.

Nevertheless, Ames's discussion of "self" in Confucius has opened up to me an interesting new perspective on the matter. I see now that my own terminology in my essay on "The Problem of the Self in the Analects" was unfortunate in a key respect. I failed to follow through consistently on my program of seeing through the distortions embedded in extant translations and commentaries and—so far as possible—reading the original text freshly, even "naively." I think Ames, too, makes the same error in a slightly different form. But it is his analysis that opens the way to the reading that I now see as the one that is truer to the original.

It is not a solely terminological project for me to show that Ames and I agree on certain major theses where his terminology leads him to think we differ. The project is a substantive one, for what we shall see is that, though he and I have taken different routes, we end up confirming the substance of each other's interpretation of Confucius.

Ames challenges my denial that the Confucius whose words we read in the Analects was committed to "cultivation of the self" as a central teaching. In my essay on "The Problem of the Self in the Analects" I said it was the commentators, not Confucius, who have focused on the concept of the "self" as somehow a basic one in Confucius's think-ing; and it is they who propose self-cultivation as a principle of porten-tous significance for him. Ames's first major reservation about my view concerns just this thesis of mine.

In developing my analysis, I focused my attention on the terms *chi* and *shen* as referring in the Analects to "self." Ames differs from me on this point, suggesting that I am begging the question when I take the terms that *we* would appeal to in explaining what *we* mean by "self" to be the terms that best express what for Confucius was the self. Ames maintains that if Confucius's notion is "importantly different from our own," then, in focusing on the words I did, I may have been

"underestimating the magnitude of the problem in the translation of Chinese culture into our own tradition."

In place of my choice of terms to represent the idea of 'self' in the Analects, Ames proposes that we take the term *jen* to denote 'self.' And Ames translates *jen* as "authoritative person" in its more exact and specific connotation. (I rendered it in my paper as "true humanity.") It deserves mention, though it is not central to my concern here, that Ames's translation is a novel rendering of the term *jen*. I do think the case that Ames and Hall make for such a rendering in their rich '*Thinking Through' Confucius* is a strong case, though I think that some other term than "authoritative" (perhaps speaking of, e.g. the "consummate person") would avoid some of the unfortunate overtones of the word "authoritative."

I turn, then, to explore Ames's thesis that it is *jen* which denotes 'self.' We are told by Ames that Confucius articulates 'self' (i.e., *jen*) in a "robust sociological language." "The conception of self in Confucius is dynamic as a complex of social roles." "Not just role playing, but *good* role playing, creates a self." [emphasis in original] Ames adds: "The notion of autonomous individual does not arise. Ironically, in this tradition, the more individualistic and narcissistic one is, the less one is a 'self.' "

Ames comments that "The function . . . of disciplining *chi* (one of the terms commonly rendered as "self") through ritual practice is to take up the appropriate place for oneself in relationship to other persons in the community." And Ames stresses that even the word "relationship" can be misleading, for it suggests that there are two terms and a ground between them, whereas there is for Confucius a distinctive social pattern which we may refer to as self-other without implying that these terms refer to ultimate atomic entities that constitute the irreducible terms of these social relations.

This is not the place to inquire finely into every nuance of such formulations. I prefer to say, summarily, that I agree with the substance of what Ames says. The fact is that I was affirming essentially the same position in my essay on the 'self' in the Analects, in my essay on the "one thread," where I discussed *jen* at some length, and in my book on the Analects.

Perhaps one place for me to locate the source of misunderstanding between us is at the point where Ames speaks of me as being

"puzzled" over the seeming absence of an 'inner psychic life,' and then later offers as "the answer to Fingarette's problem" the thesis that for Confucius the "self" is articulated in "a robust sociological language."

As a matter of fact, contrary to what Ames says of me, I was not puzzled by the absence of any concept of an inner psychic life in Confucius, nor did I express any puzzlement, nor did I characterize this absence as only "seeming." On the contrary I said that Confucius's language and imagery in this context was genuinely different from ours—and radically so—but that it nevertheless presents an "intelligible and harmonious picture to us" (p. 34, *Confucius—The Secular as Sacred*). Rather than posing a problem, this picture revealed something that *was* central for Confucius—the social nexus as the realm of distinctively human existence, action, and value.

I argued that what Confucius taught us to aspire to is a condition I called "selflessness"—a term whose use in this context I explained in some detail. This ideal condition of human being, the consummately human mode of existence (and therefore exemplifying the consummately human person), I described as one in which the *Tao* constituted the ground of all the person's actions. I contrasted this with the presence of self—i.e., the presence of "individualistic", egoistic, particularistic grounds for action. Such a private self, a private willfulness, though it is the very core of human being in the modern Western tradition, is not at all so in Confucius's view.

Moreover I indicated—what I had said in my earlier book, and what I developed in further detail in my "one thread" essay—that in speaking thus of the *Tao* I was referring to the ritual forms of social relation and action, the *li* viewed as the structure of ideal conduct and thus as one conceptual perspective on *Tao*. The complement to the perspective of the *li* is the *jen* perspective on *Tao*. *Jen*, I argued, is the view of the *Tao* from the perspective of the person's stance, a stance that is in conformity with the *li* inasmuch as it is actualized in conduct in the form of *li*. Thus *jen* is the ideal human stance. To think in such terms is to take the behavioral-social perspective. To speak of a stance in accord with *Tao*, or of forms of conduct that accord with *Tao*, is to speak of one thing, the *Tao*-actualized-in-community, but to do so from two different perspectives on *Tao*.

Now—again putting aside nuances that in other contexts might be important—the substance of the matter is that Ames prefers to speak

of "self" in connection with the person who has achieved this ideal stance, whereas I chose to use the English word "self" to refer to what it means in English and to what we in the West view as the self—the private ego and will. My way of speaking inevitably led me to speak of the person who had achieved *jen,* and thus had transcended egoistic motivations, as having got free of selfishness, as being "selfless." And there is no controversy: One *is* supposed to cultivate *jen.*

In short we both are describing the non-ideal, not fully cultivated person in essentially the same specific terms; and we both speak of the consummately human, or "authoritative person," in essentially the same specific terms. When I speak of the ideal person as having an empty self, or as being selfless, I mean that the person has now actualized what Ames calls in English the "authoritative self."

Taking the English word "self" in its normal English meaning, as the private individual ego, I said that Confucius in effect wanted us to cultivate selflessness. I think that is legitimate usage, not distortion. I hold no brief for my usage, however, as against Ames's—so long as one makes clear what the usage is. I was explicit about what I meant in my writings; he has made his meaning clear in his writings. I think it is encouraging to see that although our linguistic choices differ, our substantive view comes out much the same.

Beyond all this, however, there remains a further development of this line of thought that Ames's analysis suggested to me, and which makes me doubly grateful for his work. I now suspect that we distort Confucius's thought at the outset by imputing to him any concept of "the self" at all.

Let me explain what may initially seem a preposterous supposition. And I will use my own essay on the self in Confucius as a text in need of correction. I translated, for example, as follows: "Master Tseng says, 'I examine my self' . . . "; "One should not allow what is not *jen* to affect or impinge on one's self"; "govern the self rightly"; " . . . sacrifice the self . . . " In these passages, and in others, I may have lost the battle before I started.

What if, instead, I had written: " . . . examine myself," " . . . impinge on oneself," " . . . govern oneself . . . " " . . . sacrifice oneself . . . "?

The point is: Why should we reify "self" by giving it the independent noun form in English, and thus impute to Confucius the notion

of some inner entity, some core of one's being—whether egoistic or ideal? If Ames and I are right in our basic view of Confucius's ideas in this area, we ought to make it a point to avoid speaking of "the self" in Confucius. We ought to speak of a person as acting, but not suggesting by "person" this notion of an Actor who somehow embraces inwardly a moral or psychic core which is then expressed in action. On the contrary, the fundamental moral-human reality is (as Ames and I agree) the social nexus, and persons along with many other things receive their specific, humanly relevant nature, as well as their humanly relevant location, by reference to and as a result of the communal life-forms. "Person" is an abstraction, a set of complex attributes conceptually abstracted from the social reality; social reality on the other hand is not an abstraction but is the concrete reality.

In short, we would do better, as I now believe, to translate Confucius by use of the reflexive idioms in European languages. Then, when I "examine myself" what I do is simply to examine this person, not some inner, individuating core of my humanity. We should translate the relevant Chinese much as we translate the German, "Ich fühle mich heiss," or the French, "Je me demande. . . . " These are reflexive syntactical forms with no implication whatsoever of an inner core of one's identity.

All of this, not too surprisingly, implies that the later commentaries and Western translations that render these remarks of Confucius in terms of "the self"—e.g., "cultivate the self" have been tacitly putting into Confucius's mouth a notion that he never had but that derives from their own Indian, Buddhist, or Christian intellectual backgrounds.

This point of view, in turn, throws a certain light on the notion of responsibility. For it is of the essence of the latter concept, in its important uses in the West, that it casts the person in the role of an ultimate initiator of action. Where we ascribe responsibility, we so to speak close the circuit. The point, in law and in everyday morality, is that we need go no further: Action has its inception with the person held responsible. It is this mysterious ultimacy that gives rise to such doctrines as that of "the will" and "the self"—the invisible interior person and act. We do not really explain how an ordinary person can *initiate* action—the Creation out of Nothing—but we postulate a secret homunculus with a wonderful special power. This latter image

satisfies because the idea of the person as being in some way the absolute initiator of action is in effect retained, but we evade the necessity of explaining how this could be by locating the transaction in a private, inaccessible domain.

On the other hand, the Confucian viewpoint, seeing "person" as a complex abstraction from the concrete social nexus, does not require or even permit use of our concept of personal responsibility for an act or consequence thereof. Lacking the concept of person as the locus of the ultimate, as an "atom" out of which actions and relationships are *ab initio* constructed, this Confucian viewpoint needs no concept of a mysterious interior self or soul to represent what the physical body plainly is not—an irreducible source of action beyond which there are no further links in the chain of causes of that action.

Thus Ames's essay helps take us further toward appreciating and understanding the parochial character of the individualistic, moral conception that holds sway in modern Western thought.

# Mike W. Martin

Having explored our conception of personal responsibility and related conceptions from cross-cultural perspectives, we can return with fresh insight to analyses of this cluster of notions from an internal standpoint. Martin's subtle and probing analysis of honesty with oneself strikes a chord in my own philosophical soul.

Martin elegantly sets out important distinctions intimately related to the concept of personal responsibility. He distinguishes carefully between the virtue of honesty with oneself and the pretender to that virtue—implacable self-exposure. He distinguishes between the virtue of truthfulness and the uttering of true propositions, between the virtue of candor and, on the other hand, mere lack of tact. This sort of analysis, distinguishing between authentic virtues and their literalistic and perverse look-alikes, makes it possible to consider deeper issues unhampered by the surface clutter of emotionally charged labels whose ambiguities in regard to the genuine article and the look-alike obscure what is really at issue.

Profiting from, and accepting a very great deal of what Martin shows, I end up with two major questions. One of them concerns a

matter internal to the analysis that I had not even seen until Martin's analysis revealed the issue clearly to me. It has to do with the element of independent value judgment that is essential for discriminating the authentic virtues from their literalistic false cousins. The second question is one that I bring to the matter independently of Martin's analysis, and in part as the fruit of cross-cultural analysis. I question whether the most fundamental values he takes for granted are as self-evidently valid as he seems to presume. Specifically, I question whether such virtues as self-honesty, truthfulness, and candor, even in their most authentic forms, are, or are universally held to be, the supreme values Martin seems to expect the reader to agree they are. I might add that the two questions I have identified here are not so unrelated as they might initially seem.

My first question concerns Martin's thesis about the criterion for identifying the cardinal virtues. These virtues turn out to be identifiable as such only on the condition that we have independently judged, on the basis of other values, that the putatively virtuous conduct is worthy of approval or admiration. I take this to be a most important insight of Martin's. As he shows, it is only in this way that we can distinguish, for example, the virtue of candor from the vice of hurtful tactlessness.

However if we do accept Martin's analysis, we run into a paradox. For suppose I ask whether my conduct is consistent with the virtue of truthfulness toward my friend (even though on this occasion, out of tact, I evaded speaking the unpleasant and hurtful truth, and thus knowingly allowed what is untrue to be inferred). On Martin's analysis, in order to answer my question I must not only know that I engaged in a misleading evasion of the truth, but also whether in the circumstances my doing so was "objectionable" in the light of other important values in that particular situation.

Now presumably the importance of calling something a virtue is that this identifies it as a touchstone, an independent criterion, of how one ought to act. But it seems that I do not know whether I have acted rightly (virtuously) until I have judged, in the light of other values I consider important, whether my conduct has been objectionable. In short the judgment that I have acted virtuously is derivative from a prior value judgment, and is not an independent basis for making value judgments.

Thus this concept of virtue cannot play the role that one typically expects of it: One cannot identify a form of conduct that, in and of itself, serves as a supreme criterion of moral value—or indeed as an unambiguous criterion of moral value at all.

One of the implications of this outcome, of particular practical interest, is that it produces still another kind of paradoxical result. The paradox arises because the "important values in a particular situation" can surely include those embedded in important traditions and social conventions about the proper forms of social intercourse. But traditions and conventions differ.

Americans and Japanese differ markedly in their conventional values regarding outspokenness. There are many countries whose conventions of courtesy call for saying what it is believed will please the interlocutor, regardless of whether it is true. Also, as is well known, the classical culture of China raised indirect allusiveness—rather than outspokenness—to an art form.

This conventional indirectness and ambiguity is not *mere* form. It is akin to euphemism. But if the purposes of conventional euphemism are to be achieved, there must be some substance to the matter. That is, if in fact the frustrating or critical message were clearly and truthfully delivered to the one addressed, then the point of the social convention would be defeated. Euphemism genuinely obscures an element of the relevant truth. For this very reason euphemism can *mislead,* sometimes seriously. It is not rare that finally "calling a spade a spade" wakes a person up to the unpleasant part of the truth, formerly obscured by euphemism. Conventional indirectness or untruth plays a similar role, even though everyone involved knows—*in a way*—what is going on.

In any case, the virtue of healthy candor in one culture is the vice of civilized affront, of insult, or of aggressive ego in another. And this line of thought leads me to my most fundamental difference with Martin—not with the substance of his analysis, but with the value assumptions from which that analysis sets out.

My difference with him is that I do not see good enough reasons to accept these traits, even those he eventually defines as the authentic virtues, as having supremacy as values. I accept his thesis that their moral value depends on other important values, and so I see them

as having varying degrees and kinds of value, depending on the individual's way of life, and the social conventions and values in that individual's cultural background. More specifically, I believe that the assumption of supremacy is one that in practice, and perhaps often in word, is rejected by a great many people—probably by far most— even in the Anglo-US-North European culture. In the latter cultural areas these virtues of honesty often receive lip service as supreme, but are relatively rarely treated as such in practice—because too great or too consistent a commitment to self-honesty or candor conflicts with other important values in the way of life of the majority. One must be "practical," as they say.

Finally, there is an ambiguity in Martin's position, as I read it, that calls for comment. If being in touch with what is most truly ourself is constitutive of self-fulfillment, then self-honesty is indeed an essential component of the ideal condition. But if, as I think Martin also and more usually means us to understand, self-honesty is a necessary instrumental condition, the *means* of achieving a certain ideal self-awareness, then the claim is a dubious empirical claim.

Of course self-honesty may well be a means to self-fulfillment. But it is not a necessary means, and even more importantly, it can not uncommonly be a serious obstacle to that end. Martin gives no substantial consideration to this latter possibility, which can be thought of in the following way.

The realities of human nature are such—as Freud and many others since him have observed—that every individual is in some respects unable to bear the psychic burdens that an honest insight into self would generate. Freud did not lightly use the term "defenses" (*Abwehr*). The fundamental insight that the term expresses is that there can be aspects of ourself that in some situations or periods of our life are (for various reasons) so unbearable to contemplate openly and honestly as to threaten self-destructive trauma if confronted. In order to defend such autonomy as we have from being thus overwhelmed, we are compelled to engage in some form of denial of the truth. Such denial is literally self-defense. Freud saw and systematically explored the double-edged character of self-honesty: It can be a way of getting in touch with oneself in a way that increases autonomy. But it can often be something that would cripple or destroy our autonomy, something

that can pitch us headlong into a condition of diminished self-honesty, and even of deep neurosis or psychosis, i.e., of systematic, chronic loss of autonomy.

We have rich evidence that the achievement of self-awareness is seen in some Eastern traditions as an ideal which must be arrived at in stages. Each of the pre-ideal stages typically requires certain forms of unawareness and self-delusion if progress to the next stage is to be made. In particular I have in mind various of the enormously rich, millennia-old Hindu and Buddhist meditational disciplines. In these disciplines "devices" are essential, the devices being in effect distractions from some aspects of one's inner nature, fictions or even actual untruths or deceptions designed to fend off what is at that stage threatening or confusing. Such self-distraction and self-deception opens the way to awareness of the specific truth that one is at that stage prepared to confront.

Martin's perspective is, I believe, reflective of a Western intellectual's perspective. For that reason a cogent analysis such as his is very valuable. It illuminates the field for those many who dwell therein; and it provides a good map for those who stand a bit outside it and try to be objective students of the terrain. And in particular, as I said, I find his analysis of the criteria of a genuine virtue to be illuminating, although when followed through to its implications it reveals their radically dependent character.

# İlham Dilman

Dilman's theme is closely related to Martin's, but it raises the issues in a way that is remarkably close to the way I have gone at them in my own work. Indeed as long ago as the writing of my Ph.D. dissertation, my inquiry centered on discovering whether there is any internal relation between gaining a new understanding of oneself and changing one's values and conduct. We all know that significant, new self-knowledge is often followed by shifts in one's values and conduct. My question was whether there is some sort of necessary connection here, a connection, moreover, that is in some way rational or at least humanly meaningful rather than merely causal.

In the course of that inquiry my strategy rested on acquiring a reasonable mastery of psychoanalytic theory and clinical data. For it seemed on the face of it that in psychoanalytic therapy there was some internal, rational, and necessary connection between acquiring insight and personal change. I saw here a potential source of information as well as a generator of philosophical intuitions. It was the beginning, though I did not realize it at first, of deep changes in my own personal and philosophical life.

The philosophical question I posed was in no way satisfactorily answered in my dissertation, but that question has remained a central one for me ever since, at times addressed directly in my writings, at times lying in the background. I have tended to the conclusion that there is some internal connection between self-knowledge, the notion being understood in some important and natural sense, and who we are and how we live upon gaining that knowledge.

İlham Dilman, whose sensitive and sophisticated probings into such matters I have admired and profited from for so many years, has done very much in various of his writings to throw light on this question. In his essay in this volume, he tries to clarify and tighten his argument for the thesis that self-knowledge *is* self-change, and is not merely a contingent cause of change. Self-knowledge, he argues, is change in the direction of authenticity, of taking charge of one's life. It is not only "finding" but *being* one's true self.

Whereas Professor D. Z. Phillips sees this view of self-knowledge as an unduly optimistic one, Professor Dilman supposed that I would be sympathetic to his position, which is the case. Nor do I think Dilman's position is unduly optimistic.

What is necessary, however, is to see why this is not really a question of optimism or pessimism but of what we are getting at when we say, for example, 'At last she knows who she is.' Dilman's analysis could be characterized as optimistic or pessimistic if the asserted relationship between self-knowledge and such things as autonomy, being in control of oneself, and personal growth were a causal relation. In that case we might suppose that the causal relations had been too simplistically stated in the direction of outcomes justifying optimism, and that Dilman's analysis is blind to the possibility of causal contexts that warrant pessimism about the outcomes.

As I see it, however, the analysis is not a causal one. The point can be stated, highly simplified but along essentially the right lines, in this way: Not knowing who one really is can be viewed as analogous to having several possible destinations, but not yet having chosen, or having evaded choice. It is only in actually choosing that one truly knows where one is going. And it is therefore in virtue of choosing that one is in this respect in control of one's self. Having chosen, one might say, "I know at last where I'm going, I have at last found my proper direction." This "found" is not an announcement of a mere piece of information that I have learned about myself. "I have at last found myself" is a truth; but it is a truth that I have created by a certain kind of decision I have made. I do not choose and then find out what I have chosen; rather, in certain contexts choosing is finding oneself. More fully and formally stated: When, after doubt, confusion, indecision and deliberation, I finally choose with confidence and full, unambiguous commitment, I may properly express this by speaking of having found myself. This line of thought points out, I hope, the main lines along which we will best follow Dilman's thinking.

Central to the analysis is Dilman's distinction between *knowledge about* oneself—the sort of knowledge based on observation of one's past and one's present that any observer could in principle acquire—and *self-knowledge*, or *finding* oneself. Questions of optimism or pessimism arise because this distinction is often obscured. Then it seems that the claim is that learning some fact *about* oneself necessarily brings about (causally) a change in the direction of greater personal autonomy. That claim would indeed be both unwarranted and unduly optimistic, as well as mysterious.

Finding oneself in life is a subjective event in the sense that it includes as a distinctively necessary component the act of committing oneself. "Subjective" as used here does not mean unreal, but "peculiar to the subject." "I know who I am" means, among other things, "I know what I stand for." And this knowing consists in the actual self-aware *standing* for it.

Although Dilman speaks of autonomy as control over oneself, he is of course careful to emphasize that we are not and cannot be in total control of our nature and destiny. We live and move in a sea of circumstance, very much of which is beyond our control, but which

nevertheless has a pervasive influence upon us and within us. In ways too complex and too pervasive of our being for us to be able to fully understand it, we are each a product of those circumstances.

Yet, that much granted, here I stand, here and now, capable of initiating commitments and conduct that can render determinate in some important respects a future which still allows of alternative possibilities until I do make my determining move. Thus my act can genuinely render an otherwise indeterminate future determinate in some respect.

It is also true, and a source of confusion here, that acting with self-knowledge may also engender causal chains that issue in one's adopting certain further intentions and acting accordingly. This may result in growth toward still further personal autonomy or emotional maturity. But then again, it may not. This is a contingency. Much will depend on circumstance, and so one cannot predict *a priori*. To assume that the effects will always be salutary and in the direction of further autonomy would be optimistic, indeed unduly optimistic.

Thus Dilman is right in saying that to know oneself is to be in control of oneself. It would be more strictly correct to add the qualifier "insofar": To know oneself is insofar to be in control of oneself, to be autonomous. There never is total self-knowledge, i.e., total, definitive resolution of all value issues in regard to all possible relevant circumstances, and so, even in this respect, there is never total control of oneself.

I believe that in his omission to make explicit this latter qualification, thus allowing for the overtones of absolute or all embracing success in the matter, and perhaps in his omission to sufficiently emphasize the difference between subjective self-knowledge and objective knowledge about oneself, Dilman does open himself to misunderstanding that results in charges of undue optimism.

Inevitably one must bring into this discussion the theses of Professor Martin. Broadly speaking, Martin argued for the high importance of honesty with oneself, characterizing it as a primary virtue that is intimately linked to such traits as candor and truthfulness, as well as to autonomy and moral virtue generally. I in turn was critical of the conclusion that honesty with self is a primary virtue. It may seem that in this I am inconsistent with my sympathy for Dilman's thesis. The

fact of the matter, as I see it, is that the Martin and Dilman essays are not on all fours as far as their major claims go.

In the first place, Dilman aims to display relationships among such items as self-knowledge, commitment, and autonomy, but his argument does not extend to, nor does it require, the thesis that these are virtues. This thesis is of the essence in Martin's essay. I do believe that the tone in which Dilman's discussion is carried on tends to obscure the difference, especially because he is writing in a cultural context where it is taken as almost *a priori* that autonomy is a cardinal ideal. And in addition the reader can readily assume that Dilman himself takes autonomy, "being in control of oneself," as a primary value in life. But, in this essay at least, that is not part of his argument.

Secondly, I see a certain apparent parallelism between Martin and Dilman—a misleading appearance, however—in that, in my mind, neither one sharply enough differentiates subjective from objective self-knowledge. Hence both leave room for alternative interpretations of their theses. However the direction of the ambiguity, so to speak, is reversed: Dilman, as I read him, is essentially presenting self-knowledge as constitutive of autonomy; Martin, on the other hand, relies primarily on self-knowledge as causal in his major line of reasoning, although there are times that he uses language suggesting he has subjective self-knowledge in mind. (For example, Martin at a certain point contrasts mere intellectual or intellectualizing honesty with something more "genuine"—which I take as suggesting an actual subjective movement of the self rather than mere truthtelling.) It is insofar as it is a causal account that Martin's account seems to me to be flawed, and it is insofar as Dilman's is a subjective account that I am sympathetic.

In the end, I may say in regard to both accounts, with their explicit or tacit emphases on personal autonomy as a prime virtue, that I have basic doubts that so great an emphasis, with its plain overtones of claims of universality, can be coherently defended. On the basis of conceptual analysis I doubt that this cluster of notions is internally coherent; and I am also resistant on the basis of cross-cultural comparison as exemplified in several studies in this volume, and in my own other works on Confucius's thought.

# Angus C. Graham

I take up Graham's essay last of all because he deals in it, boldly, with last things. He does so in what might be characterized as secular and subjective terms. Yet he does so in a way that still allows for the plausible claim that it has profound, even ultimate value and significance. Plainly it has links to what we are told of in Taoism and Ch'an Buddhism. However the simple and personal terms in which he presents the experience, free of portentous philosophical or theological jargon, free of built-in (and question-begging) metaphysical or epistemological claims, gives credence to his persuasive appeal that we re-think the nature and significance of the mystical experience. Not so incidentally, Graham's account adds an important dimension to his own theses about value, spontaneity, and rationality as expressed in his other writings.

His essay touches closely some themes I have been addressing in my remarks on the other essays in this volume. For on one hand Graham calls us to acknowledge that the question of how to live should take its place as second in priority to the question: What, ultimately, do we live *for*? His essay reminds us that this latter question is arguably the supreme question in other traditions than ours, and that there is a shared core in the answers given. He proposes that this core of ultimate value is the state of being he so eloquently describes, what may be labelled ineffable at-oneness. This dissolves all the ultimate questions about the meaning of our life. It is to be contrasted with a condition in which one feels need, desire, frustration, anger, anxiety, or other forms of alienation within one's experience.

As I have said, Graham portrays this experience in simple and non-mysterious terms. For convenience I would like to use a label for this point of view, and given that it is merely a label I hope Graham would not be averse to it: I shall say that in Graham's view it is the *aesthetic* dimension that is ultimate. I mean by this to bring out that it is direct intuition and immediate, concrete experience which has normative primacy.

This emphasis contrasts with what I would label the moral emphasis, or equally well for present purposes, the *procedural* emphasis, that gives primacy to such notions as autonomy, self-knowledge, and honesty with self. Emphasis on these notions places at the center, as prime virtues

or moral accomplishment, and as prime values, the question of *how* we are to live. Here the "how" is a notion about procedure, with no specific implication as to what the content of our life or the quality of our experience would be or should be if lived in that way. The central desideratum is that I should make my choices autonomously, that whatever I choose to be or to do I should be honest and understanding in choosing to live as I do. It is therefore a life for which I should be prepared to accept responsibility, this being in effect a criterion of having chosen autonomously, with honesty and understanding.

In my earlier remarks I challenged the at least tacit presumption that these "procedural" virtues are self-evidently central values in life— or, for that matter, that they are central virtues. I suggested that they are at most secondary, dispensable from the perspective of other cultures and especially Eastern ones.

Graham's essay does not directly broach the question of how these procedural virtues are related to each other, or the question as to what degree of importance they have as compared to the aesthetic summum bonum. In other writings of his, however, these questions are in effect addressed.

For Graham, too, is deeply committed to certain procedural values, in particular honesty with self (in more or less the broad and multidimensional sense outlined by Martin), and autonomy. His thesis in other of his writings is that we should choose as our ends that which, as we contemplate our situation, most attracts us. However he places important constraints on the preconditions for making such choices. In a nutshell, he holds that the centrally necessary precondition is "awareness"—i.e., the fullest understanding of our circumstances that can effectively be achieved compatibly with appropriately timely action in the circumstances. The rational thing to do, then, is that which is most desired under the condition of such optimally full awareness. No other procedural device—such as logic, moral principle, or virtue—can rationally take us further (for by the hypothesis all have already been taken into account so far as feasible). Therefore there is nothing left to do, no further procedure, except to act, and no rational way to choose how to act except to act as one under those conditions of optimal awareness feels spontaneously like acting. These ideas are not developed in the essay we are here considering. I will return to them shortly, however.

I am deeply impressed by Professor Graham's depiction in various ways of the experience of what he follows Bataille in calling Common Felicity. I appreciate that label as a device that avoids the mystery and metaphysics Graham wants to avoid. Yet it seems to me a bit too prosaic sounding in English for the quasi-ecstatic kind of experience that is in question. In another use of the word "common," it is a most *un*common felicity to be in the condition in question. Nevertheless, labels aside, Graham's poetic accounts of this everyday kind of sublime felicity are eloquent, and they reflect the profound aesthetic sensibility that we also see in his extensive discussions of the arts in other works of his.

I do agree that experience of this kind occurs and cannot plausibly be denied some sort of value supremacy in our life. I do not mean to prejudge here whether other values can be equal; it is enough for the moment to acknowledge that when these moments come they transport one into, as he suggests, a condition of blessedness, a paradisaical condition, a peace that surpasseth understanding.

I do not see, however, that Graham guarantees such experience to be—either always or even occasionally—the consequence of his recommended method for acting rationally—i.e., acting spontaneously in the context of optimal awareness. Although he uses the term "awareness" here in connection with "Common Felicity," it does not seem to be the same use as we see in connection with his ethical theory generally. This ambiguity obscures two things: the awareness essential to the route by which one rationally comes to act, and the quite distinctive awareness of the state of felicity.

The kind of felicitous experience Graham describes in his present essay is one whose distinctive marks are heightened consciousness, and heightened sensory discrimination. But there is absence from such consciousness of concerns about needs, desires, logical or practical questions—the questions that one must be aware of in conforming to his formula for action.

I would agree that under the condition of felicity we can be more clearly and consciously aware of what we are perceiving—we see, as perhaps the professional artist more readily than the rest of us can see, the actual shapes, color, and apparent movements and locations of objects, rather than perceiving all this in stereotypical forms. In

the condition of "Common Felicity" we hear sounds in their 'musical' immediacy rather than in their conventional utilitarian context.

This supremely felicitous experience is rich in the perceivable *effects* of various causes, including the effects of contextual relations (theoretical, historical, socio-cultural). But the felicitous experience is poor in the discriminating apprehension of these causes, and poor in its discrimination of the many chains of effects of that experience. Thus the Common Felicity experience seems to be far indeed from being the kind of awareness that Graham says ought to inform our ultimate choice of ends.

Perhaps we are to take it that the awareness of Common Felicity is an awareness that is the ultimate desideratum rather than the awareness that ought to shape our dominating desire. But then I must raise the question I hinted at before, and postponed: What reason have we to suppose that the appropriate condition of choice will result in choice that engenders the condition of existence that is of ultimate value in life?

Moreover Graham's acknowledgement that his past experience shapes his current "felicity" experience must recall to us that others, with other sorts of past experience, will find a different content in their perceptual world when they are felicitously immersed in the world of perception. And recognition of this in turn suggests the question: What if the person's past visual or aural experience has been pervaded by the banal and tawdry? Presumably, on Graham's theory, this person's "felicity" experience is equally a foundational source of that person's code of ends and means. Is it legitimate here to ask: But *ought* it to be?

I would argue that the value of the experience, viewed as potentially foundational, will vary depending not only on what kind of life led to it, but also on what kind of life it would generate if it served in a foundational role for that life. Here I believe I express common consensus more than does Graham—and I take it he does not mean to be arguing for a novel and idiosyncratic doctrine but to be clarifying the substance of what we in fact do believe—though confusedly— about what's worthwhile in life.

Or to put my point another way, supposing Graham were to reject my theses about the relevance of the past and future so far as the

value of the immediate experience goes: If the past cannot reduce the value of the experience, given that at the moment it is "blessed" in its quality, then it should not matter whether it is induced by LSD, Demarol, heroin, recuperation from illness, or idleness. And whatever sort of life it nourishes thereafter should not matter, either. But these are conclusions I do not believe Graham would accept in toto. Or is there a further tacit assumption—that the authentic felicitous experience can only arise within an authentically lived life (in some sense of "authentic")?

I leave Graham's essay, then, with something like the same feeling I had after study of his earlier work on spontaneity, rationality, and awareness. On the one hand I fail to be persuaded of the supreme value claimed for the procedure or experience described by Graham. That is, I do not see it as the ultimate term in a hierarchy of human value. But then, as is evident, I am generally resistant to claims of ultimacy, so I do not place too much importance on this particular instance and my criticism of it. Much more important in my mind is that I find his exposition and discussion of the substantive phenomenon he identifies to be wonderfully refreshing and illuminating.

That is to say, I find Graham's work here and in his book on spontaneity to be true wisdom and enlightenment, cast in the ill-fitting clothes of theoretical proof or doctrinal definitude.

## *Postscript*

Subsequent to the preparation of these Comments for press Angus Graham died. In addition to the sorrow of his family and his friends around the world, his death meant a truly major loss for all students of Chinese thought, and no less a loss to the world of humane letters. His scholarly works were to me, as to so very many others, a profound source of information and insight, and his generous correspondence with me was a delight to receive. Though I never met him, his death touches me deeply and personally.

## Conclusion

By the time I had finished my graduate studies, I had come to appreciate that my youthful quest for a "scientific" and conceptually definitive

answer to fundamental questions of ethics, and thus a rational foundation for deciding how to live, was both naive and illusory. The great questions have been debated for millennia; there seems no good reason, given the continuing debate, to expect that they allow for a definitive resolution. Nevertheless—and paradoxical as it may at first seem—as a result of this later perspective, my commitment to rigorous analysis of the family of moral concepts still remained a primary commitment for me. I pursued it in a more catholic way, however, with intensive substantive probing of specific areas in psychiatry, law, Eastern philosophy, and analytical moral psychology.

Yet alongside this, as even more fundamental, grew an awareness that ultimately any particular family of concepts, any doctrine, must peter out into incoherence, contradiction, and irrelevance as one presses outward from its core context of use toward the universality or the ultimate truth it may seem to claim. More than this, it became evident to me that our important doctrines are not only limited in their range of relatively coherent application, but are also parochial in their content. For there usually exist radically different, incommensurable doctrines, often in other cultures, that can serve as alternative visions of much the same area of human existence.

I expressed something of the sort in 1963 in my earliest book, *The Self in Transformation,* which reflected the first ten or fifteen years of my philosophical reflection and research. I would like to quote some passages from the chapter on karma in that book.

> It is the special fate of modern man that he has a 'choice' of spiritual visions. The paradox is that although each requires complete commitment for complete validity, we can today generate a context in which we see that no one of them is the sole vision. Thus we must learn to be naive but undogmatic. That is, we must take the vision as it comes and trust ourselves to it, naively, as reality. Yet we must retain an openness to experience such that the dark shadows deep within one vision are the mute, stubborn messengers waiting to lead us to a new light and a new vision.

> This shifting of visions is not then any the less a matter of genuine and deep commitment. It is not a sampling or tasting, not an eclecticism. For one calls upon a vision with a life, one's own, behind it. One earns a vision by living it, not merely thinking about it.

> We know . . . that . . . the very Buddhas and Bodhisattvas have their
> special favorite powers and realms. . . . One may be a sensitive and
> seasoned traveler, at ease in many places, but one must have a home,
> . . . [Yet] there is no Absolute Home in general. (pp. 236–37, *The
> Self in Transformation*)

That was actually written in about 1960. After that first dozen or so
years of exploring the philosophical and spiritual parallels to the
insights of psychoanalysis, embodied in *The Self in Transformation*, much
of my most fundamental experience in the next decade or two grew
out of or paralleled my study of the *Book of Job*.

In 1978 I wrote in "The Meaning of the Law in the Book of Job":

> . . . the Voice out of the whirlwind, whose words constitute one of
> the great poems of literature, reveals to us, not by second hand descrip-
> tion, but in direct poetic revelation, the glories, the wonders, the
> powers, the mysteries, the order, the harmonies, the wildness, and the
> frightening multifariousness of untamable existence, and its inex-
> haustible and indomitable powers and creativity. The *Book of Job*
> shatters, by a combination of challenge and ridicule and ultimately
> by direct experiential demonstration, the idea that the law known to
> human beings reflects law rooted in the divine or ultimate nature of
> being. . . . [Here I spoke of "law" but one can substitute for "law"
> the broader class—concepts, doctrines, and theories.]
>
> We are allowed [in the *Book of Job*] a vision of existence as inex-
> haustibly rich in creative energies. We see life and death, harmonies
> and discords, joys and terrors, grace and monsters, the domestic and
> the wild. We are as nothing as measured against the whole; we are
> puny, vulnerable, and transient. As mere beings we can only be hum-
> ble. But as beings who are conscious of this miracle, who participate
> however humbly in it, we are transcendently elevated and exhilarated.
> We are like unto the angels. (pp. 268–69, in *Revisions*)

My comments in this present volume are intended to express aspects
of this continuing, underlying theme of my thinking. Each of the essays
presents, among other things, a context in which the theme is in some
form evoked and instantiated. In some cases the theme emerges in
connection with a discussion of some form of responsibility. I have
in mind here the essays of Hasse, Schoeman, Fletcher, and Peele. These
essays, and some of my own comments on them, illustrate how self-
evidently important a role in our life the notion of responsibility plays.

The issues are truly of utmost gravity for anyone born or raised in European culture or any of its derivative forms. Indeed, for those of us who belong to such a culture, it is a defining feature of our belonging that it becomes a central task to accept or take responsibility for one's life, to *be* responsible. The exploration of the concept of responsibility thus becomes, as I see it, a philosophical inquiry of the first importance.

Nevertheless, such exploration eventually reveals two things of basic significance. One is that responsibility is not a given fact about a person's conduct, something simply present or absent, something one identifies by means of a judgment or perception that is value-free and culture-independent. On the contrary, as these essays and my Comments reveal, the more carefully we investigate the more evident it becomes that in crucial respects we give sense to "responsibility" according to the personal or social policies and values pertinent in the context, and also in accord with the relevant concepts and practices peculiar to our own culture. Hasse and Schoeman make the former point; Fletcher and to a good extent Rosemont and Ames provide illustrations of the latter. Responsibility, in its usable, full-blooded form, is a cultural creation, not a fact of human nature.

The second discovery of significance about the cluster of concepts centering around responsibility is—as I see it—that these notions embody irreducible incoherencies and contradictions. This is not the place to go into the detail, and none of the essays brings this feature out. I will merely postulate, to suggest what I have in mind, that there is no coherent answer to the question as to how free will and personal responsibility, in their most distinctive moral meanings, can be reconciled.

The argument for this suggestion can be put summarily in this way. The concept of free action requires, ultimately, that we conceive of the person in the moment of choice as the true initiator, by that choice, of the pertinent conduct. To speak of choice as true initiation of action is to say that the content of the choice is not decisively determined by already extant conditions that are independent of the choice. This is the freedom required by the concept of the moral responsibility of the individual. On the other hand, if action is to be responsible, it is also required that the action be shaped by one's character, one's values, one's perceptions of the situation, and also in relevant ways by the actual

conditions in the situation. Insofar as there is an element in one's choice that is not conditioned by *any* of these, that element of choice, by this hypothesis, does *not* reflect one's nature, values, or situation, and thus it cannot in that respect be *responsible* choice. How, then, can responsible action be free action? The propositions irretrievably clash.

Of course there is much that has been written and still is being written about the ins and outs of this dilemma. My previous remarks constitute not a proof but merely an indication of a line of thinking. One is still free to suppose that in spite of the lack of a clear and generally accepted solution to the dilemma, even after centuries of effort by some of the best minds of our civilization, there nevertheless does exist a coherent answer which unfortunately has not yet been found. Alternatively, one can look beyond our own civilization and see that in other major thought-cultures this family of concepts is not present, and the problem never arises. The latter observation can lead one to surmise—and leads me to surmise—that we have refused to acknowledge the parochial nature, the possibly genuine incoherence of some of our basic ideas. We are so parochial as to deem it self-evident that concepts so basic to our way of thought *must* have universal application and unconditioned validity.

I am, of course, inclined to view this history, and the internal logic of the matter as well, as demonstrating that the incoherence is real and inherent. An essay such as Fletcher's illustrates for me this parochial character, though in connection with Biblical ways of thought, and reconfirms what I have learned from the study of Chinese thought.

I will merely add, without belaboring the point, that I believe much the same sorts of comment are appropriate in connection with that other crucial notion: the modern Western concept of the self. I have in mind here our concept of self as a kind of atomic reality, complete in itself, the core reality that constitutes the person. This self is conceived as an inner, private theater in which secret dramas constantly are taking place, dramas that then may be publicly revealed, at our option, through speech, action, or communicative gesture. The essays in this volume on Confucian thought, and my comments on them, illustrate something of what I mean. Roger Ames's essay raises the issue directly. Henry Rosemont's discussion from the Confucian perspective of the concept of human rights, and my comments on his essay,

provide a bridge between the concept of self and the moral concept-cluster that includes responsibility, and they show the cultural relativity of both sets of concepts.

On the other hand, the Dilman and Martin essays represent beautifully and in their own distinctive ways the serious and rigorous pursuit of understanding of the inner meaning of our self-freedom-responsibility cluster of concepts. This sort of analysis is a pursuit that, as I say, I believe to be essential and of profound importance for modern Westerners, even if in the end these concepts remain subject to the radical limitations I have been outlining.

I do not mean to propound a total cultural relativism. It does not seem true that concepts such as responsibility, human rights, choice, autonomy, and self are entirely creations of particular cultures, without any element of human universality. For example, the people in every society of which we have knowledge manifest some apprehension of what I would label normativeness. It is difficult to understand what human existence could be without a normative dimension. But this is an incomplete notion, a concept-schema rather than a concept, and the normative in practice always has specific, culture-dependent content. The analyses of responsibility in this volume, as I have emphasized, show this dependence on the values, policies, and institutions in which the normative concepts come into use.

Likewise there seems to be some universal concept-schema of agency, but the schema allows the actor to have human, animal, material or indeed any external shape or form at all. In this regard the modern West has a quite narrow use of the schema in its concept of action—essentially restricted to human beings. Agency in turn may be necessarily connected with intention, self-aware purpose. But, again, the specific content necessary if these concept-schemas are to be employable will vary. That the self of the modern individualistic West does not correspond to Confucius's concept of agency comes as no puzzle or surprise if one has this sort of view of normative and agency concepts.

It may seem that I myself am putting forward an incoherent thesis. On the one hand I argue that we should pursue with all authentic seriousness not only the conceptual meaning but also the existential meaning of responsibility, freedom, autonomy, authentic self-identity. On the other hand, I argue that we should recognize the radical

limitations of these ideas and attitudes, their ultimate incoherence, and the existence of alternatives with equal claims to validity and with their own analogous, radical limitations.

I can put my apparent dilemma in simpler and more concrete terms by way of illustration. It may seem not only incoherent but a literally impossible project: (a) to live one's life genuinely committed to the belief that what one chooses and what one does really counts, that we do have the responsibility which goes with our possession of at least some power of genuine control over events and our destiny; and yet on the other hand, (b) to live one's life understanding that what we call our choices and actions, real as they are, nevertheless are events that themselves are fully shaped by the surrounding conditions, at least insofar as there is any meaning to what we do. As I wrote in my essay on the *Bhagavad-Gita*, even our thoughts, desires, intentions "come upon us," "happen" to us, and are not "controlled" by our choice. As I argued in that essay, this dilemma is expressed in the teaching of the *Bhagavad-Gita* to the effect that our central spiritual task is to understand "the action in inaction, the inaction in action."

In any case, as a practical matter, it is not difficult to live a life genuinely founded on these apparently contradictory commitments. It is no more difficult than what we do in trying to live our life in terms of the doctrine that we are actors, who can accept responsibility, and who, when doing so, are acting freely, i.e., as the true originators of whatever it is that we responsibly do. In living by this set of concepts, we already live a contradiction.

If living life in terms of fallible, limited, ultimately incoherent and self-contradictory concepts were impossible, suicide or paralysis would be the only possible reactions. But living such a life is not impossible; it is our fate. Humility is in order here, intellectual humility as well as moral and spiritual. It is self-deception to teach ourselves that we can understand, that we can control, that if one so wills, the self can act responsibly.

But for those of us whose home is in this particular conceptual world, we must nevertheless live in it. We may and should try to broaden and deepen and humanize our understanding through the serious attempt to see and live in the world according to other visions. Angus Graham's essay, and his philosophical writings generally, provide

a model and an inspiration in this regard. In the end, however, we must live our own vision, cultivate our own domain. Each one needs a home in which to live. We need to care for that home if we are to live in dignity. But what is home for us is not home for everyone, nor for all times and places.

I conclude these Comments as I began them—with an acute sense of the honor done me, with pleasure and appreciation for the opportunity to add my voice to that of those who have contributed to this volume, and with warm friendship and admiration for them and for their work.

# BIBLIOGRAPHY OF THE PRINCIPAL WORKS OF HERBERT FINGARETTE

A. **Books**

1. *The Self in Transformation.* 1963. New York, N.Y.: Basic Books. (Reprinted in paperback in 1965.)

2. *On Responsibility.* 1967. New York, N.Y.: Basic Books.

3. *Self-Deception.* 1969. London: Routledge and Kegan Paul.

4. *Confucius—The Secular as Sacred.* 1972. New York, N.Y.: Harper and Row; Harper Torchbooks, 1972. (Japanese edition published in 1990.)

5. *The Meaning of Criminal Insanity.* 1972. Berkeley: University of California Press. (Reprinted in paperback in 1974.)

6. *Mental Disabilities and Criminal Responsibility.* 1979. With Ann Fingarette Hasse. Berkeley: University of California Press.

7. *Heavy Drinking: The Myth of Alcoholism as a Disease.* 1988. Berkeley: University of California Press. (Reprinted in paperback in 1989.)

B. **Articles**

1. "Psychoanalytic Perspectives on Moral Guilt and Responsibility." *Philosophy and Phenomenological Research* 16 (1955).

2. "Freud and the Standard World." *Review of Metaphysics* 10 (1956).

3. "Blame: Its Motive and Meaning in Everyday Life." *The Psychoanalytic Review* 44 (1957).

4. "Eros and Utopia." *Review of Metaphysics* 10 (1957).

5. "The Ego and Mystic Selflessness." *Psychoanalysis and the Psychoanalytic Review* 45 (1958).

6. "Orestes: Paradigm Hero of Contemporary Ego Psychology," *The Psychoanalytic Review* (50th Anniversary ed.) 50 (1963).

7. "Responsibility." *Mind* 75 (1966).

8. "Human Community as Holy Rite: An Interpretation of Confucius' Analects." *Harvard Theological Review* 59 (1966).

9. "The Concept of Mental Disease in Criminal Law Insanity Tests." *University of Chicago Law Review* 33 (1966): 229–48.

10. "Performatives." *American Philosophical Quarterly* 4 (1967).

11. "The Perils of Powell: In Search of a Factual Foundation for the 'Disease Concept of Alcoholism'." *Harvard Law Review* 83 (1970): 793–812.

12. "The Forensic Psychiatrist's Dilemma: Legal Definitions of Mental States." *Bulletin of American Academy of Psychiatry and Law* (1972): 1–21.

13. "Insanity and Responsibility." *Inquiry* 15 (1972): 6–29.

14. "Diminished Mental Capacity as an (English) Criminal Law Defense." *Modern Law Review* (London) 37 (1974): 264–80.

15. "Addiction and Criminal Responsibility." *Yale Law Journal* 84 (1975): 413–44.

16. "Disabilities of Mind and Criminal Responsibility: A Unitary Doctrine." *Columbia Law Review* 76 (1976): 236–66.

17. "Punishment and Suffering," Presidential Address—APA 1977, *Proceedings of the American Philosophical Association* (Sept. 1977): 499–525.

18. "The Meaning of the Law in the Book of Job." *Hastings Law Review,* Centennial Anniversary Issue on Religion and Law (1978): 1581–1617. (Reprinted in *Revisions: Changing Perspectives in Moral Philosophy,* ed. Stanley Hauerwas and Alasdair MacIntyre. Notre Dame: University of Notre Dame Press, 1983, 249–86.)

19. "The 'One Thread' of Confucius' Analects." (Harvard East-Asia Research Center, First Conference on Ancient Chinese Philosophy, August 1976), *Journal of the American Academy of Religion* 47 (1979): 373–406.

20. "Feeling Guilty." (Invited Address to APA, 1979), *American Philosophical Quarterly* 16 (1979).

21. "How an Alcoholism Defense Works under the ALI Insanity Test." *International Journal of Law and Psychiatry* 2, No. 3 (1979): 299–322.

22. "The Problem of the Self in the Analects." American Philosophical Association, Asian and Comparative Philosophy Symposium,

Washington, D.C., 1977; *Philosophy East and West* 29, No. 2 (1979): 129–40.

23. "Rethinking Criminal Law Excuses." *Yale Law Journal* 89, No. 5 (1980): 1002–16. (Invited address to American Law Assoc. National Conference, 1979)

24. "The Concept of Ideal Authority in the Analects." *Journal of Chinese Philosophy* 7 (March 1981): 29–49. (Invited main paper, International Conference on Confucianism, University of Hawaii, 1980)

25. "Legal Aspects of Alcoholism and Addiction." (Position paper commissioned by World Health Organization, Expert Committee on Alcoholism and Drugs, 1980) *British Journal of Addiction* 76 (June 1981): 125–32.

26. "Legal and Philosophical Aspects of the Disease Concept of Alcoholism." in *Research Advances in Drug and Alcohol Problems* 7 (1983): 1–45.

27. "Intoxication as an Excuse in Law," with Ann Fingarette Hasse. In *Encyclopedia of Crime and Justice,* ed. Sanford H. Kaddish. New York, N.Y.: Free Press, 1983.

28. "The Music of Humanity in the *Conversations of Confucius*." 10th Anniversary Memorial Issue, *Journal of Chinese Philosophy* 10, No. 4 (December 1983): 331–56.

29. "Action and Suffering in the Bhagavad-Gita." *Philosophy East and West* 34 (1984).

30. "Alcoholism and Self-Deception." In *Self-Deception,* ed. Mike W. Martin. Lawrence, Kans.: University Press of Kansas, 1984.

31. "Reconceiving Alcoholism," presented to International Research Conference on Alcoholism, Edinburgh, June 1984.

32. "Alcoholism and Karma." Presented to the Plenary Session of the International Research Conference on Comparative Philosophy, Honolulu, August 1984.

33. "Disability of Mind Doctrine." *Annals of the American Academy of Political and Social Sciences,* special issue on Insanity Defense (December 1984).

**34.** "Victimization: A Legalist Analysis of Coercion, Undue Influence, Deception, and Excusable Prison Escape." *Washington and Lee Law Review* 42 (Summer 1985).

**35.** "Alcoholism: Can Honest Mistakes about One's Capacity for Self-Control Be an Excuse?" *International Journal of Law and Psychiatry* 13 (1990): 77–93.

**36.** "Reason, Spontaneity, and the *Li.*" In *Chinese Texts and Philosophical Contexts: Essays Dedicated to Angus C. Graham,* ed. Henry Rosemont, Jr. La Salle, Ill.: Open Court, 1991, 209–26.

# INDEX